THE ART OF
HOWARD TERPNING

"The old Cheyennes could not write things down. They had to keep everything in their heads and tell it to their children so the history of the tribe would not be forgotten . . ."

JOHN STANDS IN TIMBER, CHEYENNE.

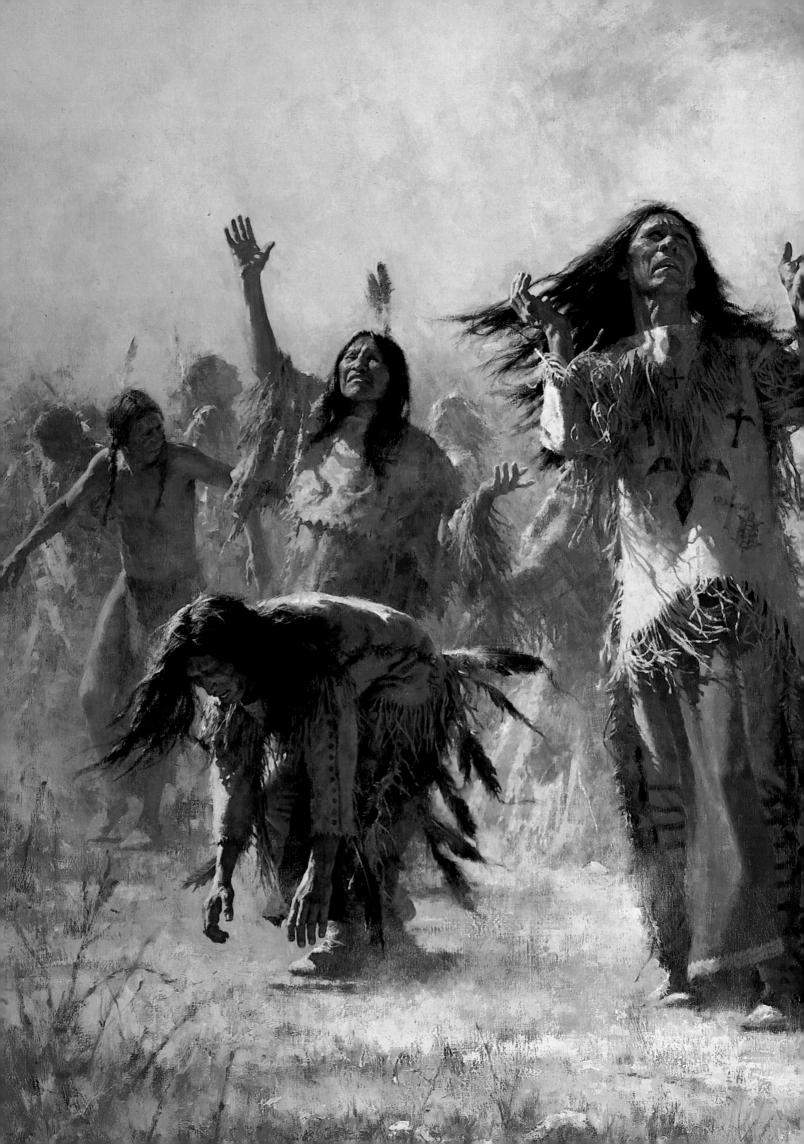

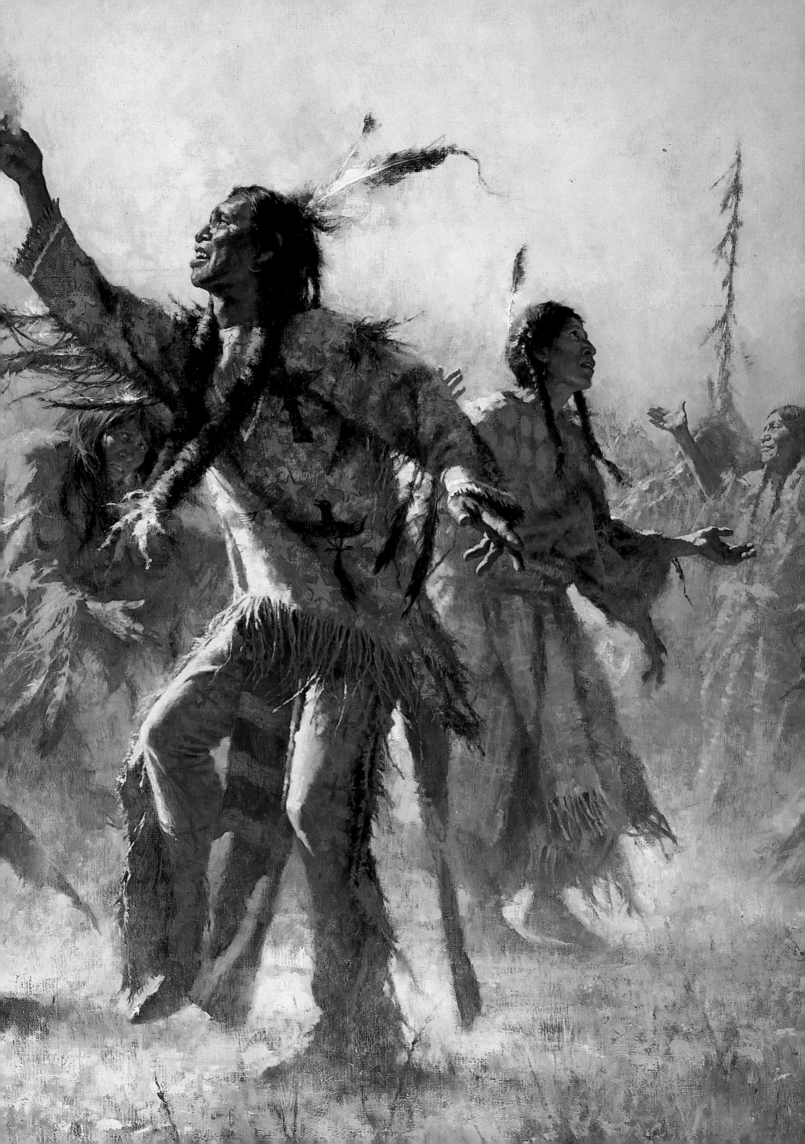

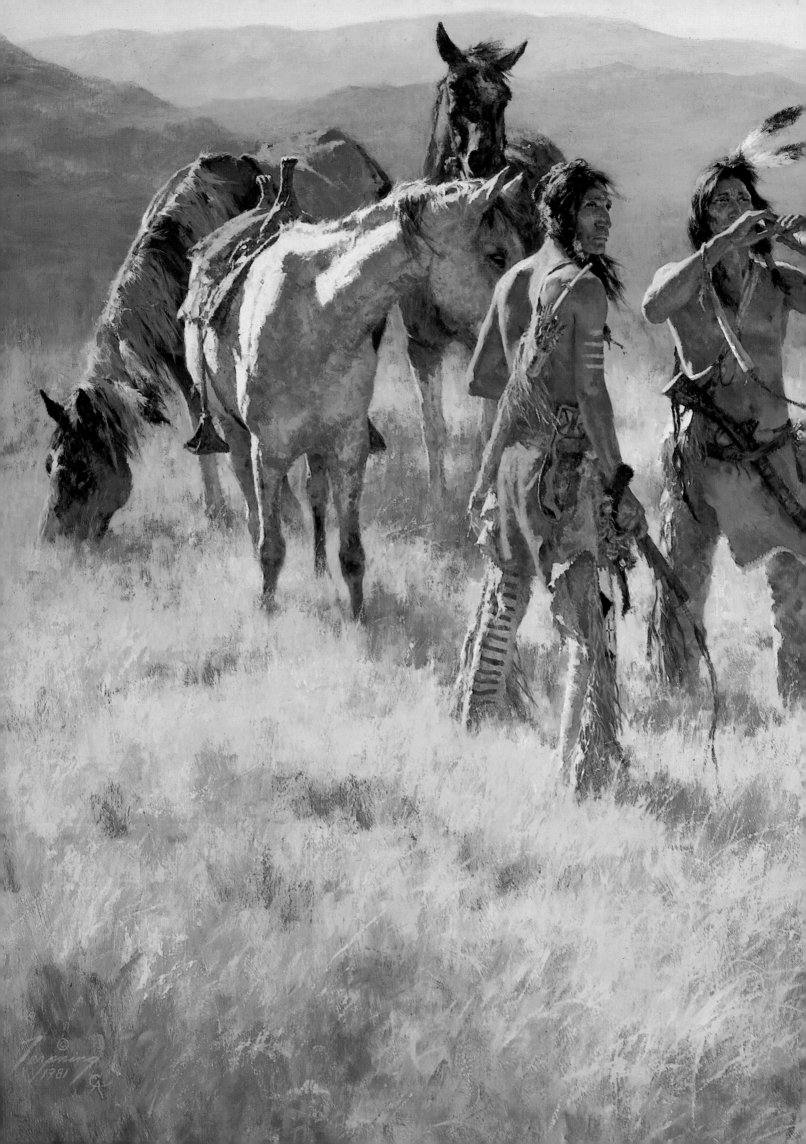

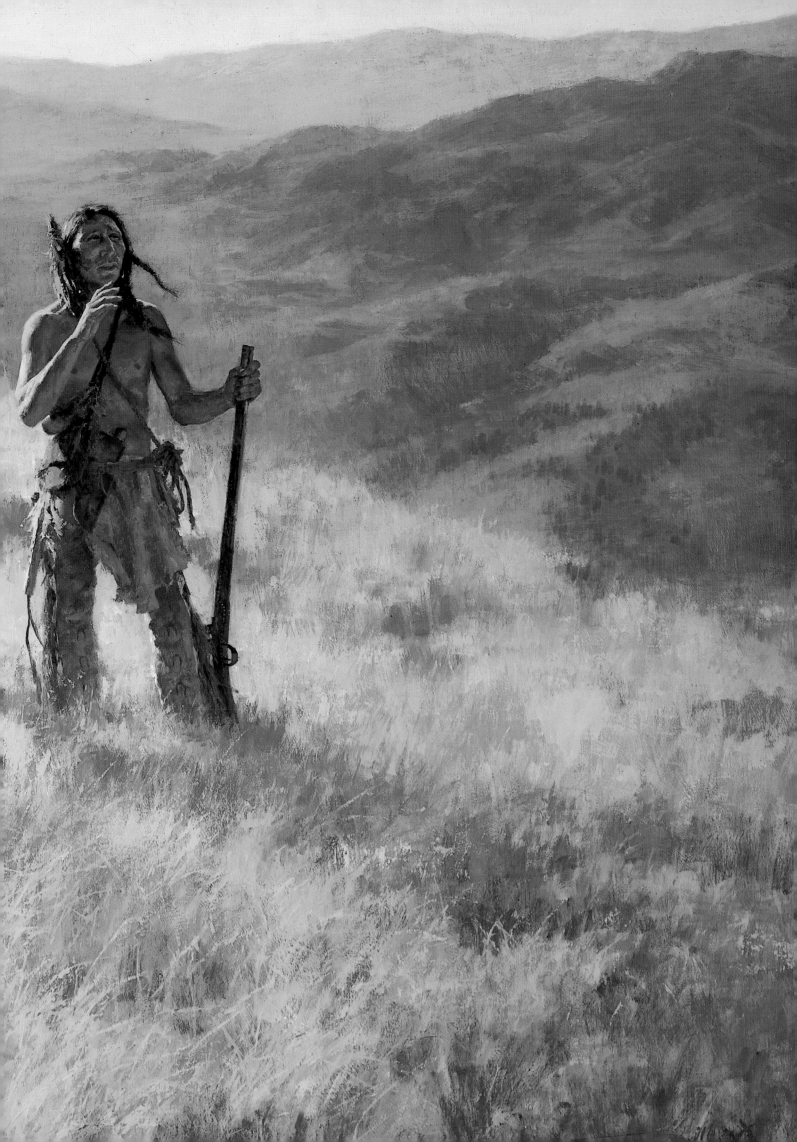

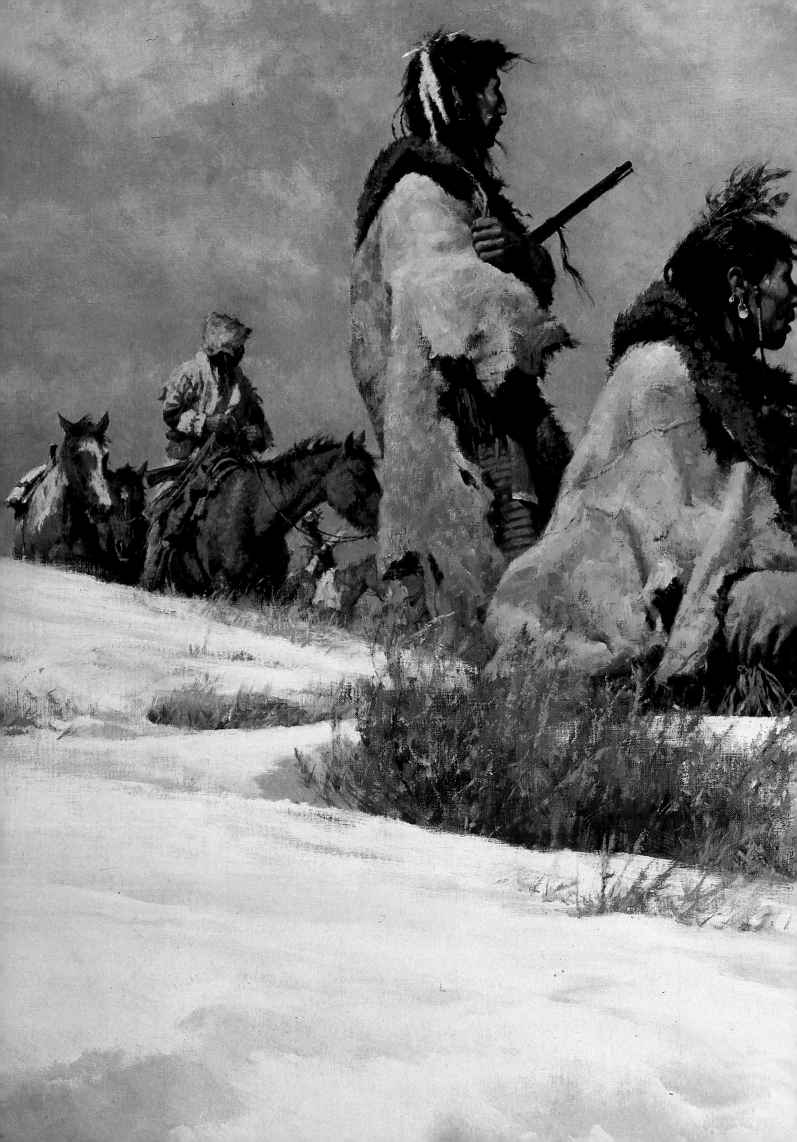

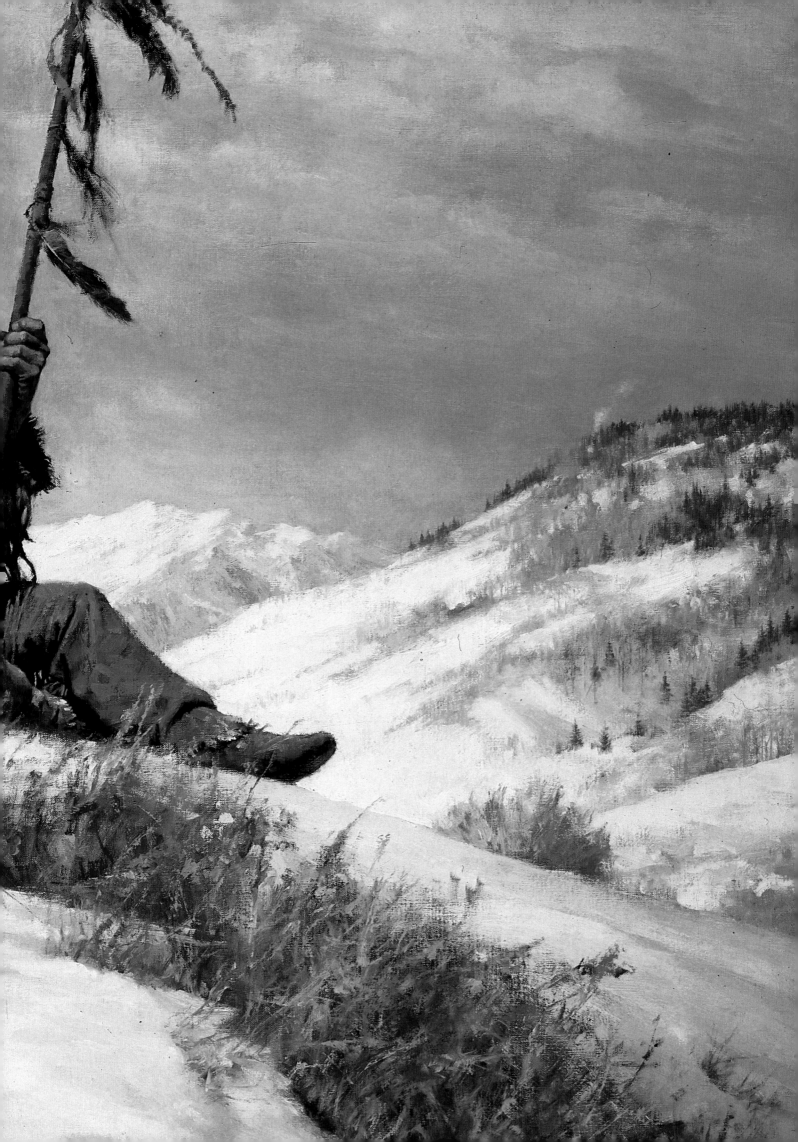

THE ART OF
HOWARD TERPNING

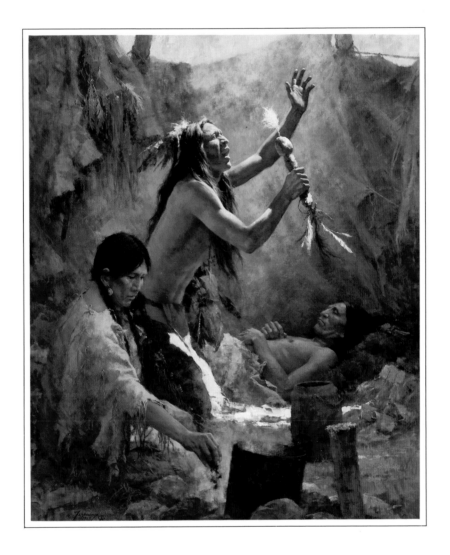

TEXT BY

ELMER KELTON

INTRODUCTION BY

DARRELL R. KIPP

BANTAM BOOKS
NEW YORK TORONTO LONDON SYDNEY AUCKLAND

This Book is Dedicated to the Native American People

ACKNOWLEDGMENTS

The Greenwich Workshop extends grateful thanks for material that appears by permission of the following: (p154) General Cigar Company, Inc., for permission to reprint an advertisement for Gold Label cigars by Howard Terpning; (p155) Pendleton Mills for permission to reprint an advertisement for Pendleton Mills by Howard Terpning.

FRONTIS ART

2-3 Detail from *Hope Springs Eternal—The Ghost Dance*
4-5 Detail from *Dust of Many Pony Soldiers*
6-7 Detail from *Signals in the Wind*
9 Detail from *Medicine Man of the Cheyenne*

THE ART OF HOWARD TERPNING

A Bantam Book/Sept. 1992

Library of Congress Cataloging-In-Publication Data

Kelton, Elmer.
The art of Howard Terpning : the outstanding painter of the American Indian / text by Elmer Kelton : introduction by Darrell R. Kipp.
p. cm.
ISBN 0-553-08113-8
1. Terpning, Howard,—Criticism and interpretation. 2. Indians of North America—Pictorial works. 3. West (U.S.) in art.
ND237.T388K45 1992
759.13—dc20
91-46852
CIP

Bantam Books are published by Bantam Books, a division of Bantam Doubleday Dell Publishing Group, Inc. Its trademark, consisting of the words "Bantam Books" and the portrayal of a rooster, is Registered in the U.S. Patent and Trademark Office and in other countries. Marca Registrada. Bantam Books, 666 Fifth Avenue, New York, NY 10103

Published simultaneously in the United States and Canada
Printed in Italy by Amilcare Pizzi, S.P.A.

Book Design by Kathleen Herlihy-Paoli
Photographs of Indian Artifacts by Paul Berquist, Manley-Prim Photography

92 93 94 0 9 8 7 6 5 4 3 2 1

CONTENTS

INTRODUCTION

The Blackfeet are my people. Like all native Americans, we have strong pride in our history. Art has been a cardinal point in our tribal traditions since the earliest times. In the dawning, after Old Man from the Sun was sent to them as their teacher, the *nitsitapiks*, or Real People of the Far Off Spotted Robes, took from their dreams and origins the colors and symbols with which they adorn themselves to this day despite the thousands of years that have passed.

The Indian world adapts to changing motifs. It displays its secrets openly, yet keeps them, for the rest of the world does not discern their true meanings. In the reservation high school, the sports teams dress in colors of red and black and often wear amulets given to them by the grandparents of the tribe. The red and black were not chosen randomly but were selected because they are the sacred colors of the tribe, given them in the form of the sacred digging stick, a gift from the Sun, Moon, and Morning Star.

The language of the confederacy—the Blackfeet, North Piegans, Bloods, and Blackfoot—remains the keeper of the secrets. Despite a deliberate and determined onslaught to rid the tribes of the Mother and Father Tongue, it continues to nourish the people like a fragile grandmother. The language swirls with the wonderment of the Real People's origins, religion, thought, laughter, and prophecy.

The language *is* the people. In the language code are the secrets of the symbols adorning the Indian world. The language and symbols extol the virtues and magic of the tribe. Today the speaker and the artist true to the secrets remain the two keepers of the code and symbols. To see a painted Blackfeet lodge is to see the tribe's cosmos. The untrained and unknowing see only an abstraction of geometric design. The knowing see a universe locked in the mystery of symbol, color, and oral tradition. The painted lodge remains a testament to the power of artist and symbol. Each continues to extend the tradition of the Real People's world.

The Blackfeet Indians of today can go to the *Katoyisiks*, called in English the Sweet Grass Hills, in the east central part of their homeland, and see the *sinaxin* etched into the stone cliffs by their ancestors, the Far Off Spotted Robes, long years ago. The *sinaxin* remain vivid and clear in their renderings. Except for the occasional slash of the vandal's gross intrusion, they remain powerful to the viewer season upon season. *Sinaxin* in Blackfeet means the *writing pictures*. The wandering tribes of North America have left them as lasting recordings of their life on the great Mother Earth.

To the tutored eye, today's landscape of the Indian reservation presents a modern-day contradiction of wheatfields licking up against the base of a long-ago buffalo jump; a mountain meadow nurturing a herd of cows oblivious to the ghosts of the tribal summer camp; or the elderly medicine man in cloth shirt and pants sitting alongside the backpacker's trail winding up a sacred mountain.

Outside of Starr School, one of the communities on the Blackfeet reservation, a beautiful mountainside covered with cottonwoods locks and hides a sacred burial place as tightly as any high, ivy-covered cemetery fence. For some reason the

postcard-pretty scene deters one from a closer inspection, and its beauty seems better appreciated from a distance. Closer, the calm repose of a small valley appears, then wanes. The children of the ancient ones, and undoubtedly *their* children, will never need to ask why they stay respectfully clear of the special place even though no sign or warning is offered.

The eye cannot always see what the heart knows, but when both understand the secret, *writing pictures* demand the hand of the artist. All Indians, Blackfeet or not, see the *sinaxin* through their own world. Like the gallery visitor, they may at one time give a quick and casual look, at other times stand awed and silent when their observation reveals a truth. It is a true artist who can capture the eye and the heart in the *sinaxin*. The *sinaxin* of the artist keep the spirit of the people and place alive.

At the turn of the century the Indian was considered the vanishing American. In subsequent times he has been considered the invisible American, a ghost of the past. It is the artist who brings the Indians back into focus and places them in a world that is real. The artist's compassion for this Indian world has produced some of the greatest reflections of their existence. In these collections of art it is possible to gain some true sense of the reality of the people, and their place.

Many visitors come to an Indian reservation to view and to question. They consider themselves honest and sincere; yet few truly discover the quintessential Real People of the reserve. Their inability to see past preconceived notions of the Indians denies them the blessing of a true exchange between people. Those who do come with the honest intentions of good friends find all the elements present that keep a people alive and together, gracious despite a long-standing pressure to change or eradicate them. They find the people willing to be friends.

Today the tribes of North America find their populations increasing dramatically each year, and the need for greater understanding by the world around them becomes increasingly important. In the same manner, within each tribe it becomes clear that a knowledge and understanding of the ways of the ancient ones will guide the spirit and health of the tribe's trek into the future.

The artist and the speaker, keepers of the ways, become more and more important today. Their words and *writing pictures* ensure that the cycle of secrets is kept accurately and openly. If one wishes to share in the secrets, the only requirement is a sincere effort to learn about and understand the world of the tribe.

Several years ago Howard Terpning and I, along with several others, traversed the reservation looking again at the multi-layered history and mystery of the region. From a quiet grove of cottonwood trees holding sacred offerings alongside the Two Medicine River, all the way to Chief Mountain, the sacred site for many Indian tribes within its view, we shared thoughts and friendship with those who were beside us. Our fellow travelers, George Kicking Woman—a keeper of the sacred pipe—and Ed Little Plume, are both fluent speakers of the Blackfeet language. Their insights allowed us to delve deeply into the history of the special places we visited.

Today I look at Howard's work and sense the power of the *sinaxin* within each piece, and a sense of the truths he heard from the speakers. His is a special collection with the strength of the ancients' writing on the stone.

DARRELL R. KIPP *Apinokio Peta*, (Morning Eagle)
Blackfeet Reservation
Browning, Montana

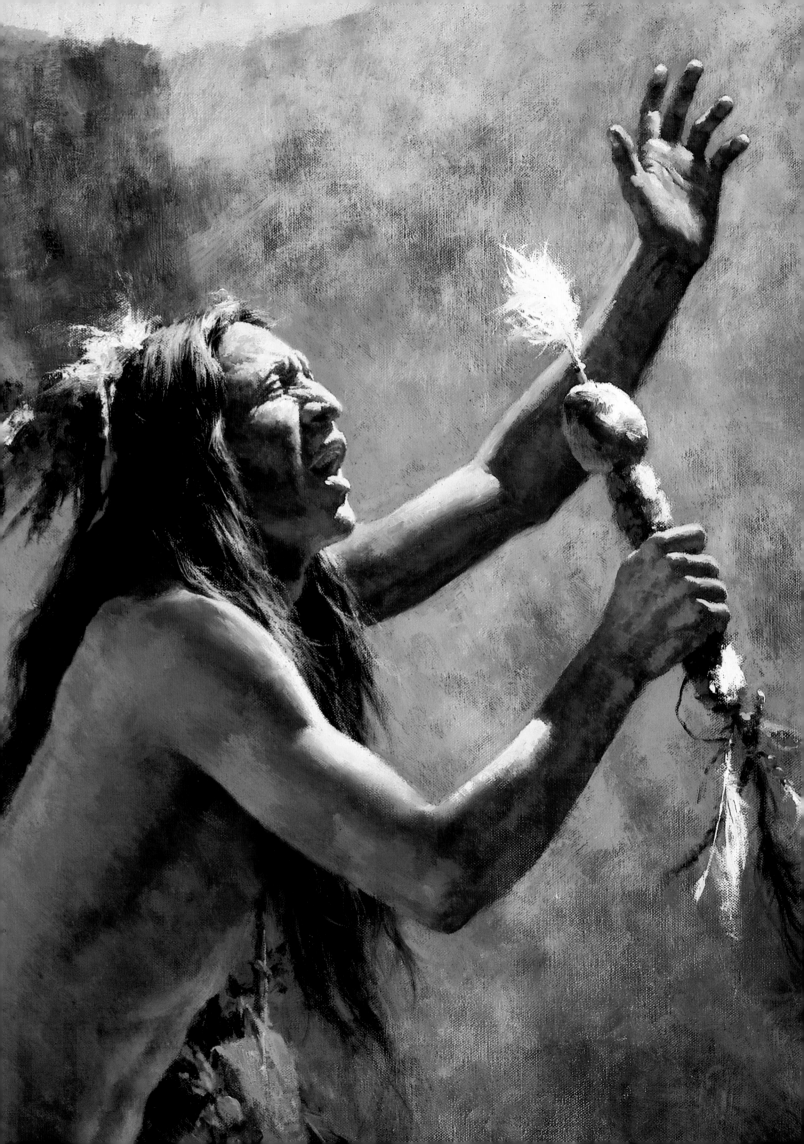

THE ORIGINS

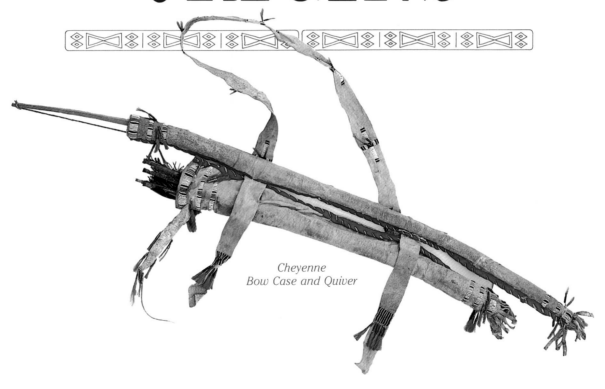

*Cheyenne
Bow Case and Quiver*

*"I was born upon the prairie, where the wind blew free and there was
nothing to break the light of the sun. I was born where there were no
enclosures and everything drew a free breath . . . I live like my fathers
before me and like them I live happily."*

PARRA-WA-SAMEN, TEN BEARS, COMANCHE

Origins of the native Americans are shrouded in the dusty veil of time. Archeologists tell us that their fur-clad ancestors ventured upon this continent between ten and fifty thousand years ago, during intervals when the great ice ages lowered the oceans to form monstrous mountain-crunching glaciers as much as a mile deep halfway down the North American and European continents. This drained off a wide passageway from Siberia across the Bering Strait to Alaska.

Over this broad, tundra-covered land bridge, hunters with stone-tipped spears and axes followed the migrations of giant bison, woolly mammoths, camels, musk oxen, and other game onto a pristine continent half covered by ice. Over the millennia, most drifted southward down open corridors between the massive glaciers, fanning out along the many waterways as they moved beyond the ice packs.

Separated, they gradually formed distinctive cultures that reflected the natural resources available to them in the varied environments. In the east, they became primarily gatherers and eventually farmers. On the plains and in the southwest, they became hunters and gatherers. Along the coasts and beside the lakes they became farmers and fishermen. Living in relative isolation, they developed languages that over time bore little or no resemblance one to another. Even in physical characteristics, they evolved in different directions.

That is the scientists' view. Every native American tribe had its own version of the creation story. They did not speak of a land bridge, or the great expanses of cold, blue-white ice. Their migrations were probably slow enough that from one generation to another they never realized they were moving into a virgin land.

Almost all had some supernatural or religious theme of benevolent spirits regarding man. Most assumed man to have been created about where the various tribes found themselves. Wherever they happened to be, that was the center of the universe.

The Blackfeet told of Napi, the Old Man, in a time when all the world was covered by water. To find out what was beneath it, he sent down the duck, the otter, the badger, and finally the muskrat. The muskrat remained so long that the Old Man feared it had drowned. It came up, finally, carrying a little ball of mud between its paws. The Old Man blew on this mud, which began to swell and grow until it became the earth. Napi then built the mountains, gouged out the rivers and lakes, planted grass on the plains and timber along the rivers and in the mountains. After making all the birds and animals, he made himself a wife, known as Old Woman. The two together decided upon the form man should take. The Old Man taught the people how to gather and hunt, then retired to a high mountain and disappeared.

Variations of the Old Man legend were known to the Arapaho, Gros Ventre, and Cree.

A Kiowa myth tells of a supreme being who created all of the world and all the plants and animals on it except the Kiowas. He came across a hollow log, struck it a hard blow, and out came the Kiowa people. He gave them their tools and weapons, instructing them in their use, then returned to the sky to become a group of stars.

Pawnees had a theory about how the world would end. The power above had placed a great buffalo bull in one corner of the sky. Each year the bull would lose one hair. When the bull had lost all its hair, the legend said, the sun would go dark, and the human race would die.

Though it is a common misconception that the Plains Indians culture had existed with little change for ages before the white man's intrusion, the fact is that a majority of tribes were relative newcomers to the regions they inhabited when the first white explorers found them on what was regarded at the time as "the Great American Desert." Most had drifted there from farther east because of population growth or murderous intertribal hatred and warfare. Much of this grew from ancient quarrels over tribal rights to use of the land. Some of it was simply the innate human tendency of the strong, like the Iroquois, to prey upon the weak. Fighting was intensified by the spread of firearms and egged on by competing French and English traders who coldly pitted one tribe against another for their own profit.

Many tribes brought their old woodlands culture to the plains but lost much of it through decimation by war and by the need to adapt to a vastly different environment, a wholly new kind of life. They were also affected by their contact with other people, often assimilating some of these new ways and beliefs into their own cultures.

The popular image of the Plains Indian is that of the fierce, nomadic, horseback warrior and buffalo hunter, moving his tepee encampments with the migrations of the herds. Though this image is basically correct, such an existence lasted only a couple of centuries at best, a fleeting moment in terms of the time the Indian and his forebears had lived on the American continent.

In a sense it was the last flare of glory for an Indian world that already was near extinction under the relentless pressure of the hair-faced newcomers from Europe. The glittering though bloodstained Aztec culture in Mexico had already been devastated by the Spanish. The woodland tribes of the eastern United States were virtually gone. They had been crowded out by the white man's constant takeover of their lands and cutting down of the forests, wiped out by his guns and his imported diseases such as smallpox, measles, and diphtheria, against which the Indians had no natural immunity.

As one tribe exerted its power against a neighbor and forced it to move, the displaced neighbor in turn collided with the next tribe. Historian James L. Haley has likened this to billiard balls banking around a table, knocking each other first one direction and then another.

The Blackfeet were among the earliest of the "modern" Plains Indians, settling along what became the Montana–Canada border after driving out the Kutenai. Their Algonquian dialect ties them to eastern tribes and makes them relatives of the Arapahoes and Gros Ventres. Evidence points toward a woodlands origin farther east, probably in the Red River Valley of Minnesota. Reasons for the Blackfeet migration can only be speculated upon: war, crowding by an expanding population, the attraction of big game on the plains.

Historian John C. Ewers suggests that they may have lived for centuries in the transition zone between the forests and the grasslands before moving out onto the high plains in the eighteenth century and, after acquiring the horse, settling against the eastern foot of the Rocky Mountains. They became, in their time, the most powerful tribe north of the Missouri River.

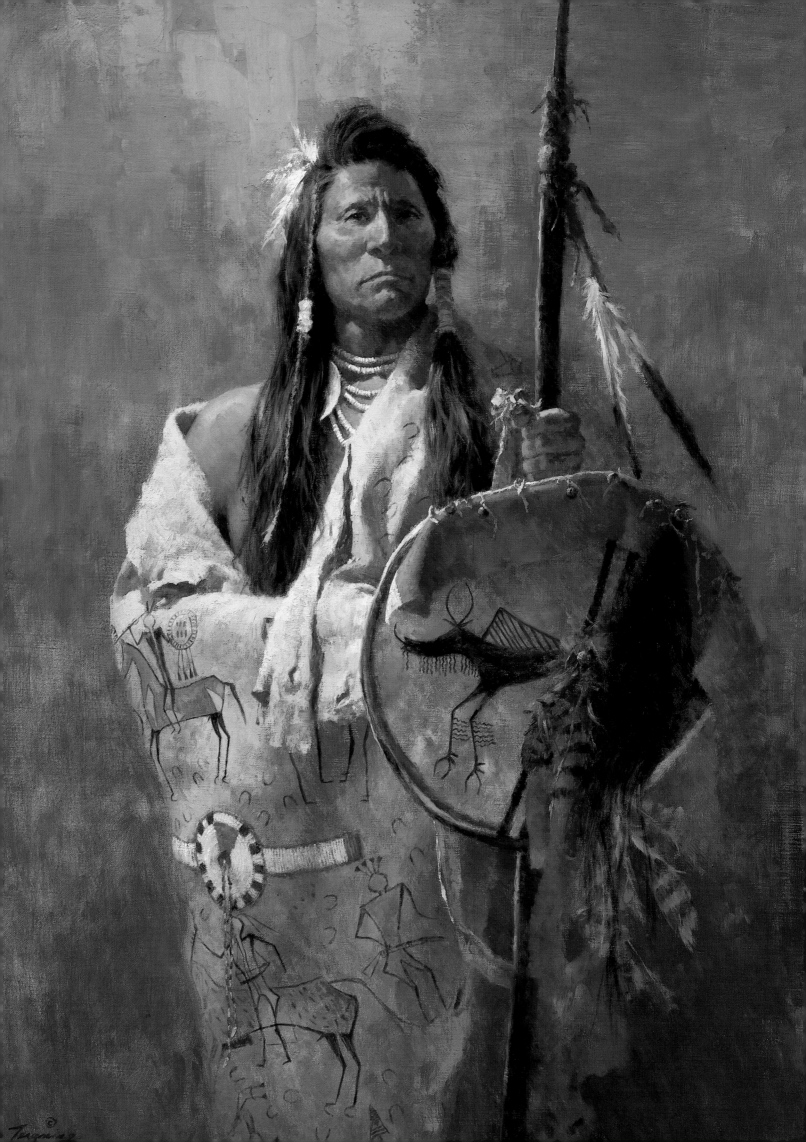

The Sioux had a homeland in the woodlands of the Ohio, Wisconsin, and Minnesota rivers. They came under heavy attack by the Crees and Assiniboins, who traveled in massive raiding parties, slaughtering their opponents with firearms acquired from the English. They were also harassed by a traditional enemy, the Ojibwas, or Chippewas, who used firearms to avenge earlier offenses by the Sioux. The various Siouan groups were aggressors at one time and place, victims in another, their fortunes rising and falling with shifting alliances and enmities.

Though Santee Sioux remained in Minnesota, most of the other Sioux migrated west into South Dakota. This move brought them into conflict with Crows, Kiowas, Arikaras, and Cheyennes, who had moved onto the plains ahead of them. It earned them their name from a French interpretation of an Algonquian word meaning "enemies," much as the Apaches would gain their name from a Spanish interpretation of a Zuni word having the same meaning.

Tribal tradition suggests that the Cheyenne may have originated north of the Great Lakes, toward Hudson's Bay. They were cousins to the Arapahoes, who preceded them west. Handed-down stories tell of their having lived by a large lake far to the north, of building willow seines to catch fish. It is believed they began moving westward under heavy pressure from the Crees, who were armed by the Hudson's Bay Company. Their movement brought them under savage attack by the Assiniboins, a Siouan people carrying English-origin rifles. They retreated southwestward to the Missouri River. Some settled there to raise crops, as they had done in their original homeland, while others moved out onto the plains to live off the vast buffalo herds. There, as a Cheyenne expression put it, "we lost our corn."

STATUS SYMBOLS

What the plains warrior wore or carried often told much about his life. Here a Crow, haughty in his status, has wrapped himself in a buffalo robe painted with the scenes of his triumphs on the hunt and in warfare. His lance is decorated with feathers. Many men adorned lances, war shields, or even their horses' bridles with scalps taken from their enemies. The shield here carries the warrior's depiction of a buffalo. Almost certainly it is made from the thickest part of a buffalo bull's hide, stretched across a hoop and braces made of willow or other pliable woods and stuffed out with buffalo hair or other materials which will give it strength.

George Catlin, an artist who visited the upper Missouri in 1822–23, left an account of a Sioux method of shield manufacture. The warrior would dig a hole about two feet deep, the diameter of the shield, and build a fire in it. He would stake out a piece of green hide from the buffalo hump so the heat would shrink and thicken it while the maker kneaded it with glue. It would finish metal-hard. A final step was to give it medicine powers to ward away harm. Then the warrior could carry it into battle with every confidence that it would bring him out alive.

The Crows originated as part of the Hidatsa, who lived in earth lodges and raised food crops along the Missouri River after earlier being forced out of their eastern woodlands homeland by armed Crees and Ojibwas. Calling themselves Absaroke, which referred to the sparrow hawk—a far cry from the crow—they had migrated westward and settled in the Yellowstone country by the time they began to be contacted by white traders.

The Caddoan-speaking Pawnees, who retained traces of Aztec-influenced culture, had drifted up from Texas in perhaps the thirteenth century to live in earth-covered wooden lodges along both banks of the Missouri and along the Platte in what is now Missouri, Kansas, and Nebraska. There they farmed, fished, and hunted. They became victims of slave-capturing raids by Siouan tribes to a point that they were forced westward out onto the plains. The later Arikaras of the Dakotas were evidently Pawnee survivors.

The Comanches were of Shoshonean origin and of the same Uto-Aztecan group as the Paiutes, Utes, Bannocks, and Hopis. They broke away from the main body of Shoshones in the Great Basin west of the Rockies and began moving southward along the eastern slope. Originally a poor, preyed-upon tribe eking out a subsistence living, they acquired the horse and quickly turned into fearsome warriors. In an amazingly short time, they took over most of the plains from the Arkansas River south into the broken hill country of Central and Southwest Texas and almost everything from the Pecos River east.

The Kiowas' origins are clouded by uncertainty. Their language suggests some kinship to the Pueblos. Early encounters with whites, however, occurred as far north as the Yellowstone. Tribal traditions place them near the sources of the Yellowstone and Missouri rivers in western Montana and indicate some association there with the Crows. They appear to have wandered as far as the Black Hills but were pressed southward by the Sioux and Cheyenne moving in from the east and northeast. Working their way down to the Platte and the Arkansas, they warred for some years with the Comanches, then made peace about 1790. They remained allied with that tribe until the white man defeated both on the Texas plains some eighty years later.

Tracing the Apaches is difficult. Most were desert and mountain rather than Plains Indians, though in historic times the Lipan branch of the Apaches was scattered across the Texas plains and the Texas hill country until invading Comanches drove them west into the mountains. The Jicarillas lived in the grasslands along the New Mexico–Colorado border. They, like their Navajo cousins, were Athapascan people who had migrated down from the Mackenzie and Yukon rivers, probably sometime after A.D. 1000. They preyed heavily on the Puebloans as their many divergent bands settled in what would become Arizona, New Mexico, and Texas.

Each group adapted itself to its particular environment. Over time, many were only dimly aware of the others, if at all. In historic times, some warred against their kin of other bands. One thing they shared, beyond a common root language, was

a reputation as ferocious fighters; and another, because they lived near the earth and its creatures, was a reverence for nature.

Indians revered certain birds and animals, such as the eagle, the hawk, the elk, the wolf, and the buffalo. They feared the bear and avoided it. In Indian legend, the scratches on the sides of the Devil's Tower in Wyoming were made by an angry grizzly trying to climb up in pursuit of some young Indian girls. Almost all plains tribes dreaded the owl as an ill omen, bad medicine. In Comanche folklore, the people were for a long time terrorized by a huge cannibal owl.

The lives of the plains folk in pre-horse times were hard by later standards. Traveling was difficult and restricted their movements to shorter distances than would become their custom once they had the horse. Most of the tribes were sedentary or at least semi-sedentary, living on the edge of the drought-prone plains more than in the midst of them, subsisting from farming and gathering as much as, or even more than, from hunting. They had some knowledge of selective breeding, which helped them develop strong dogs as beasts of burden. Even so, a dog was limited as to the amount of goods it could carry on its back—perhaps fifty pounds—or drag on a travois—perhaps seventy-five pounds.

This prevented the semi-nomadic people from accumulating much in the way of personal property. The travois poles had to be small and relatively short. That, and the weight of the skins to cover it, limited the size of the tepee. A group traveling with dogs might make only five or six miles a day. The dog was less dependable than the horse, for it might suddenly veer off the trail to chase a rabbit, or turn to fight with other dogs, perhaps dumping its load.

The people's inability to carry large quantities of food and water was another handicap to their migrations. It restricted them to areas where water was available and where they could subsist on roots, berries, wild onions, and whatever else they could pick or dig up when they were unable to keep the camp in meat, or where they could grow crops such as corn, squash, and beans to sustain them.

Hunting was difficult, which kept the band in constant dread of hunger. Unable to run as fast as the buffalo, the Indian had to trick them by sneaking into the herd under a buffalo robe or wolfskin, setting grass afire to force them into lance and arrow range, or stampeding them off cliffs.

The Coronado expedition in 1541 encountered Apaches on the plains and described them as subsisting entirely on buffalo, for they neither planted nor harvested corn. One of Coronado's chroniclers, Pedro Castañeda de Najera, wrote: "With the skins they build their houses; with the skins they clothe and shoe themselves; from the skins they make ropes and also obtain wool. From the sinews they make thread, with which they sew their clothing and likewise their tents. From the bones they shape awls and the dung they use for firewood, since there is no other fuel in all that land . . .

"They dry their meat in the sun, cutting it into thin slices, and when it is dry they grind it, like flour, for storage and for making mash to eat. They cook it in a pot, which they always manage to have with them."

The Apaches, he wrote, traded skins and dried meat to Pueblo Indians for their corn and cotton cloth. They moved with their "cattle," meaning the buffalo, packing goods on their dogs or on travois drawn by the dogs. ■

TELLING OF LEGENDS

Because they had no written language, it was vital to the Indians' preservation of their rituals and legends that these be handed down orally from one generation to the next. In this painting a Blackfeet elder, medicine pipe in his hand, sits atop the sacred Chief Mountain in Montana, relating to a younger man the legends which he wants to be certain will be preserved and retold for the benefit of those who come after.

The artist saw this scene in early morning, when the rising sun was in bright contrast to the dark blue shadows marking the distant mountains and deep canyons. "I am always attracted by that kind of light," he says. "The mood was so beautiful."

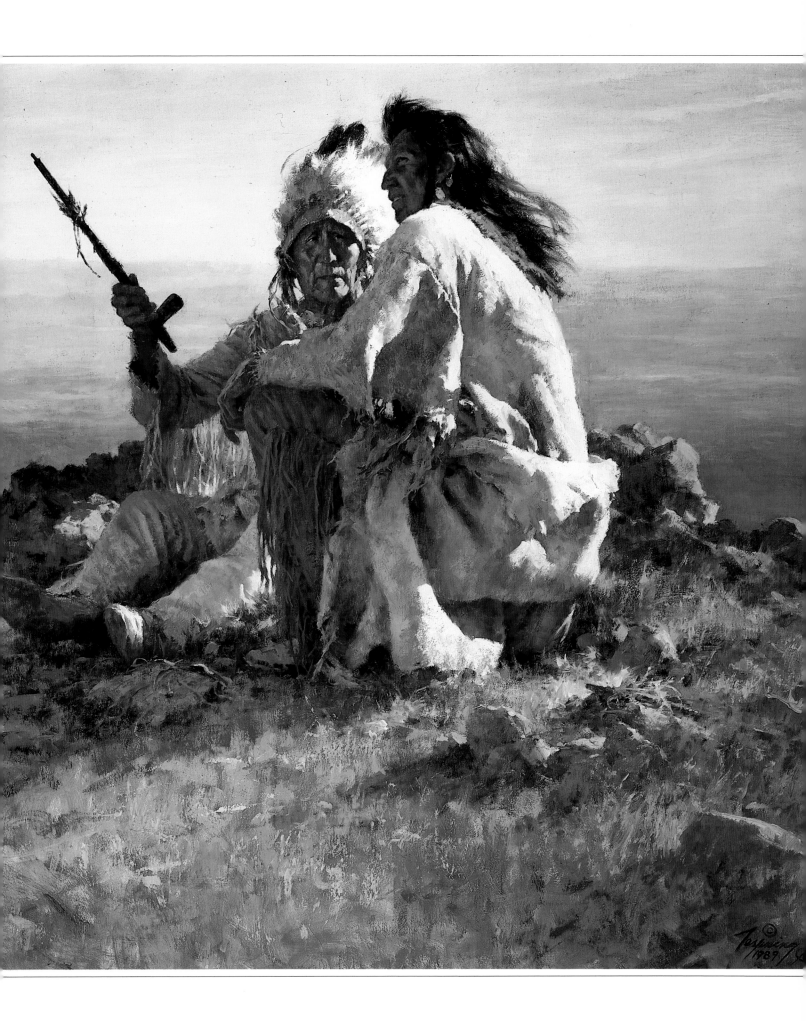

23

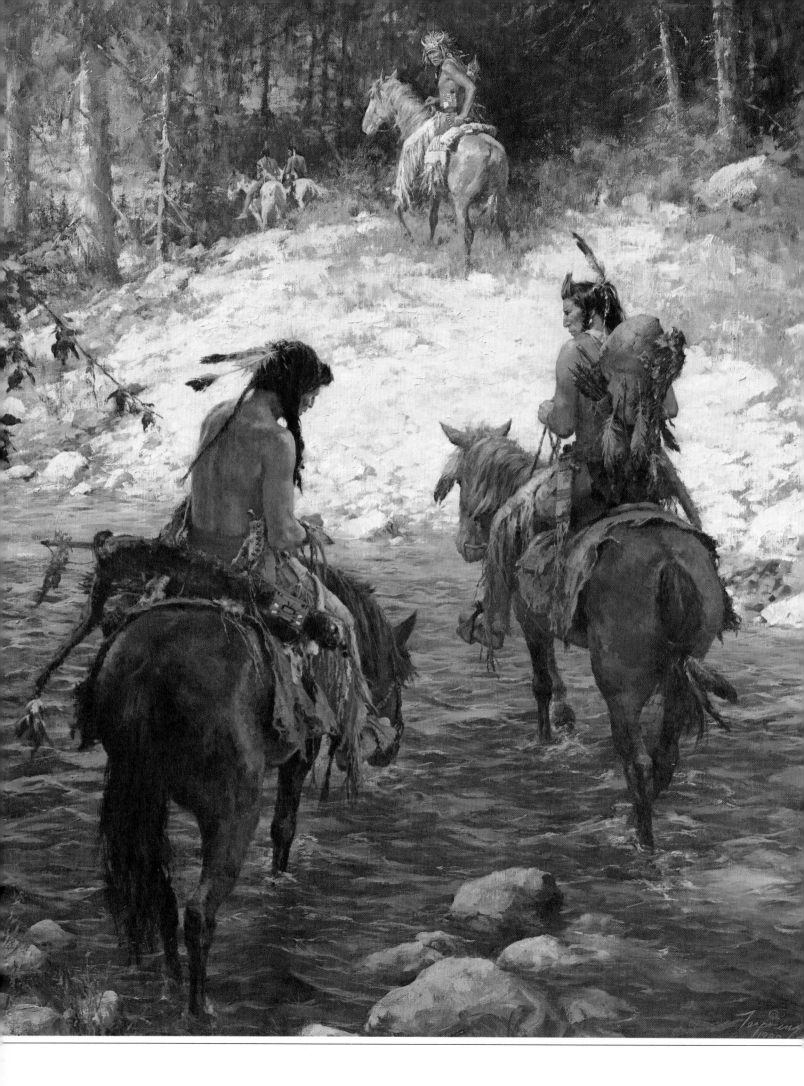

CROSSING MEDICINE LODGE CREEK

This has been one of the artist's personal favorites from among his works, perhaps in part because of the frustrations he suffered in making the composition suit him. It features a sharp contrast between dark areas and light, an effect he was striving for. One of his major problems, however, was the fact that the two central foreground figures, Crow Indians, are riding away from the viewer. He confesses that he came very near scrapping the project. Then he tried a simple device, having one of the Indians on the far shore turn and look back. This invites the viewer's attention back to the foreground figures and centers the interest.

SYMBOLS OF A TIME PAST

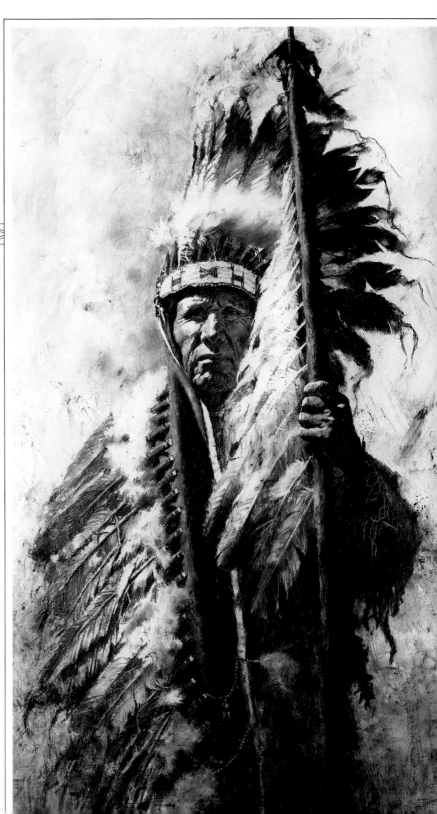

This black-and-white charcoal drawing represents an era that is gone but that has left a legacy for both native American and white. The artist set out to create an interesting design with eagle feathers, which were of great spiritual significance to the Plains Indian. They represented the eagle, known for great hunting prowess, great strength, great intelligence. By wearing them, the Indian felt he acquired some of these powers for himself. The chief's feathered bonnet has a long trailer which he has draped over his shoulder to hold it clear of the ground. His long staff also is dressed with eagle feathers.

Because the eagle today is protected, even Indians must adhere to strict federal rules to obtain its feathers.

BLACKFEET SPECTATORS

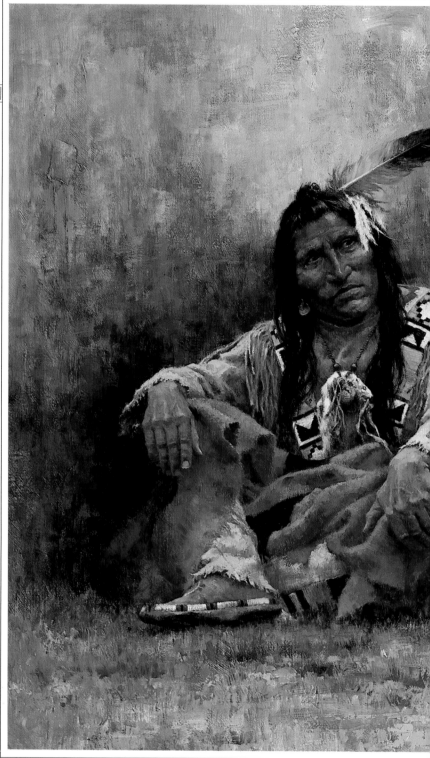

This painting is the artist's answer to those who would say that all Indians—or members of any other race but their own—look alike to them. That these happen to be Blackfeet is incidental; they are representative of Plains Indians as a whole. Each has a face distinctly his own, and each is reacting differently to whatever ceremony or dance is gripping their attention. One is skeptical, one is disappointed, and one is faintly amused.

The artist strove to give each of the three men a distinctive look through careful detailing of the hands, leggings, necklaces, beaded moccasins and hairpieces, while keeping all the accoutrements within Blackfeet tradition.

Though the spectators as rendered are obviously native American, three of Terpning's non-Indian friends—two of them fellow artists and the third an artist's son—posed to give him the composition, the positions of the figures, and the drape of the clothing. His familiarity with Indian features allowed him to transform them into this rich character study.

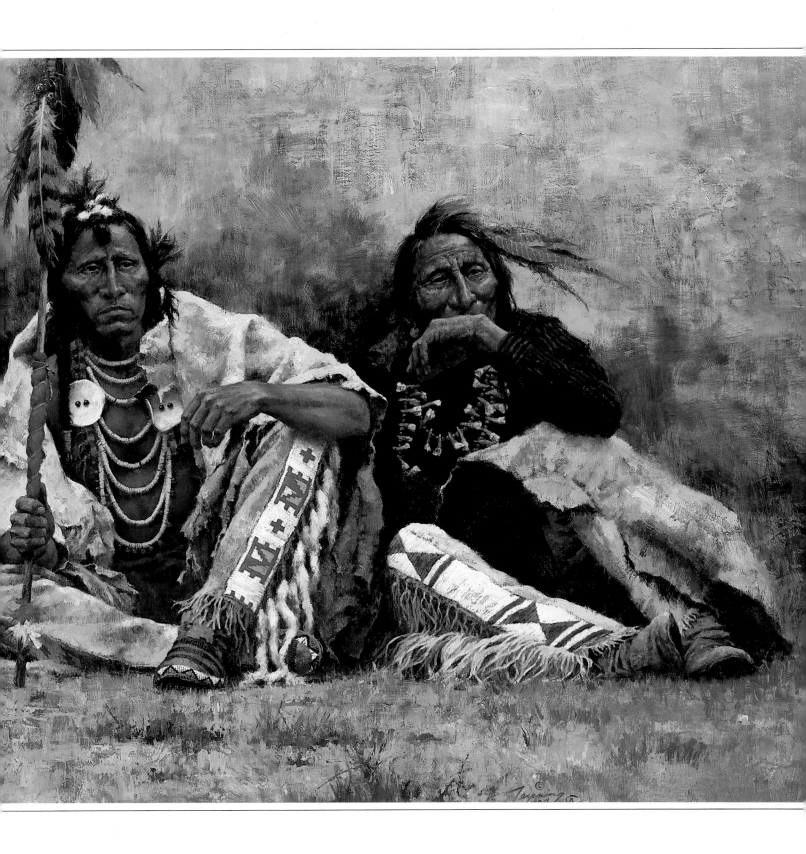

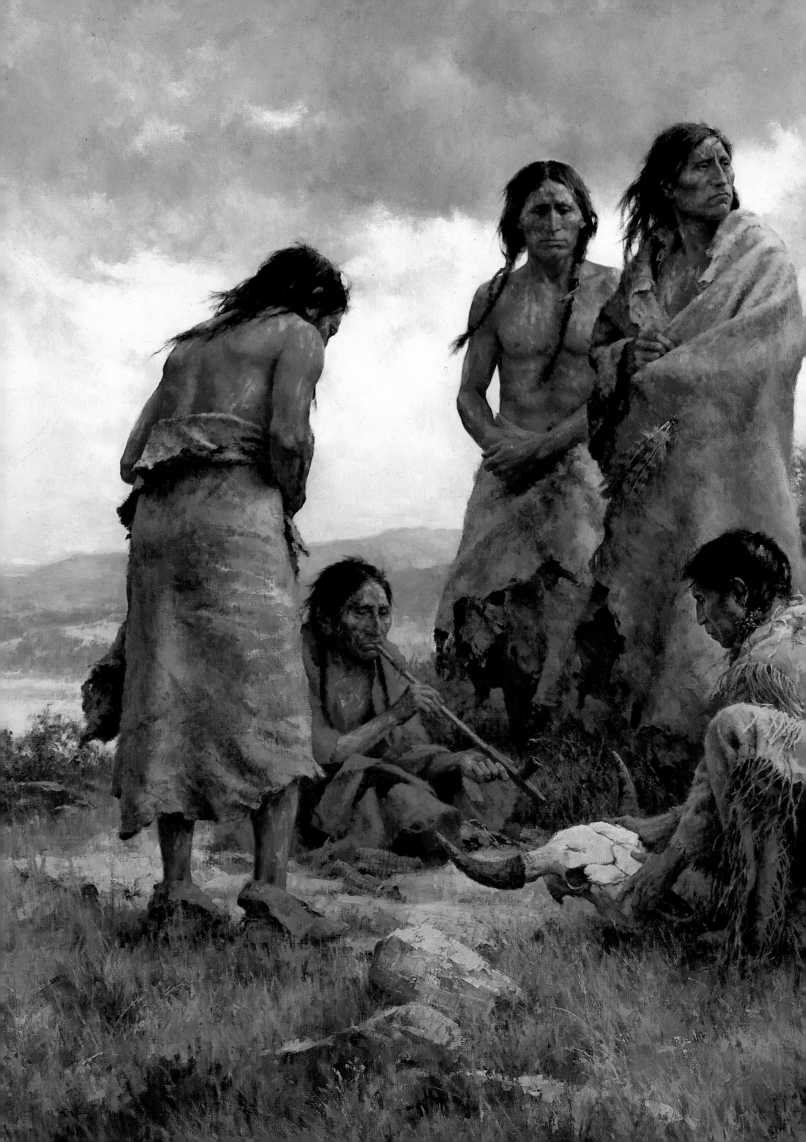

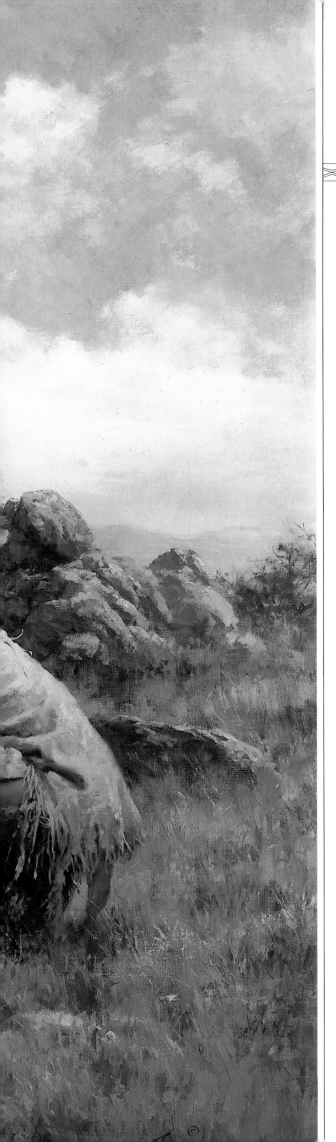

CHEYENNE VISION SEEKERS

Visions played an important role in Plains Indian life. Though their attitudes toward the supernatural might vary in particulars from tribe to tribe, one common thread was a solid faith in personal spirit guides, summoned to grant a boy his "medicine," his power as he moved into manhood. To one man his guardian spirit might be the buffalo, to another the eagle, to another such a small thing as a badger or prairie dog.

Commonly, the novice went through a cleansing ritual with a medicine man, then removed himself to a solitary place, often one having some religious significance or a connection with some great event of the past. There he fasted for four days and nights, performing prayers and chants prescribed by a shaman. He hoped before his vigil was done that a spirit guide would appear and point the direction of his life. Skeptics might say that the long fast and the solitude triggered hallucinations, but the People were firm believers. All through their lives they would summon these guides to help them in times of indecision or need.

In this painting a group of grim-visaged Cheyennes faces a crisis. Painted in holy whitewash and wrapped in hides, they huddle on a hillside and ask their god to give them a sign that will show their people the way.

BLACKFEET STORYTELLER

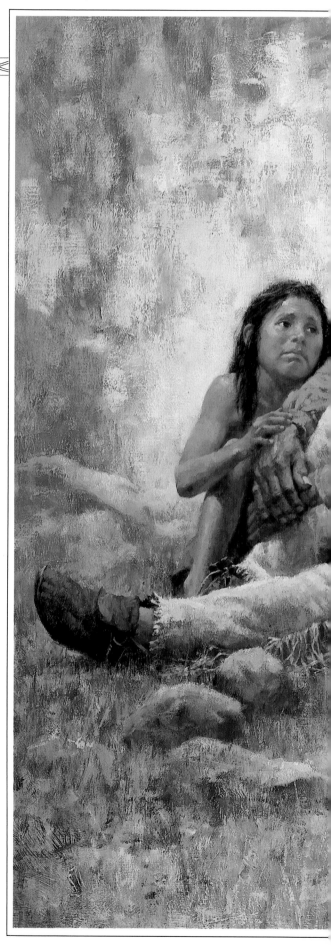

A ges before man's ingenuity created a written language that enabled him to record his history in a permanent form, stories and legends were handed down from generation to generation through oral storytelling. Old people told to the young, and those in their own turn repeated from memory. Among native Americans, storytelling around a nighttime campfire was a favorite form of entertainment, warriors reciting their exploits in hunting and warfare, the keepers of a people's history telling and retelling tribal legends so the old ways and old beliefs were not lost as one generation faded and another came to prominence.

A truly spellbinding orator was greatly prized. Each teller added his own bit of color, his own interpretation, so that over time these tales often took on fanciful shades of magic. An example is the Blackfeet legend about the first acquisition of the beaver medicine bundle, when a beaver came up out of the water and made love to a warrior's wife. The man became fond of the beaver child that resulted and treated it kindly. In his gratitude the beaver presented him with the medicine bundle and taught him all the songs that went with it. This bundle was used to call up the buffalo in times of hunger.

The artist points out a small buckskin medicine bag hanging by a thong from the neck of the Indian elder who tells the story. The girl on his left and the man on his right wear garments of trade calico. A warm, soft orange umber in the background suggests fantasy, while a subtle green light on the edges hints of the surrounding forests.

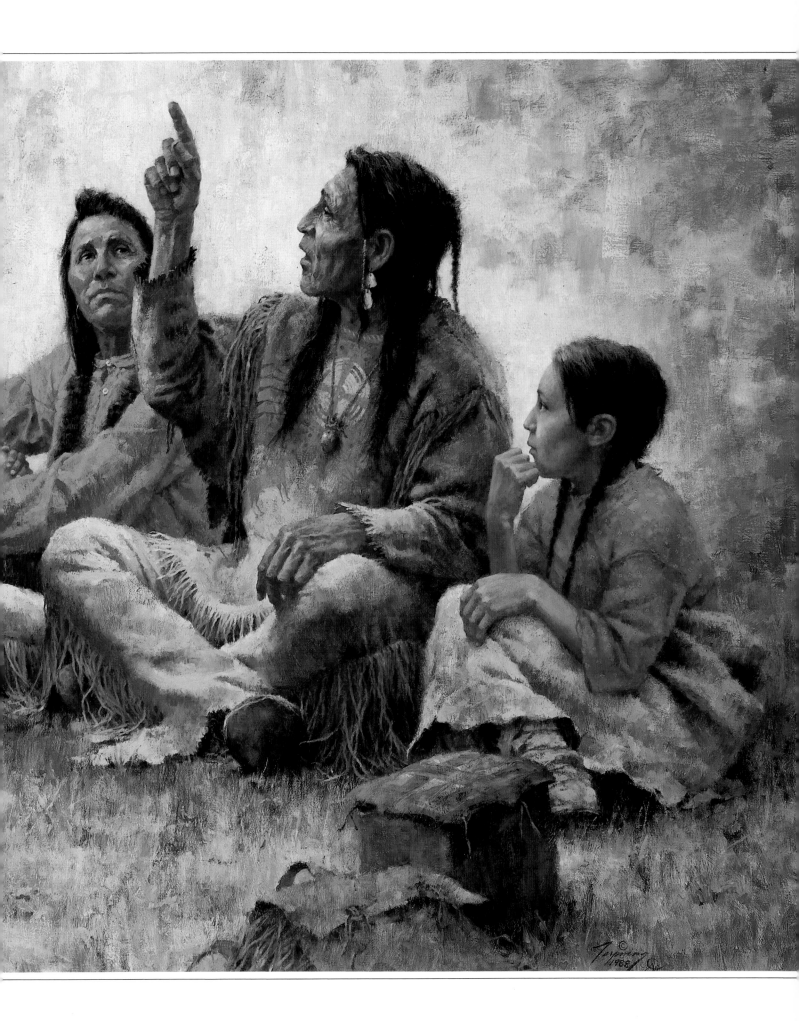

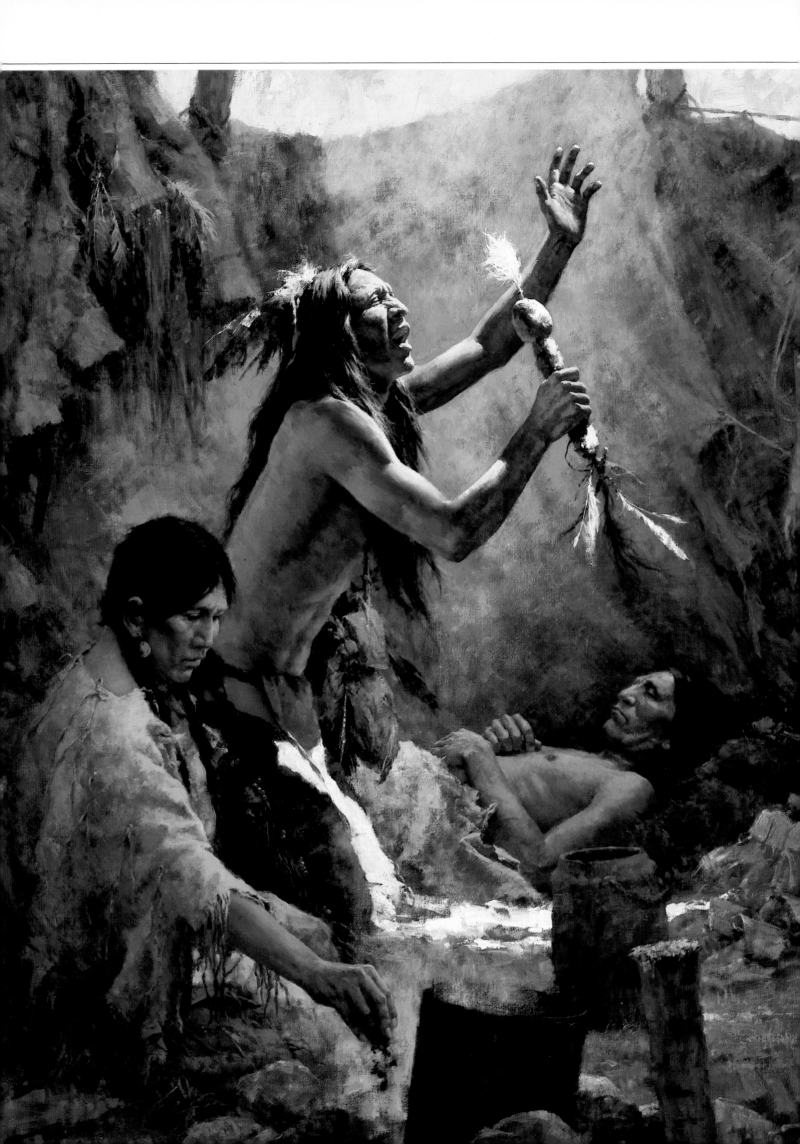

THE STAFF CARRIER

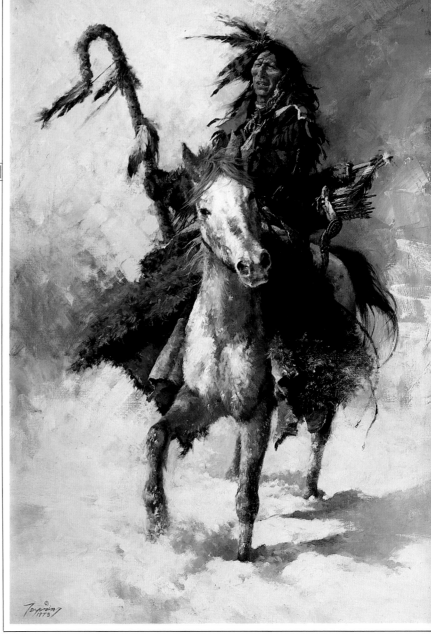

The artist explains that his intention with this painting was to create interesting patterns using an Indian on horseback in snow, a blue blanket, headdress, and Crow equipment. He points out that the horse, well protected from the cold by a heavy growth of winter hair, does not resemble most of the higher-bred types common today. The native Indian pony tended to be relatively small by modern standards, making up in stamina and heart what he lacked in size.

He was also almost unbelievably numerous. Contemporary accounts from frontier times speak of horse herds numbering in the thousands.

MEDICINE MAN OF THE CHEYENNE

The medicine man was a central figure for Plains Indian tribes. He was in effect a combination doctor and minister or priest, a healer both of the body and of the spirit. Not only did he know about the proper use of native plants that had medicinal properties—some of them employed in perhaps more sophisticated form by the medical profession today—but he knew ceremonies, chants, and songs supposed to wield magical powers for the benefit of individuals or the whole band. In the ceremony for painting the Blackfeet sacred medicine bundle, for example, the medicine man was expected to sing four hundred lengthy chants without missing a word or getting a stanza out of place. To miss might have brought evil consequences.

In this piece the artist reflects the fact that a Cheyenne medicine man usually had a woman helper, who might be his wife. Here he shakes a magic rattle over an ailing man while his helper drops sweetgrass and herbs into the fire as incense. Hanging from the medicine man's shoulder is his sacred medicine bundle, containing articles which he perceives to have spiritual powers.

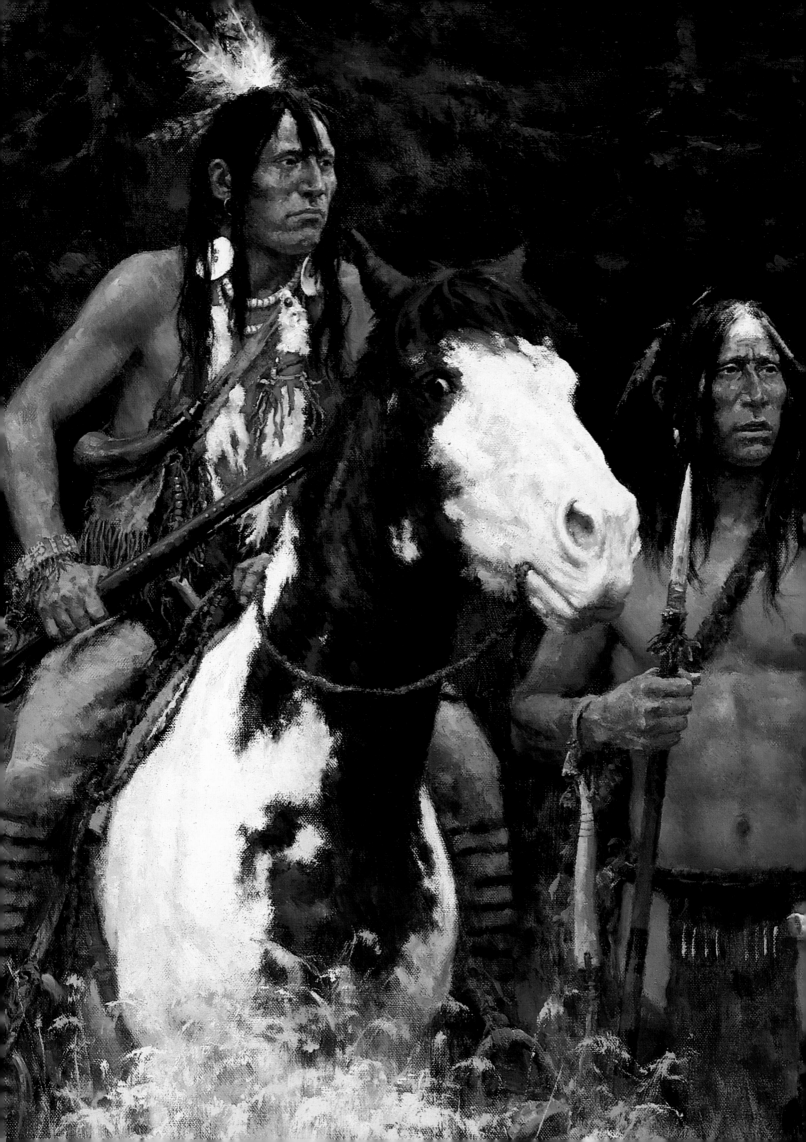

THE INDIAN AND THE HORSE

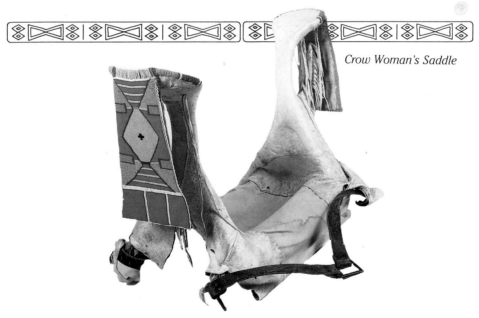

Crow Woman's Saddle

"If today I had a young mind to direct, to start on the journey of life, and I was faced with the duty of choosing between the natural way of my forefathers and that of the white man's present way of civilization, I would, for its welfare, unhesitatingly set that child's feet in the path of my forefathers. I would raise him to be an Indian!"

LUTHER STANDING BEAR, LAKOTA SIOUX

The coming of the horse transformed the Plains Indians. They were no longer a people afoot, depending upon their own strong backs and those of their dogs to transport their belongings. The horse made them highly mobile hunters and warriors able to ride extreme distances in a short time. A horse might carry or drag four times as much weight as a dog and travel at least twice as far in a day under that burden.

The spread of the horse from the southwest to the Canadian border was accomplished in less than a century. The horse enabled the Plains Indian culture to flare brightly for a brief one to two hundred years before it flickered and died in the east wind that swept from Europe.

The Comanches have a story about their first sighting of horses, in the possession of Spaniards, possibly the explorer Oñate's. They thought the riders were part of the horse until they climbed down, clad in armor. The Comanches trailed them to study what methods they used to control these "magic dogs," then they stole some and taught themselves to ride. As their horse herds increased, they began trading to other Indians.

Many of the early horses were acquired by theft from the Spaniards. Early Spanish ranchers, shorthanded, pressed Indians into slavery and taught them how to ride and handle livestock. Some of these escaped servitude, carrying their knowledge and their horses with them back to their people. Other horses were probably acquired through trade, along with instruction in how to break them to use. The Pueblo revolt of 1680 in New Mexico killed many Spaniards and is thought to have released a considerable number of horses, either to fall into Indian hands or to run wild and propagate on the plains.

A Cheyenne legend tells of a visit by Comanches who brought horses they had stolen from the Pueblos. The Cheyennes admired the horses and asked the All Spirit, Maheo, if they should have them. Maheo said they might but warned of many great changes the horse would force upon them. They would have to leave their earth lodges and live in tents because they would have to keep moving to find grass for the horses. They would have to fight other tribes for the grass. And they were to remember their former way of life once a year by building a ceremonial lodge similar to the earth lodges they had lived in, and conducting a Sun Dance in it.

Indeed, the horse became a liability as well as an asset. The mobility it gave a tribe extended to that tribe's enemies as well, putting everyone in more danger of attack than they had been when all were afoot and limited in their travel. As horse herds grew, their insatiable need for grass forced bands to disperse and to move more often because horses concentrated in large numbers can be ruinous to a range. Moves were sometimes caused more by a search for fresh grazing than by a need to migrate with the buffalo.

Horse herds increased territorial demands and may have caused a tribe to press into lands claimed by neighbors. This added to the intertribal warfare, already fierce enough because of old enmities and disputes over hunting rights.

A Piegan Blackfeet named Middle Sitter was said to have owned more than five

hundred horses. Some Comanche chiefs were reputed to have as many as a thousand. Such numbers, added to those owned by other members of the band, would place tremendous demands upon the range over which they drifted. If they remained too long in one place, the vegetation suffered severe long-term damage.

Whatever the cost, the Indian was more than glad to pay it. A warrior would keep a favorite war or hunt horse tied near his tepee, ready for instant use. The horse became a medium of exchange, a symbol of wealth. A would-be bridegroom was likely to offer horses as a goodwill gesture to his prospective in-laws, though usually he did not actually "buy" the bride in the white sense of the word.

If a warrior died, his favorite horse might be killed at the grave so the departed would not have to walk to the spirit land. This was a common practice until the fading years of the Indian wars, when good horses often became scarce. In lieu of the whole horse, its tail might be trimmed and left at the grave as a symbolic gesture.

In terms of daily life, the horse allowed the nomad to carry much more with him as he moved. Large parfleches of waterproof rawhide came into fashion as luggage and for carrying meat. Pemican was important for feeding the people through the long winters as well as while they were on the move, perhaps unable to hunt enough to keep them in fresh meat. It was made of thin slices of buffalo meat dried, cooked, pounded fine, mixed with melted fat and berries, nuts, or whatever else was available. A favorite way of eating it was to dip it in honey.

The horse transformed buffalo hunting. It vastly increased the chances of success by allowing the hunter to run as fast or faster than his prey. It allowed a larger slaughter because of the ability to pack more meat back to camp and on the trek between encampments.

The favored method of hunting was the surround, in which hunters managed to set the buffalo to circling and rode around and around them, killing until they had enough meat and skins for everyone.

Most Plains Indians had a hunt leader to direct the operation and developed some form of hunt police or soldiers. These enforced discipline so a few eager hunters would not rush in prematurely to take more than their share and frighten the buffalo into running off. Wooden Leg, a Cheyenne, described through an interpreter the keeping of discipline:

"A guard line usually was thrown out by the warrior policemen when any buffalo herd was about to be attacked. It was required that all of the hunters remain behind this line until every preparation was made and until the appointed managers gave the word for a general advance. Of course, all were excited, anxious to get at the game. Or, somebody might think the policemen were too slow in completing the preparatory steps. So, occasionally an impatient hunter became obtrusive. This one was pretty sure to bring upon himself a lashing with pony whip thongs or a clubbing with the reversed heavy handle."

Wooden Leg had gotten into that kind of trouble when he and two other youths left their place in the procession. "Four Crazy Dog warriors were right after us," he recalled. "The other two boys got away, but my pony played out on me."

He begged the soldiers not to whip him but to kill his horse, take his clothing, break his gun. They decided to do none of those things but told him he was a foolish boy. "That," he said, "was the last time I ever flagrantly violated any of the laws of travel or the hunt."

The hunt leader or the soldiers became judge and jury if two hunters claimed the same animal. Most hunters could remember theirs, however, and distinctive arrows helped verify claims.

Wooden Leg recounted the punishment meted out to two men who butchered a buffalo that did not belong to them and had been overlooked by the man who killed it. The meat was taken from them, their guns broken, their pack saddles cut up, their lodges torn down and burned.

The surround allowed the kill to be restricted to a relatively small area and made the butchering much easier. If the buffalo would not circle but ran straight, the scattered carcasses required a longer haul.

The chase was hazardous and often resulted in injury or death. Comanches trained their horses to veer away as soon as the arrow was launched or the lance was thrust because the wounded buffalo would often turn to look at its antagonist.

The Sioux, Standing Bear, said his father warned him to watch the buffalo closely. If it ran straight ahead, it was safe to move in close. If the buffalo kept watching its pursuer from the corner of its eye, it was highly dangerous. A wounded buffalo, because of its size and strength, could shove its massive head beneath a horse's belly and throw it and its rider into the air. Horses were often gored to death. A warrior set afoot, injured or not, was vulnerable to short, sharp horns.

The killing was a responsibility of the men. Usually, but not in all tribes, the skinning and butchering were left primarily to the women. Men might help with the heaviest work, such as turning the buffalo over, and perhaps in butchering the big bulls, which might have been too difficult for most women.

Virtually all of the buffalo was used, though it was common practice to leave the heart as a tribute and to insure propagation of the sacred animal.

Black Elk, an Oglala Sioux, described a buffalo hunt of his boyhood to historian John G. Neihardt. Early one morning the crier came around the village calling out that it was time to break camp. The band's four advisers, carrying fire for the next encampment, led the formation, followed by the crier, the chiefs, and finally the people and their pony drags, the horse herd bringing up the rear. The procession stopped for a time to dig up wild turnips while the advisers sat on a hill and smoked. The band then continued to a place of wood and water before camp was made.

Three scouts returned, going to the council tepee in the middle of the village, where a ceremony began. They seated themselves before the entrance of the tepee. One of the advisers filled a sacred pipe with the bark of the red willow and set it on a buffalo chip in front of him. The chip represented the buffalo, which was regarded as sacred because it furnished food and shelter. The adviser lighted the pipe, offered it to the four quarters, to the Spirit above, and to Mother Earth, and passed it to the scouts. They smoked to show that they told the truth. Then they related the good

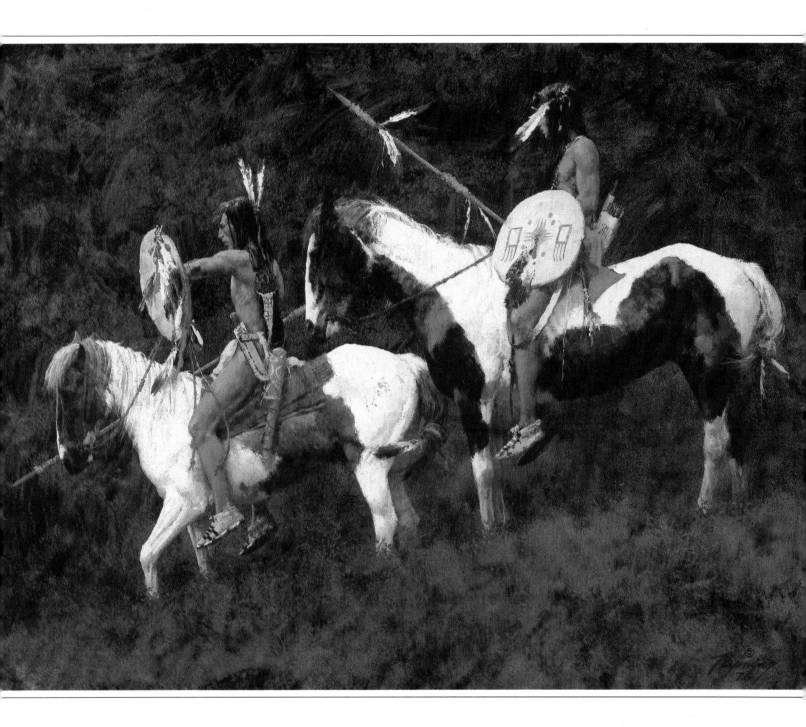

PAINTS

Most Indians favored paint horses, when they could pick and choose, and as they mastered the techniques of selective breeding, they often bred to achieve that coloration. These are Crow warriors, both with lances and war shields, the one in front carrying a tubular rawhide case containing a religious medicine bundle typical for his tribe. It was usual for young men who had successfully finished their vision quests to decorate themselves and their shields according to instructions received from a spirit guide, and to make up a personal medicine bundle which would contain items pertaining to their individual medicine or power. The decorations on the knife sheath and arrow quivers are particularly detailed in this painting.

The artist says he was intrigued by the opportunity here of using positive-negative patterns of brown and white, an interplay of darks and lights.

news about the great herds of buffalo they had found. The people sharpened their knives and arrows.

A soldier band went first, twenty riding abreast, to keep order. Then came the hunters, riding five abreast. The people brought up the rear. As the hunters reached the buffalo, they circled them, and a cry of "Hoka hey!" went up, signaling the charge.

Woman's Rawhide Knife Scabbard

"Then," said Black Elk, "there was a great dust and everybody shouted and all the hunters went in to kill—every man for himself. They were all nearly naked, with their quivers full of arrows hanging on their left sides, and they would ride right up to a bison and shoot him behind the left shoulder. Some of the arrows would go in up to the feathers and sometimes those that struck no bones went straight through. Everybody was very happy."

In this instance the men did the butchering and carried the meat back to camp on their hunting horses. Often, however, the women followed the hunters, waiting with their travois until the killing was finished, then rushing down to start the skinning and cutting up of the meat. They would wrap it in the fresh buffalo hides to keep it from dust and pony-drag it back to camp. There they would further dissect the meat, cutting much of it into long, thin strips to be dried as jerky on wooden racks. The night usually brought a great feast with singing and dancing.

Some of the meat was eaten raw as the animals were butchered. Fresh, hot liver and raw kidneys were particular delicacies. Many plains folk liked to eat the intestines the same way, running them between their fingers first to squeeze out most—but not necessarily all—of the contents. Tongues and hump meat were considered the choice parts. Fresh meat was boiled, roasted, or broiled over coals, often as part of the feast at the end of a successful hunting day. For long-term keeping, it was dried or processed into pemican.

The Crows' Chief Plenty-Coups recalled with nostalgia the cooking of buffalo in meat-holes:

"My mouth waters when I remember the meat-holes. We used to dig a hole in the ground about as deep as my waist. . . . We would heat little boulders until they were nearly white and cover the bottom of the hole with these stones. Then we would cut many green boughs of the chokecherry trees and cover the hot stones a foot deep with them. Upon these we would place thick chunks of buffalo meat, fat and fresh from the plains, sprinkling them with water. On top of the meat went another layer of boughs, then more meat, more water, and so on, until the hole was full. Finally we spread the animal's paunch over the hole, covered it all with its hide, put gravel on this, and kindled a log fire. Men kept the fire going all day and all night, yet never burned the robe. The next morning when we opened the hole to feast, even the birds of the plains were made hungry by the smell of the cooked meat. Every bit of good in the buffalo was in the pit. Little was wasted except the horns."

It was claimed, with justice, that the Plains Indians needed nothing more than water and the buffalo to live. Hides taken in summer's short hair were usually scraped clean to be made into tepee covers, parts of them cut off for other purposes. The thickest part might become the arrow-turning outer armor for a shield. Thinner parts, tanned and softened, became articles of clothing or were made into moccasins. Hides taken in fall and winter, when the hair was thickest, became robes and blankets for protection against cold.

Strips of rawhide were used for tying all kinds of equipment together. Usually wet when applied, they would shrink as they dried and bind with the strength of iron. Rawhide was also pleated into ropes. Sinews were used as thread and for tying arrowheads to shafts, points onto lances. Buffalo hair could be woven into rope or stuffed into pillows, cradleboards, saddle pads, or shields. Horns could be made into eating utensils or used to carry gunpowder. Bones were fashioned into tools and saddletrees. Hoofs became an ingredient for glue. With proper ceremony, the buffalo skull became a religious object, particularly for use in the Sun Dance. Nothing was wasted. ■

MOVING DAY ON THE FLATHEAD

Wherever Howard Terpning travels throughout the west, he can see Indians in his mind's eye, for there is no part of it to which they did not belong. On a summer pack trip, crossing a branch of the Flathead River in search of stray mules, he was struck by an extraordinary pattern of shadows cast by the pines, and by the composition of an ancient alluvial slope cut away by natural erosion over ages of wind and rain. He imagined he could see a band of Indians on the move, riding along at the edge of the water.

It is probable that such a scene was enacted many times, just as he saw it in his mind's eye. The Plains Indians were a nomadic people. As hunters rather than planters, they were obliged to follow the game, which in turn followed the rains and the grass and the changing seasons. Typically, band leaders would be at the head of the procession, perhaps preceded by scouts, known in most tribes as "wolves," who watched out for danger. Under the watchful eyes of the warriors, the women carried the camp equipage on tepee-pole travois dragged behind their horses. Small children would ride with their mothers in a cradleboard or perhaps firmly tied to the travois. Older children often rode their own gentle horses. Despite the work, moving time was usually lighthearted, for each night brought fresh camping grounds, and the end of the trail was a place for new beginnings.

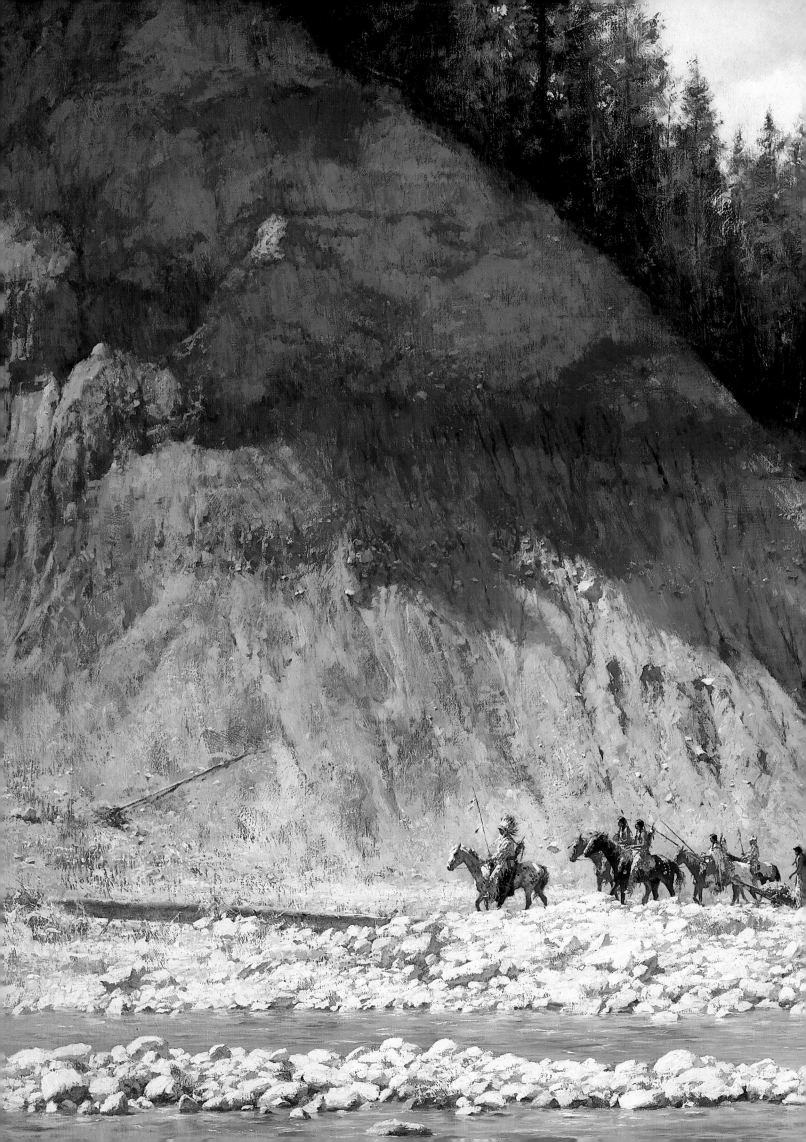

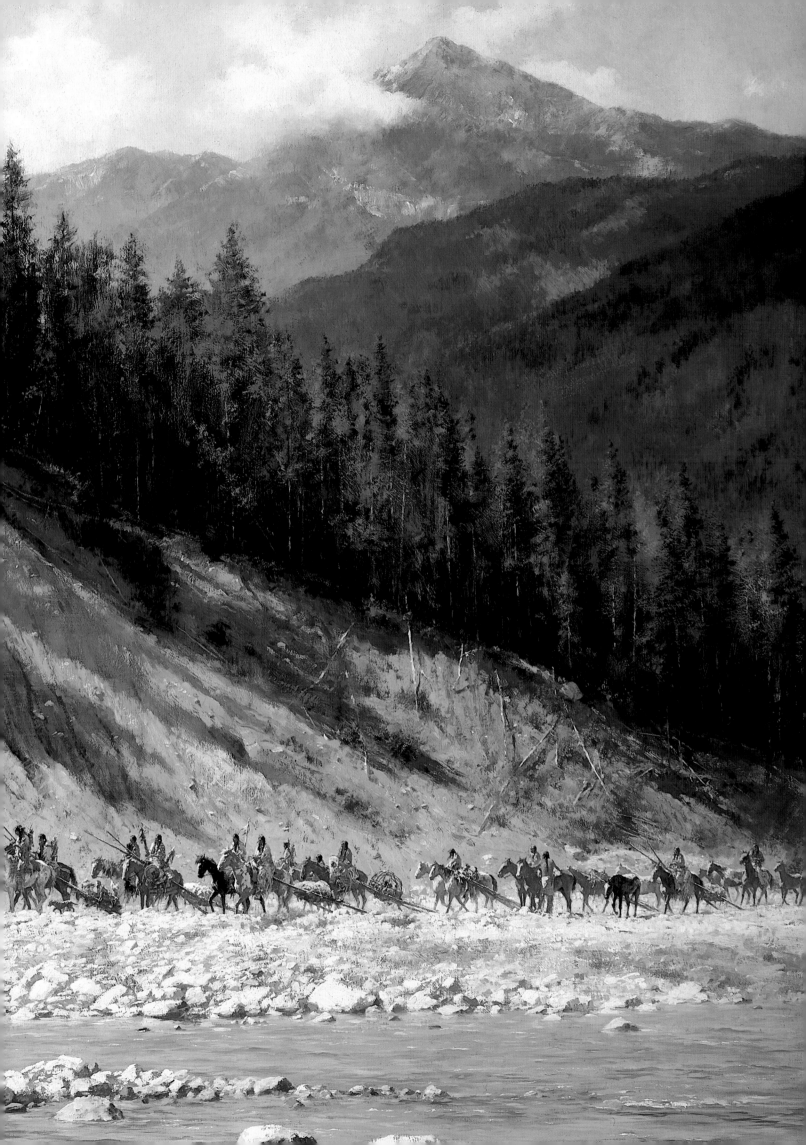

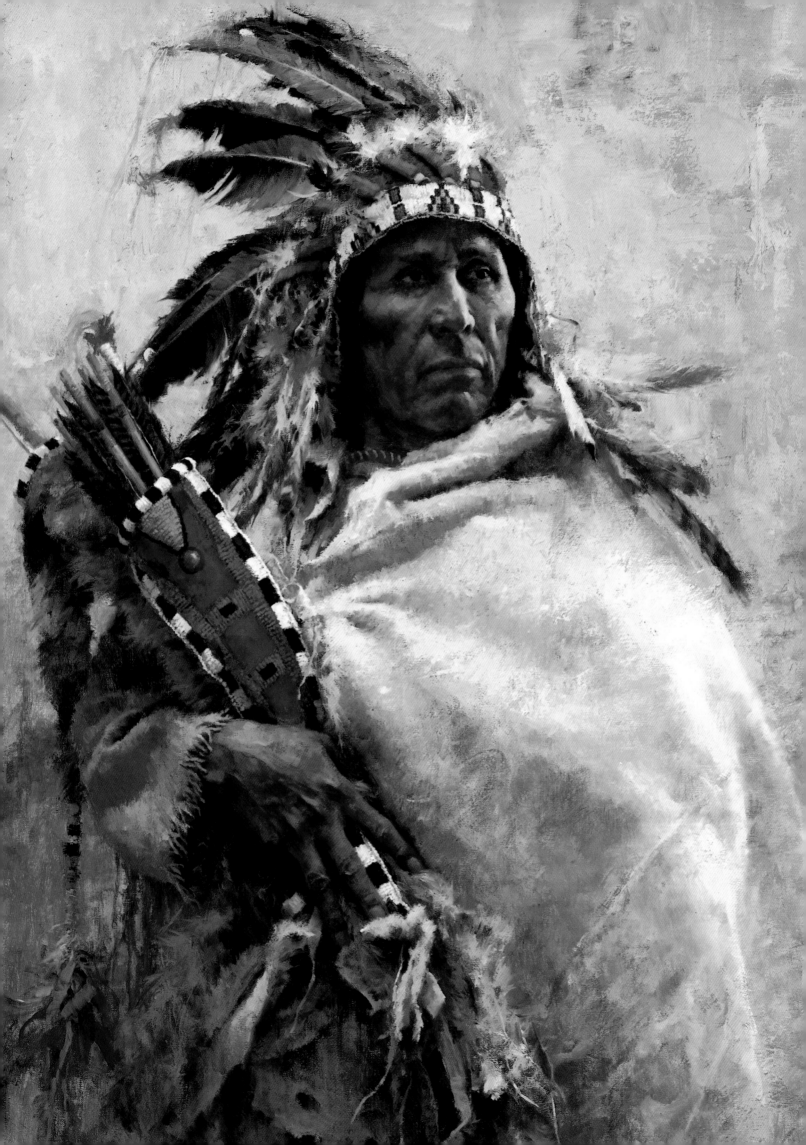

LEADER OF MEN

This is a study of a man of the Crow tribe, wearing an eagle-feather bonnet, his bow case made of mountain lion fur, his body wrapped with an elk hide, trappings which reflect his life as one who lived close to nature and its creatures. The artist says, "I wanted to create a strong pattern of light and dark. The model was actually an Apache man, but I painted him to look like a northern plains man by changing his facial structure somewhat."

THE SIGNAL

On a snow-covered hill, in a bitter cold wind, a Blackfeet warrior waves his buffalo robe as a signal to his companions. Such a robe or a blanket would be the largest item he would be likely to carry with him on the trail and therefore the most easily seen at a distance. His horse, protected by a heavy coat of winter hair, would not be likely to win a modern show, but he was wiry and tough and served the Plains Indian well in the days when the native American was still free to roam.

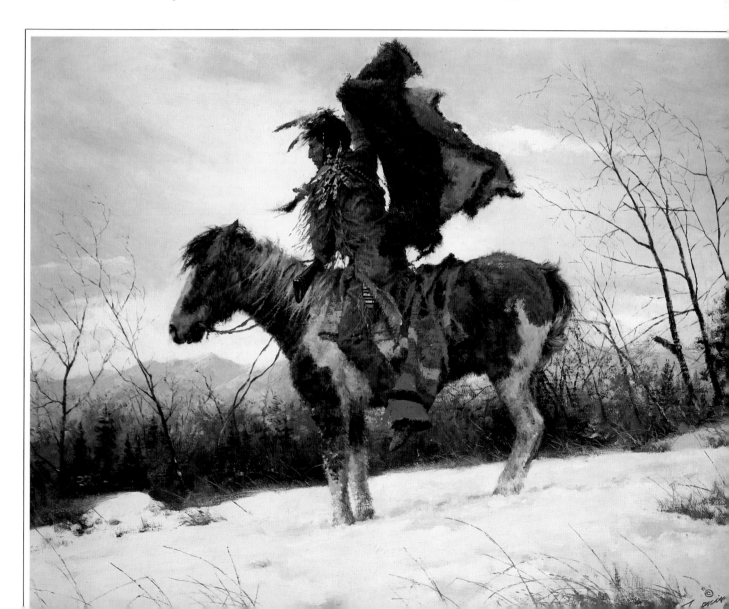

THE VICTORS

Their faces blackened as a sign of victory, two Blackfeet warriors return to camp after a successful battle. Face and body paint was used for many reasons, some purely ornamental, some to provide magical protection for the wearer, some to signify the outcome of a venture. Among many plains tribes the use of black paint symbolized victory. By contrast, black paint among the Comanches signified defeat and death and was sometimes worn by the survivors as they straggled quietly back into camp with the bad news.

The artist explains that this is a painting of paradox: a simple composition played off against the very strong values of the foreground figures. He imagined the warriors stopping behind the hill to smear black mud or charcoal over their faces, then trotting over the rise and down to the people who waited to greet their successful return to camp, knowing by the paint that they had achieved whatever they had set out to do.

The Blackfeet on the northern plains were noted for their fighting skills, their ferocity in battle against traditional enemies among neighboring tribes.

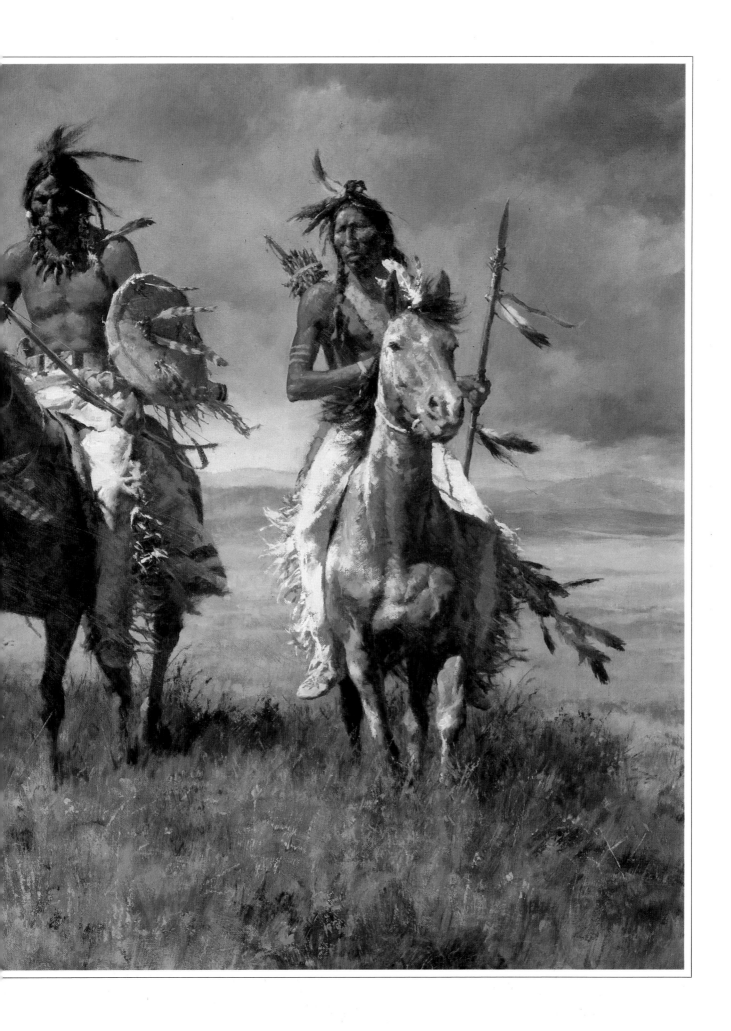

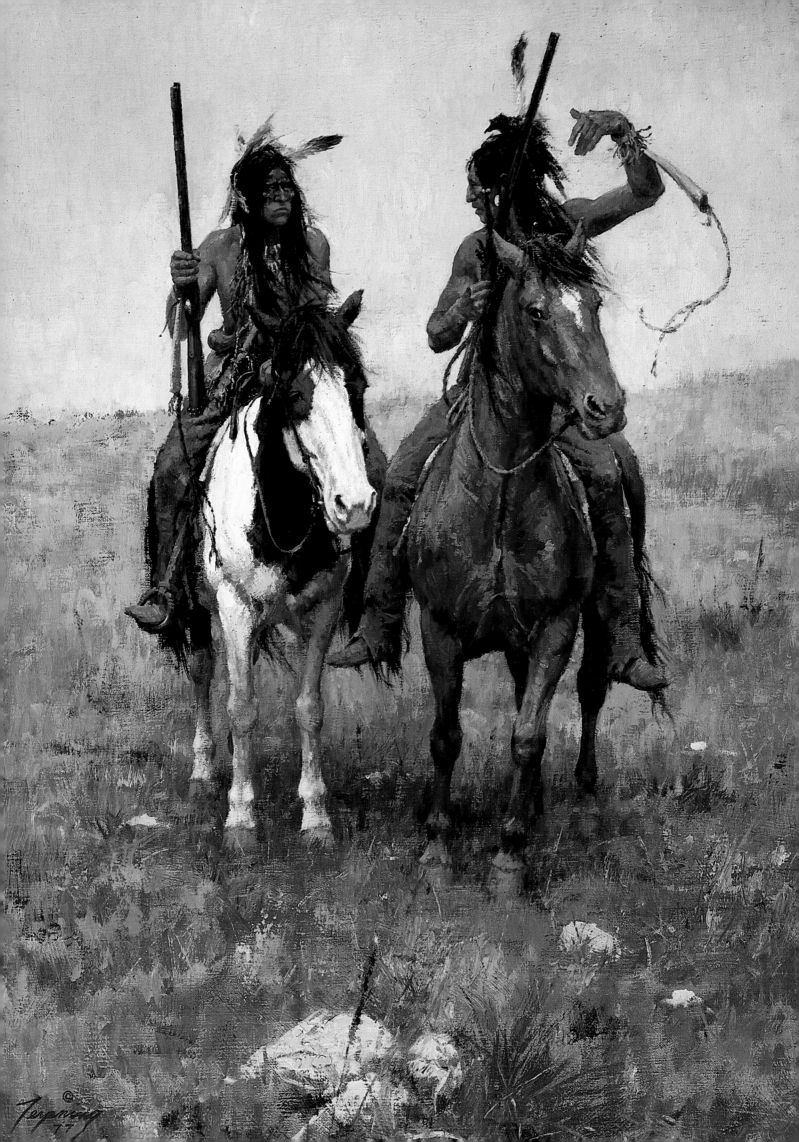

SPEAKING HAND OF EAGLE KILL

Indians were animated talkers, using their hands as well as their words to tell stories. Here the Blackfeet on the right, whom the artist has named Eagle Kill, is giving an earful—and an eyeful—to his war-painted companion. For artistic purposes Terpning attached a quirt to his wrist to give extra motion to the picture. The speaker has a stuffed bird tied in his hair. He carries an old flintlock rifle but rides only on a pad instead of a saddle. The other warrior has a full bridle and an Indian-made rawhide saddle roughly patterned after those of the white man.

Sign language developed among the Plains Indians as a method of communication between members of different tribes, whose spoken languages were often unintelligible to each other. Various motions and positions of the hands took on universal meanings, readily understood from the Canadian border to Texas. Thus could peoples alien to one another trade, parley over war and peace, or simply swap information about game, water, or mutual enemies.

Sioux Awl Case

SCOUTS' REPORT

In Plains Indian terminology the scouts who rode reconnaissance ahead of the main war party were "wolves." Often these scouts wore a wolf skin, partly for camouflage but more importantly for symbolism, drawing to themselves the cunning and hunting ability of the wolf. The young man at left is an apprentice, holding the horses while the more experienced men creep up close to observe the enemy. His turn will come when he is adjudged to have acquired enough experience.

The wolf was important in plains culture. To kill one was taboo in many tribes, for the wolf was regarded as having special powers. The Comanche believed it could not be killed by bullets but only by an arrow. Thus a warrior fortunate enough to acquire wolf medicine was impervious to the white man's rifle fire.

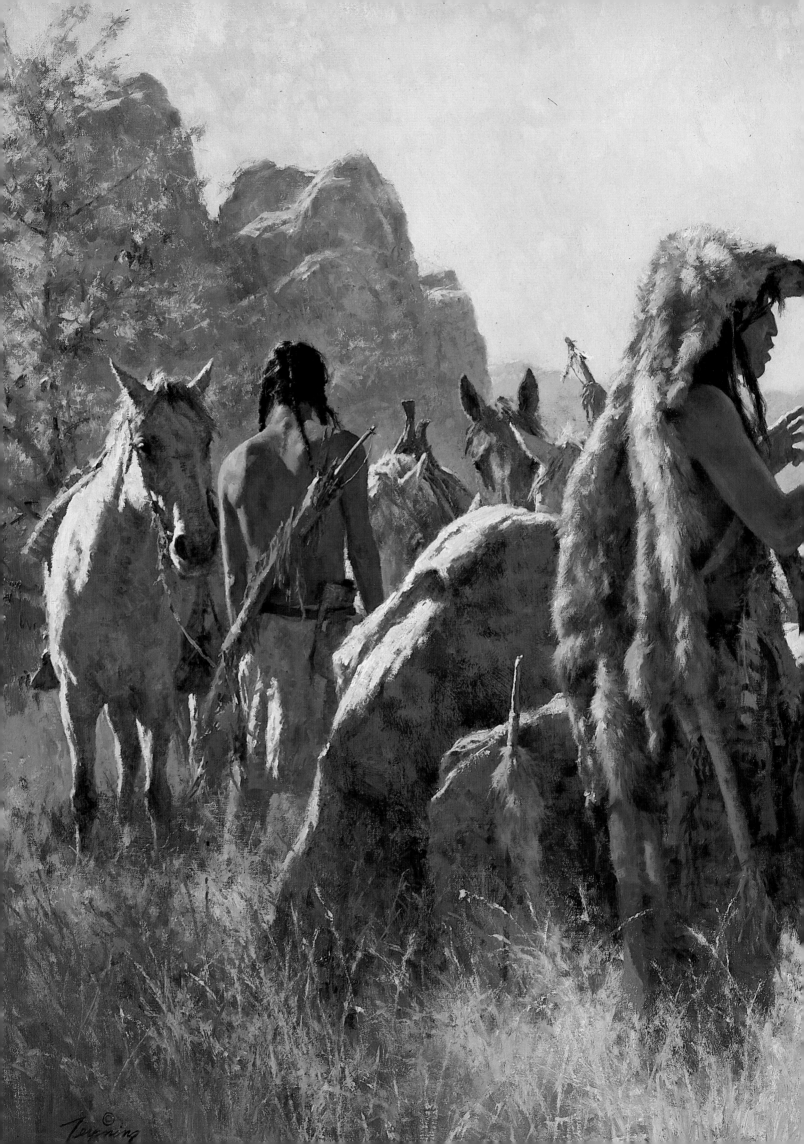

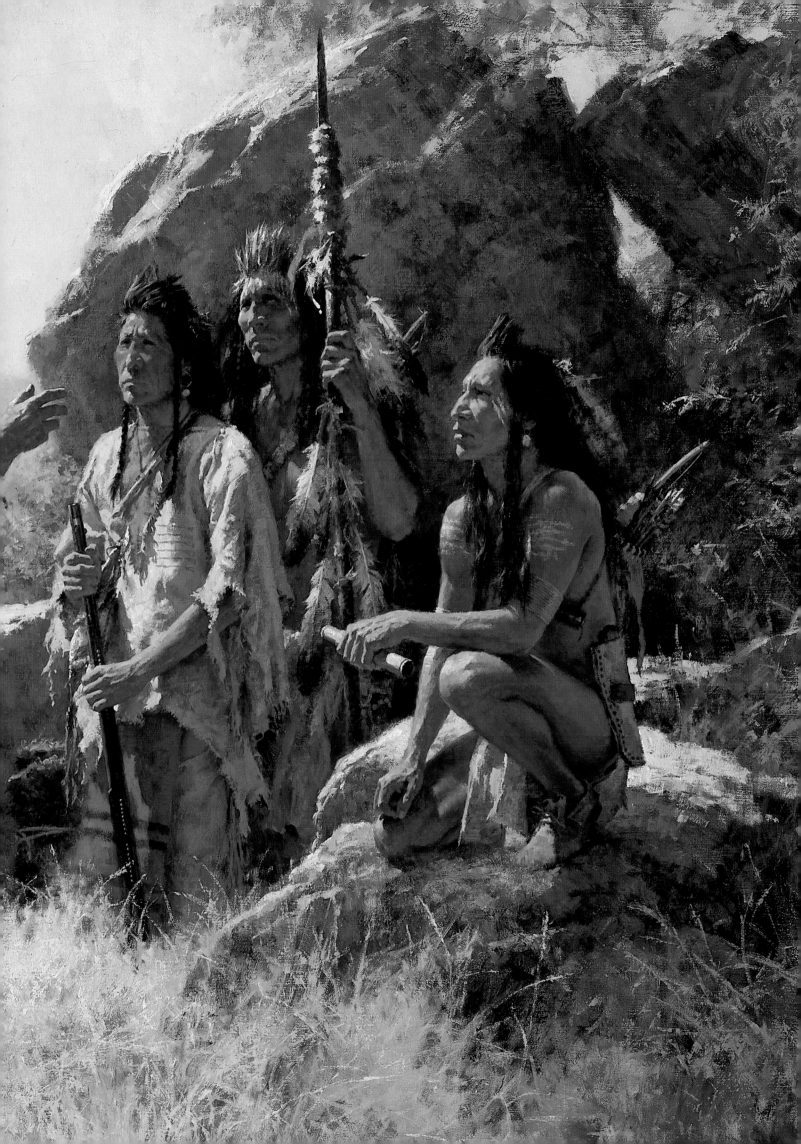

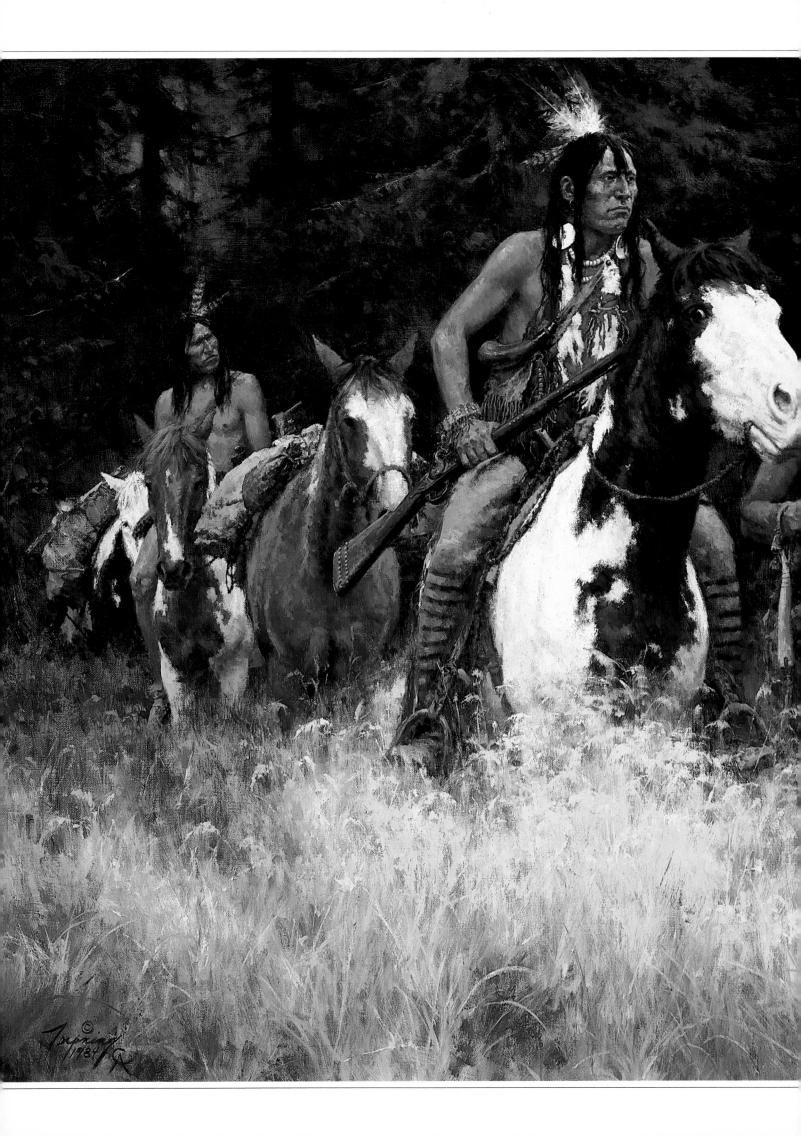

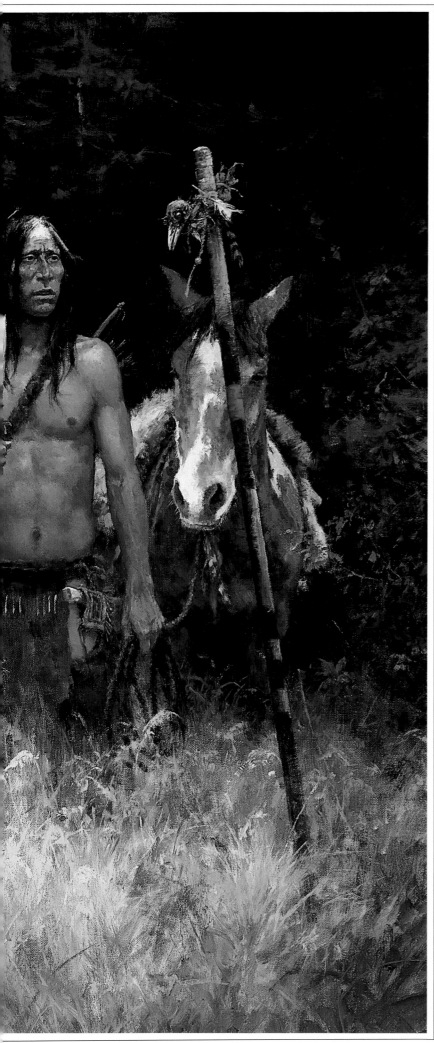

THE WARNING

Plains Indians had a strong sense of territorial rights and did not gladly suffer encroachment by peoples to whom they had not granted permission. It was generally agreed that a territory not sternly defended was a territory soon to be lost, for the stronger tribes in particular were always testing their neighbors' boundaries, gladly extending their own hunting grounds wherever they found resistance light or non-existent.

Here a Blackfeet party encounters a Crow lance, dressed in war medicine and firmly planted in the ground as a warning that if they proceed they are in for a fight. The arms they carry and the paint on their faces suggest that they are of a mind to accept the challenge. The Blackfeet were never shy about confronting whoever had something they wanted, or wanted something the Blackfeet had.

The artist explains that he was intrigued by the luxurious growth of a cool yellow-green grass he found in Yellowstone National Park and the way it disappeared against the edge of the dark forest. A key element is the white face of the pinto horse, which seems to extend out of the canvas and gives the painting a three-dimensional effect. The painting was chosen for the catalog cover of Terpning's one-man show at the Gilcrease Museum in 1985.

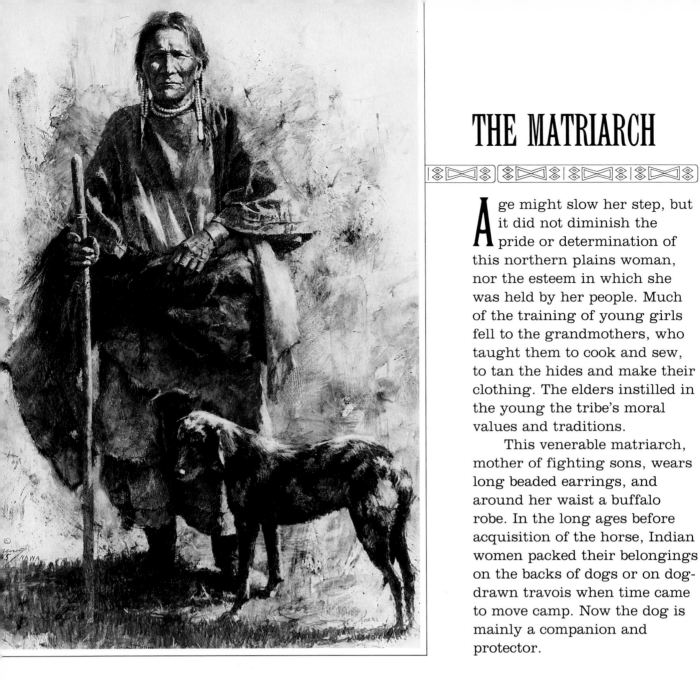

THE MATRIARCH

Age might slow her step, but it did not diminish the pride or determination of this northern plains woman, nor the esteem in which she was held by her people. Much of the training of young girls fell to the grandmothers, who taught them to cook and sew, to tan the hides and make their clothing. The elders instilled in the young the tribe's moral values and traditions.

This venerable matriarch, mother of fighting sons, wears long beaded earrings, and around her waist a buffalo robe. In the long ages before acquisition of the horse, Indian women packed their belongings on the backs of dogs or on dog-drawn travois when time came to move camp. Now the dog is mainly a companion and protector.

THUNDER PIPE AND THE HOLY MAN

Blackfeet legend says the thunder medicine pipe was a gift from Thunder, who instructed that it be well protected and brought out each spring shortly after the first roll of thunder was heard. The respected medicine man entrusted with keeping it was required to perform a ritual dance in front of his lodge where Thunder could see and thereafter shield the people from lightning's fury. The pipe was used in oath-taking, much as the Bible is used for pledging truth in white men's court. The Blackfeet believed that a man who lied after swearing upon the medicine pipe was doomed to die.

Terpning witnessed the ceremonial unwrapping of a thunder pipe at a ceremonial campground south of Browning, Montana. He reproduced in his painting the striking effect as the medicine man strode past, the hot sunlight from a tepee smoke flap passing across his face and body. The elderly woman was a participant in the indoor part of the ceremony.

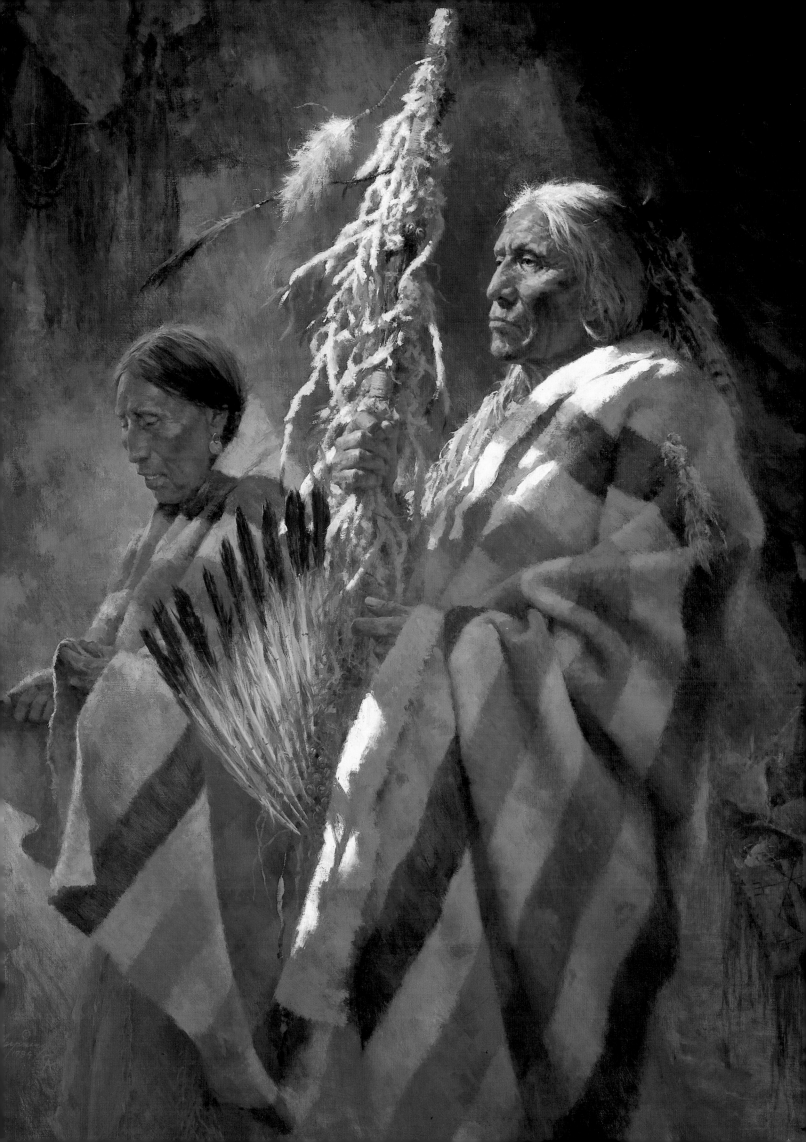

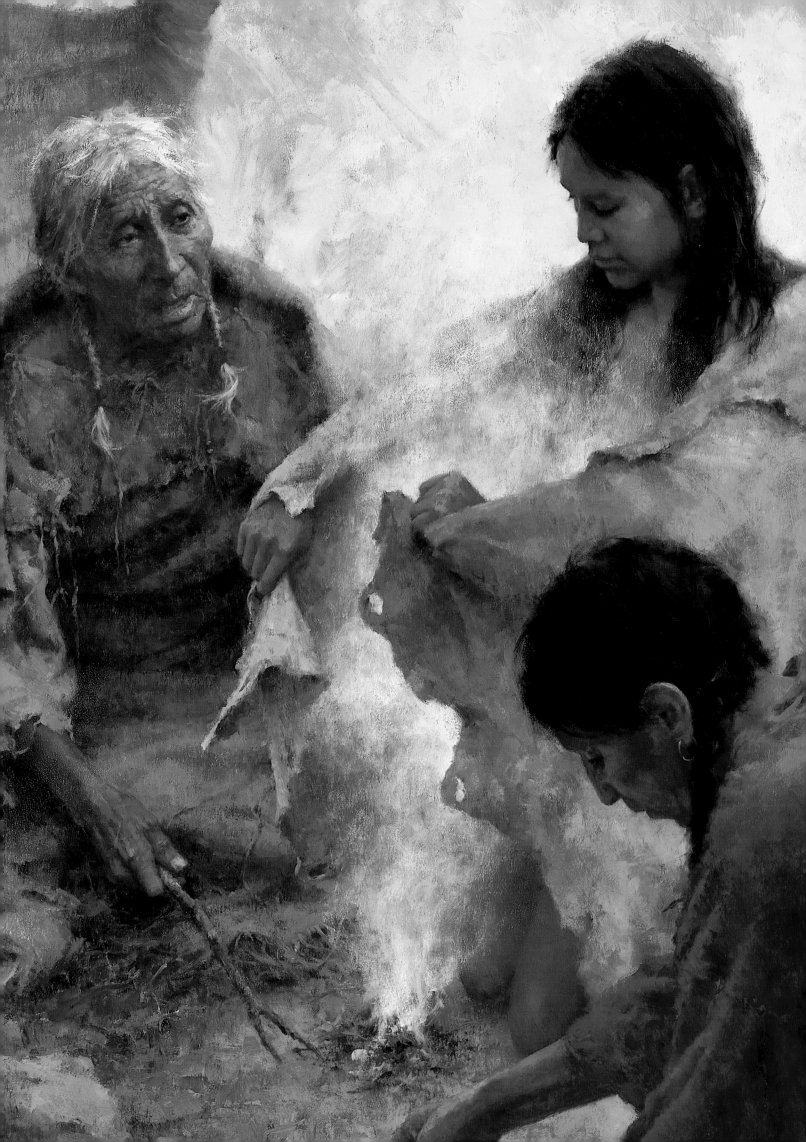

PART III

LIFE AND CUSTOMS

*Eastern Sioux
Buckskin Jacket*

"When a favor is done a white man, he feels it in his head and his tongue speaks. When a kindness is shown to an Indian, he feels it in his heart, and the heart has no tongue."

CHIEF WASHAKIE, SHOSHONE

Most of the major plains tribes, with the notable exception of the Comanches, had well-organized soldier societies. This began with the boys, who might first be members of the Rabbits when they were just learning to ride and to use the bow and arrow, then move up to the Herder society when they were old enough to take responsibility for seeing after the horses. When they were mature enough for the buffalo hunt and to go on raids, they might be inducted into one of the soldier organizations, which often performed police duties within the band or tribe.

In camp, Indians loved games. These could range from rough-and-tumble versions of lacrosse to such sit-down pastimes as the "hand game" played with small chips, often accompanied by dancing and singing. Women as well as men had games involving sleight of hand or the tossing of dicelike markers. Indians as a group were eager gamblers and might sometimes lose everything they possessed in a game or on a horse race. Horse racing was a particular favorite because they were always looking for a chance to prove the superiority of their mounts.

In one of the rare times when they were not warring against the military, Comanches managed to snooker the soldiers of Fort Chadbourne, Texas, in a horse race. Colonel Richard Irving Dodge told of a group under Chief Mu-la-que-top who brought an ugly little horse to the fort and bet that it could outrun the post's best. Dodge described it as "a miserable sheep of a pony, with legs like churns." Its rider was a large man carrying a club. The officers and soldiers eagerly covered the bets.

To their chagrin it outdistanced their fine Kentucky mare. To add insult to defeat, its rider turned and made the last fifty yards sitting backward, gesturing for the other jockey to hurry up. The red-faced soldiers later learned that the Comanche horse was renowned among Indians of the south plains and that the chief had just used him to win six hundred ponies from the Kickapoos.

Singing and dancing were a highly important part of camp life. Some was ceremonial, some purely for entertainment. Various tribes had long and intricate songs meant to bring favor from one spirit or another. One might be designed to attract the buffalo, another to bring rain, another to mark the beginning of a raid, still another to mark the end of a successful raid. There were coming-of-age dances for boys and girls moving into adulthood, funeral dances to honor the dead. A drum or drums usually accompanied these songs. The drum has been described by the Indians themselves as "the Indian's heartbeat."

Almost all plains tribes observed the annual Sun Dance in spring or summer. Despite the name, for most Indians it was not so much a tribute to the sun as a ritual to prove to the many protective spirits that a tribe deserved good fortune during the year to come.

Many tribes, particularly the Sioux and Cheyenne, used self-torture rites as part of the ceremony. This involved lancing the participating dancers' breasts and inserting a skewer attached by means of a heavy rawhide thong to the center pole. Blowing on a bone whistle, the dancers moved to the beat of a drum and pulled their weight against the thongs until the skewers tore through the flesh and broke free. This might take an agonizingly long time. In the case of the Mandans, the

participants were drawn up off the ground and remained suspended until the flesh gave way and the participants dropped to the ground, many rendered semiconscious by the pain.

At such times they were often the recipients of visions, to which they attached great significance. The lifelong scars left by the ordeal were treasured as signs of courage and character.

Once the Plains Indians were confined to reservations, the Department of the Interior banned the Sun Dance because of its self-torture aspects and, perhaps, in hopes that by weaning its wards from their old ways it might more successfully set their feet upon the white man's road. A modified Sun Dance, without the torture, was eventually resurrected among those tribes.

Storytelling was another revered custom. It had a dual purpose: it was both entertainment and the only method of passing down a tribe's history and legends from one generation to the next in the absence of a written language. In a sense, these stories were a tribe's "library." Often a band had one or more revered storytellers whose duty it was to train younger storytellers to succeed them and insure that the old ways were not lost. Though a majority of the tales eventually died with the last traditional storytellers, fortunately some have survived in print form. The written word, however, can never replace the spellbinding orator who used his voice, his hands, his eyes, his facial expressions to bring the past vividly to life.

By white standards, children were pampered. Rarely were they physically punished, or even rebuked in a severe tone. They learned to be quiet and respectful around their elders. When rebuke had to be administered, it was usually done by an aunt or uncle, more or less acting in proxy for the parents so there would be no resentment toward mother and father, no diminishing of respect. Grandfathers were heavily involved in teaching the boys, grandmothers the girls.

Children's games had a strong teaching role, both boys and girls learning to ride horseback by age five or six. Boys learned the use of the bow and arrow, girls the awl and the cooking vessels. Once they became good riders, boys began practicing the tactics of warfare, including methods for rescuing fallen companions. It was considered disgraceful to leave their wounded or dead on the field of battle if there were any possibility of retrieval. A boy learned how to grab a horse's mane as it passed him on a run and swing onto its back. He learned how, if unhorsed, to swing up behind a companion who came past him in a gallop.

Much has been said about the life of the woman in Plains Indian culture, often to the effect that the woman was of low value, hardly more than chattel, basically a workhorse whose only functions were to produce babies and perform the hard manual labor so their men could laze around camp. This is a misconception.

George Bird Grinnell, an early observer and chronicler of the Cheyennes and other plains tribes, had this to say:

"On few subjects has there been such persistent misunderstanding as on the position of women among the Indians. Because she was energetic, always busy in the camp, often carried heavy burdens, attended to the household duties, made the

clothing and the home, and prepared the family food, the woman has been pictured as the slave of her husband, a patient beast of burden whose toils were never done. The man, on the other hand, was said to be an idler who all day long sat in the shade of the lodge and smoked his pipe, while his industrious wives ministered to his comfort. . . ."

Custom made the division of labor clear and concise. The man furnished meat and fought the tribe's enemies. When the band was on the move, he rode on the outside or ahead, unencumbered by baggage, his weapons ready to ward off any threat of attack on the column. Grinnell continues:

"In the Cheyenne camp, as everywhere in the world, the man was the provider, the one who procured the food and most of the material for the needs of life, while the woman bore the children, cared for the home and thus did her share of the most important work that the Indians knew—the promotion of the tribal welfare. The man and the woman were partners, sharing equally in the work of the family, and often in a deep and lasting affection which each bore toward the other—an affection which, beginning in youth with love and marriage, lasted often to the end of life. . . ."

It is true that the woman's life was hard, the labor often unending drudgery, but her value to the tribe was duly recognized. Poor indeed was the man who had no wife to tend his home, to cook for him, to raise children who would make him proud. She had certain rights. For one thing, she ran the home. She decided where the tepee was to be placed. The husband furnished the skins to cover it and the poles which supported it, but in terms of property, the tepee was hers, along with most of what was in it.

To the wives fell the duty of making the clothes and the household equipment, parfleches, and the like. They took pride in their ability to decorate these with paints, porcupine quills, and, as they became available, colorful trade beads. Just as the men had their warrior societies, in many tribes women had societies devoted to excellence in homemaking crafts. Sometimes competitions were organized among the women,

BLOOD MAN

The Bloods are one of the three Blackfeet bands who have long made their homes along the Montana–Canada border, the others being the Piegan and the Siksika, or Blackfeet proper. Though they lived apart, they spoke the same language, had most of the same rituals and customs, and allied against their common enemies in time of war. The tribal name is of Cree origin, though the reason for calling them Blackfeet has been lost to the centuries. The origin of the Blood name is also obscure. One theory is that it came from their painting faces and robes with red earth, another that it derived from the bloodstains they brought home after the massacre of a Kutenai camp.

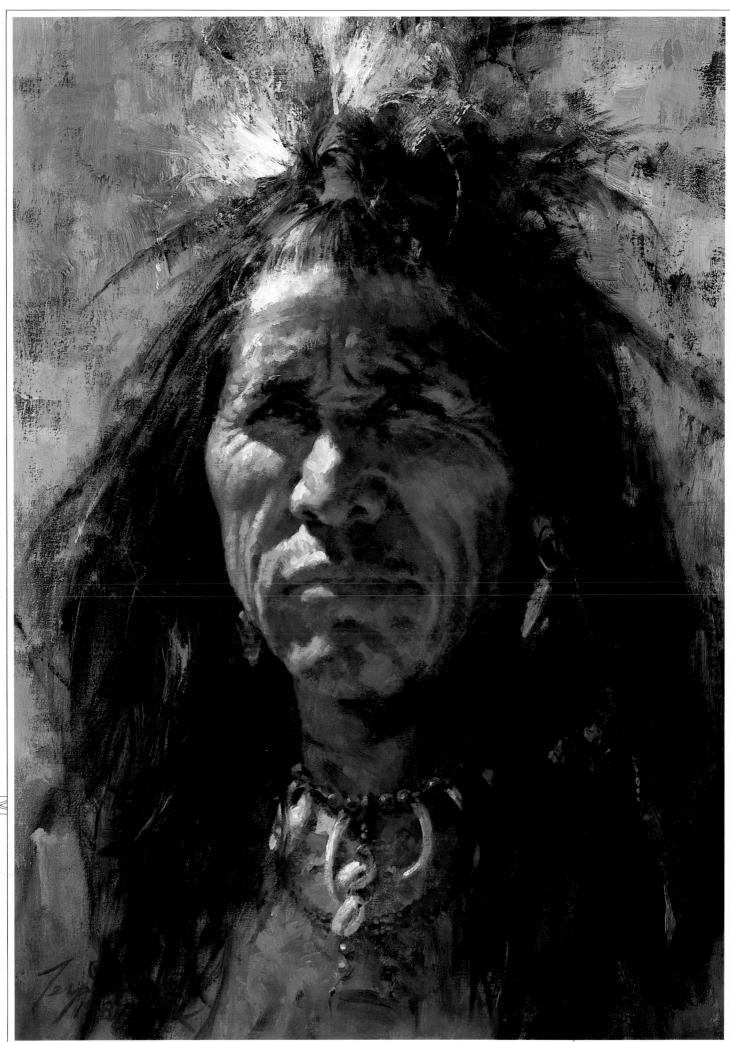

not unlike those for their white counterparts at county and state fairs. To win such a contest for a woman was in its way akin to the war honors won by her husband.

It was not unusual for a man to have more than one wife. It was generally felt that in such a case it was better to marry sisters, or at least cousins, the theory being that they were likely to get along better with each other than women who were not kin. The first wife would usually be the oldest and therefore had natural dominance over the younger. Plural marriages had a certain logic because the dangers of war and the hunt kept death rates relatively high among men. Usually there were more women than men. A man who could afford the extra responsibility married a widow so she and her children, if she had any, would not go wanting. Very often when a man was killed, his brother felt it his duty to take the widow to wife as a means of protecting her from poverty.

If disputes arose among wives, the husband usually remained aloof and pretended he neither saw nor heard. The hazards involved in interfering might well outweigh the nuisance of listening to the quarrel.

Nor was the man's word always accepted without argument by his wife or wives. Indian women were as likely as any to speak up for their rights, to stand their ground when they felt they had a grievance. Comanche peace chief Quanah Parker

COUNCIL REGALIA

⌇⌇⌇⌇⌇⌇⌇⌇⌇⌇⌇⌇⌇⌇⌇⌇

The Plains Indian reveled in finery and wore the best he had for ceremonial occasions. When not doing more immediate chores, the women spent untold hours decorating their husbands' clothing and accoutrements with trade beads and natural items such as bear claws, feathers, quills, pieces of bone, often dyed in bright colors. Warbonnets worn by three of these Blackfeet elders were usually reserved for special events. Not often were they worn into combat, where they might be lost in the fury of the fight and perhaps give an enemy some magical power over the rightful owner. The buffalo-horn headdress was fairly common and gave the wearer an eerie appearance as he went rushing against an enemy, shouting a war cry calculated to chill his opponent to the bone. In some tribes the man who carried a lance into battle was burdened with a special responsibility not to retreat. For that reason, many warriors shunned the lance as a weapon.

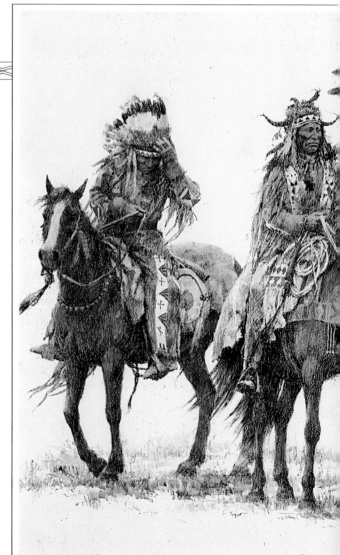

was told by an Indian agent that he could keep only one of his wives. "Go tell the others they must leave," the agent demanded.

Parker knew his wives. "You tell them!" he replied.

The agent did not, nor did Parker.

Several plains tribes had medicine women as well as medicine men. Such a one was Pretty-Shield of the Crows. Often a medicine man's wife worked at his side in trying to heal the sick, chanting with him, burning sweetgrass for incense while he performed his incantations.

Generosity was a hallmark of the Plains Indian. He might not have much, but whatever he had was subject to being shared with others who might have even less. Give-away parties were common as a token of celebration when a son or daughter reached maturity, when a son successfully completed his vision quest or went on his first raid, or on any number of other notable occasions.

When camp was being moved, a man rich in horses was expected to share their use with families who had too few or none. A man stingy with his horses was held to be of low degree.

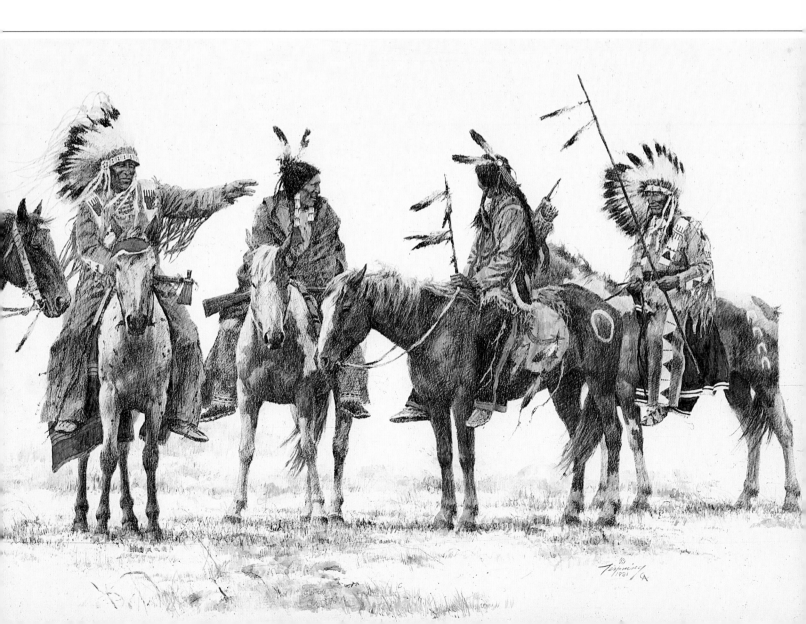

Generosity was not restricted to one's own band or tribe. A Cheyenne known as Wooden Leg recounted a soldier raid upon his camp late one winter. The people were routed, all their belongings burned. After three hard, hungry days of wandering in the cold, they finally reached a camp of Oglala Sioux, who welcomed the refugees with open arms, feeding and clothing them, giving them blankets and tepees and even horses.

That was not the last time. After the Custer fight, when troops were mercilessly harrying the Cheyenne band to which Wooden Leg belonged, they came again to a Sioux camp and were greeted with the same open hearts. "Oh, how generous were the Oglalas!" Wooden Leg declared. "Not any Cheyenne was allowed to sleep hungry or cold that night."

White men often said Indians were a sullen, unsmiling race without a sense of humor. Often in the presence of whites they had nothing to smile about. But they displayed a tremendous sense of humor among themselves.

James Willard Schultz was on an elk hunt with a Blackfeet named Pe-nuk-wi-um when the Indian shot at what he took to be an elk in the brush. The animal gave out a fiercesome cry which sounded like a grizzly. Schultz and the Indian set off in a desperate run to escape the ferocity of the bear, finally stopping, out of breath, congratulating themselves on surviving such a harrowing experience.

The next day a hunting party set out to track down the wounded animal and found it was neither elk nor bear but a lynx, dead from the Indian's bullet. The Indians howled with glee. "See the big bear which yelled. See the big bear which chases them down the mountain." They strapped the lynx to a pole and carried it into the village so everybody could have a big laugh. For a long time they spoke of the lynx as "Pe-nuk-wi-um's elk." ■

FOOT SOLDIERS

Landscape is often subdued in Howard Terpning paintings, but sometimes it is the most prominent feature. Frequently he sees a scene first, then decides how best to fit his Indian characters into it. In this instance he came upon a place in Yellowstone National Park where logs had fallen across a brook, creating what he saw as a logical crossing place for men afoot.

"I designed the creek with the logs as bridges, and summoned three Blackfeet to cross," he said.

The packs, bedding, and weapons indicate they are on a long trek, possibly to steal enemy horses and ride them home, driving before them as many more as they can take.

Elaborating on the planning that went into this work, the artist said: "I kept the figures subdued in order to present strong contrast between light and dark, negative and positive. The edges of the rocks and the white water carry the painting. I wanted you to look at the tumbling water first, and only then discover the figures heading to make trouble, somewhere."

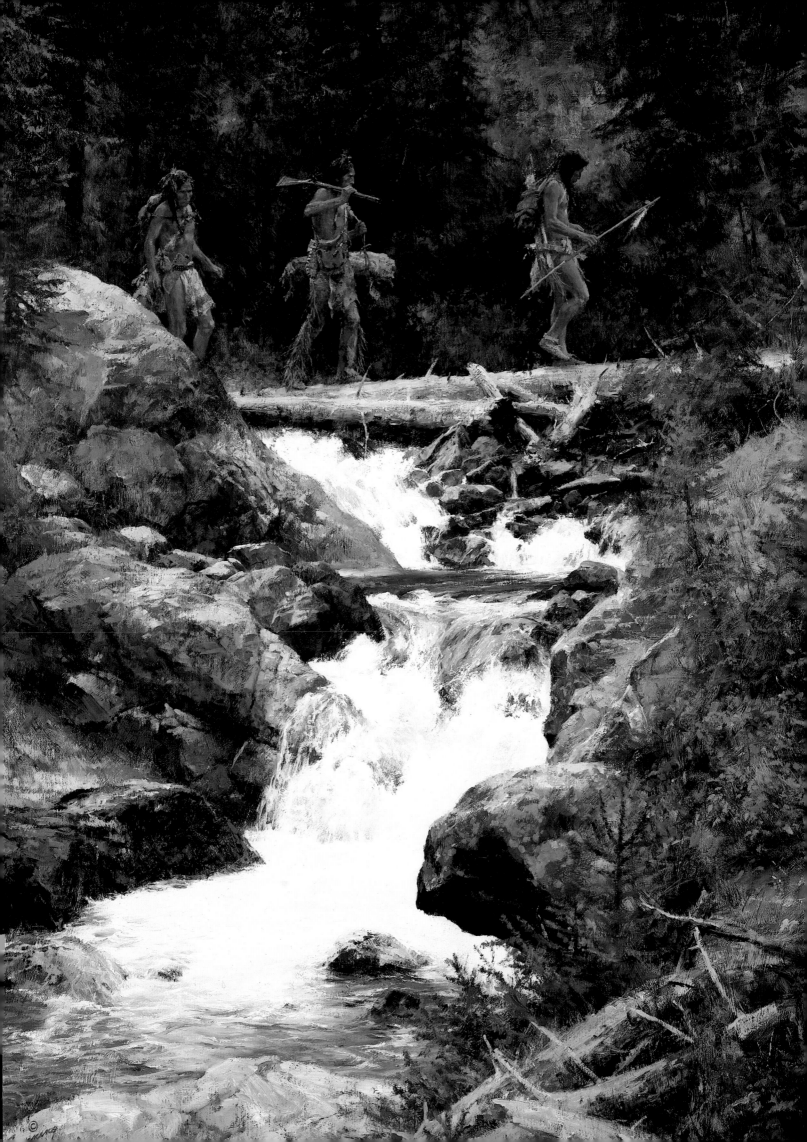

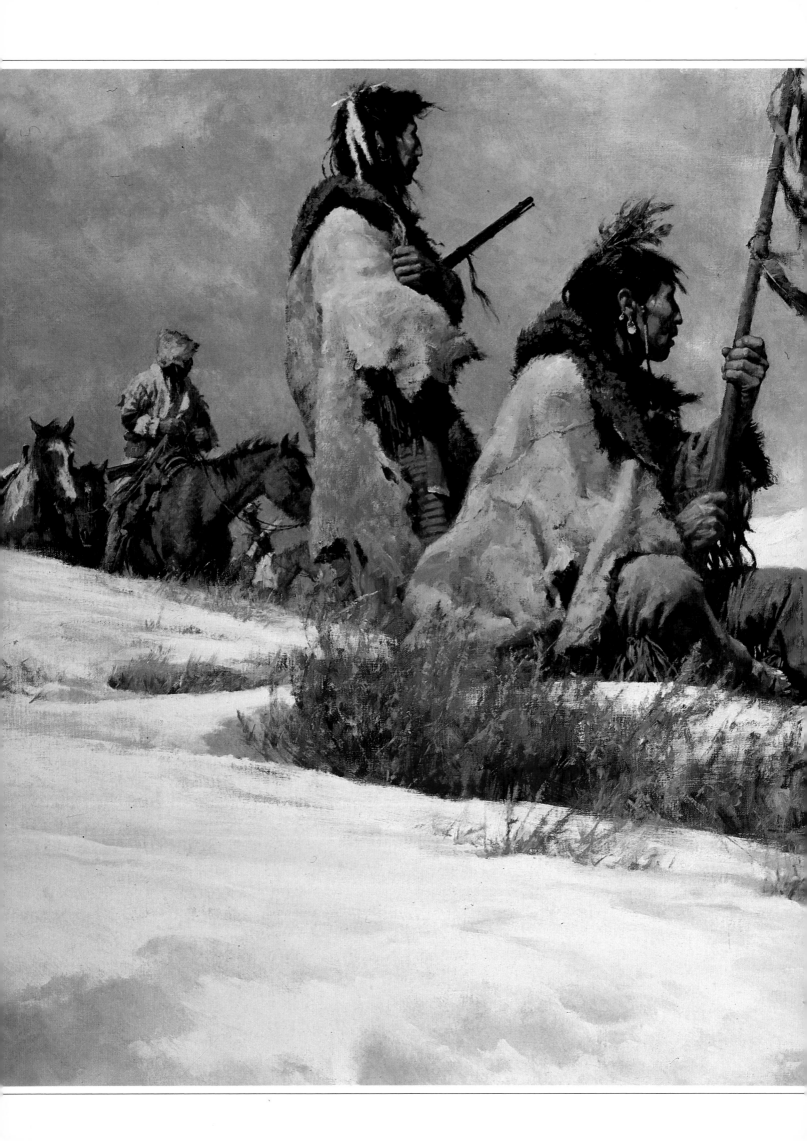

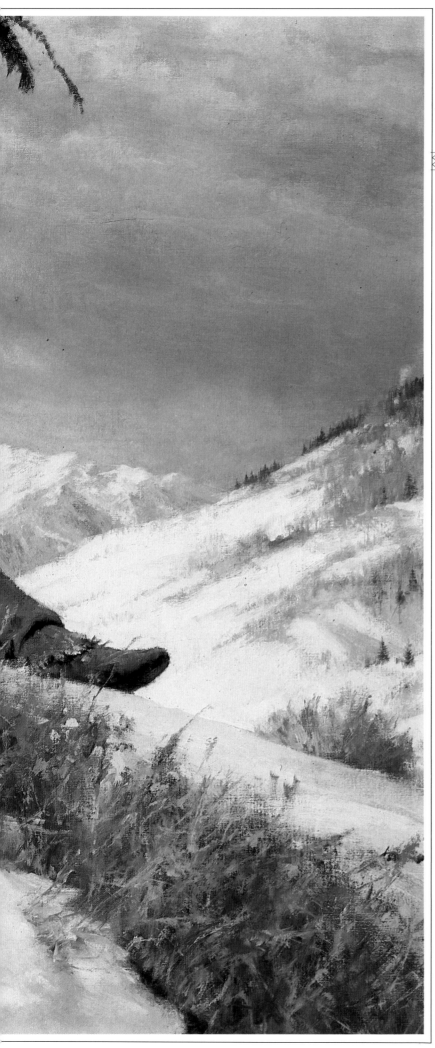

SIGNALS
IN THE WIND

Smoke signals were a common method of long-distance communication among Plains Indians. The smoke was not normally used in the complex manner of Morse code but usually had some specific meaning agreed upon beforehand between senders and receivers. It might signify the finding of a buffalo herd or discovery of an enemy, or perhaps simply provide a rallying point for scattered parties who had moved beyond other forms of contact with one another.

To create a sufficient volume of smoke, the senders might build a strong fire, then throw green or damp branches and foliage upon it. They would hold a blanket over the fire and accumulate smoke beneath it, then pull the blanket aside to let the smoke escape. A long plume rising in the air might have one meaning, short puffs another.

The artist decided in this instance to portray the scene from the viewpoint of a Blackfeet party observing the signal from afar. The cold winter wind that causes feathers and other decorations to stand out from the warrior's lance also is working against the smoke, carrying it away without letting it rise far from the fire. But these men have seen it and know whether its message is good or bad.

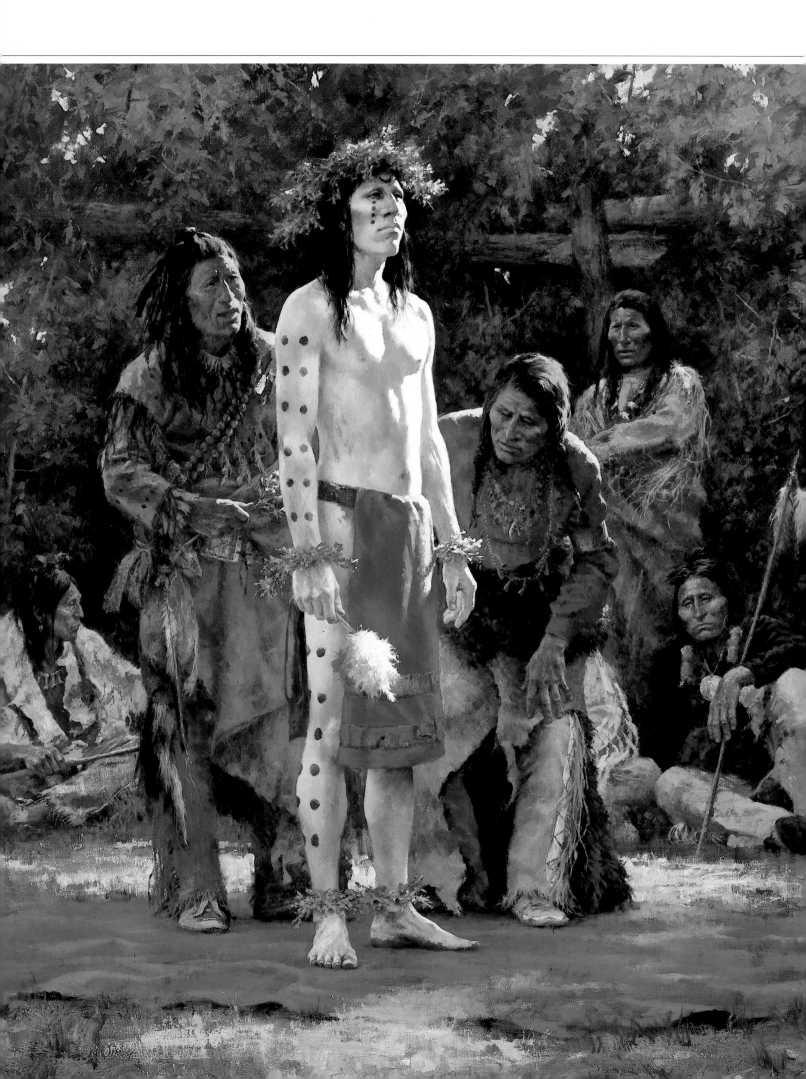

WOMAN OF THE SIOUX

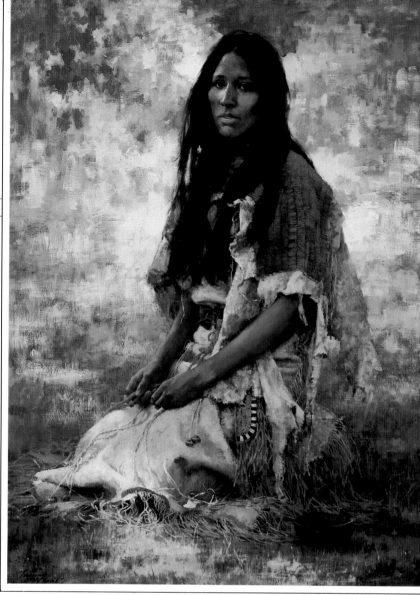

The woman's place in Plains Indian culture included most of the drudgery involved in setting up camp, the skinning, tanning, putting up of meat, cooking, water-carrying, wood-gathering, sewing, housekeeping, and, of course, childbearing and rearing. Yet as homemaker, wife, and mother, she was an indispensable part of tribal life.

Though her life in retrospect may seem mundane, Charles Alexander Eastman, Sioux physician-historian, declared, "It has been said that the position of woman is the test of civilization, and that of our women was secure. In them was vested our standard of morals and the purity of our blood. The wife did not take the name of her husband nor enter his clan, and the children belonged to the clan of the mother. All of the family property was held by her, descent was traced in the maternal line, and the honor of the house was in her hands."

PREPARING FOR THE SUN DANCE

With the notable exception of the Comanche, nearly all plains tribes placed exceptional importance in the annual Sun Dance, which stressed penance and in most cases self-torture by young warriors to demonstrate their bravery and ability to withstand pain. Among the Blood people of the Blackfeet, presented here, the youth's body was painted with white clay, and sage wreaths were affixed to head, wrists, and ankles. Elders would cut incisions in the initiate's breasts, then insert skewers of elderberry wood to which were attached rawhide ropes, firmly tied at the other end to a center pole upon which might rest the head or skull of a buffalo. After prayer the young man was expected to dance against the rope until the skewers tore loose from his flesh. The scars remained the rest of his life, attesting to his courage.

Government officials and missionaries were appalled by this agonizing ritual and applied strong pressure to stop it.

SHIELD OF HER HUSBAND

Here a Sioux woman proudly carries her husband's cherished war shield, an honor the Sioux allowed their wives on special occasions, though it was not common in other plains tribes such as the Cheyenne. The shield was perceived as having been given magical powers, and warriors went to great lengths to prevent the loss of its medicine. Some, like the Comanche, kept their shields carefully protected by a leather cover when not in use, even secreting them in some safe place outside of camp to prevent their being contaminated and losing their power.

The buckskin dress, from the artist's own collection, is a very old one adorned with blue and red pony beads, a trade item in earlier times, and tiny bells that tinkle as she walks. From her belt is suspended a knife sheath decorated with porcupine quills and an awl case beautified with beadwork.

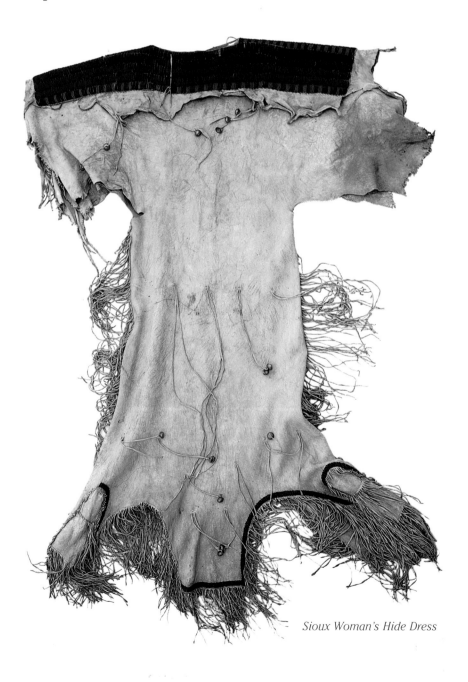

Sioux Woman's Hide Dress

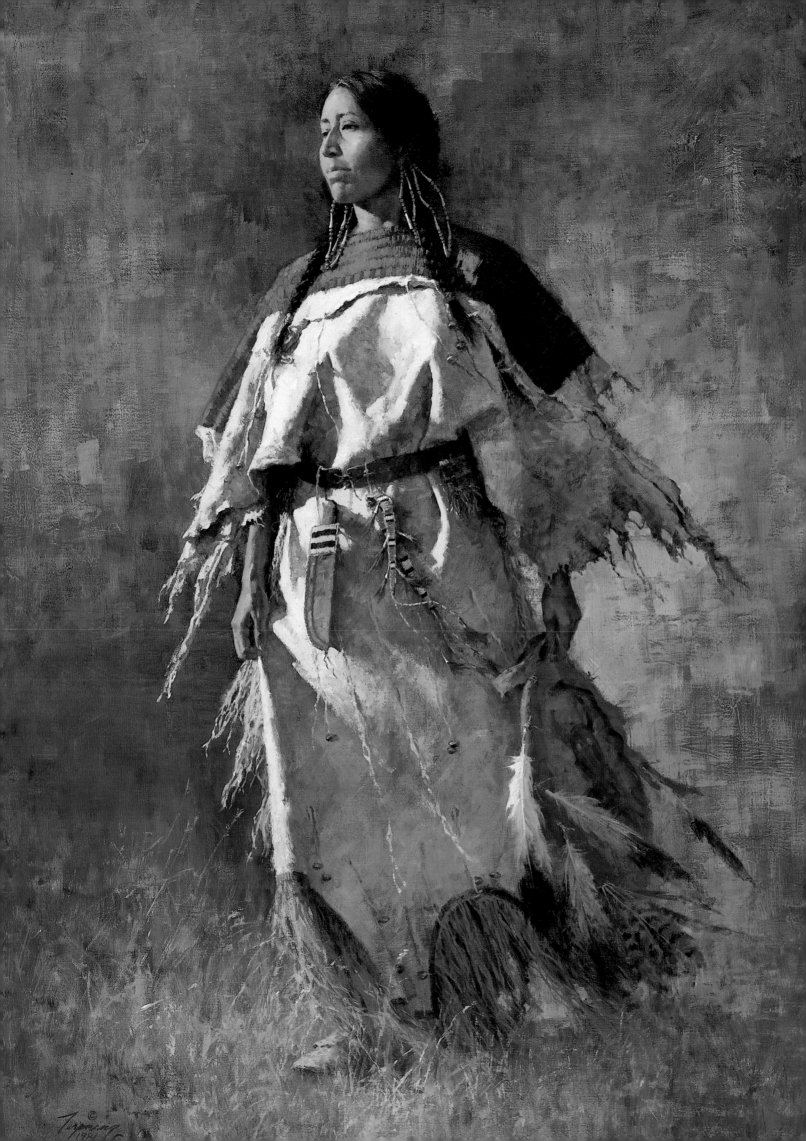

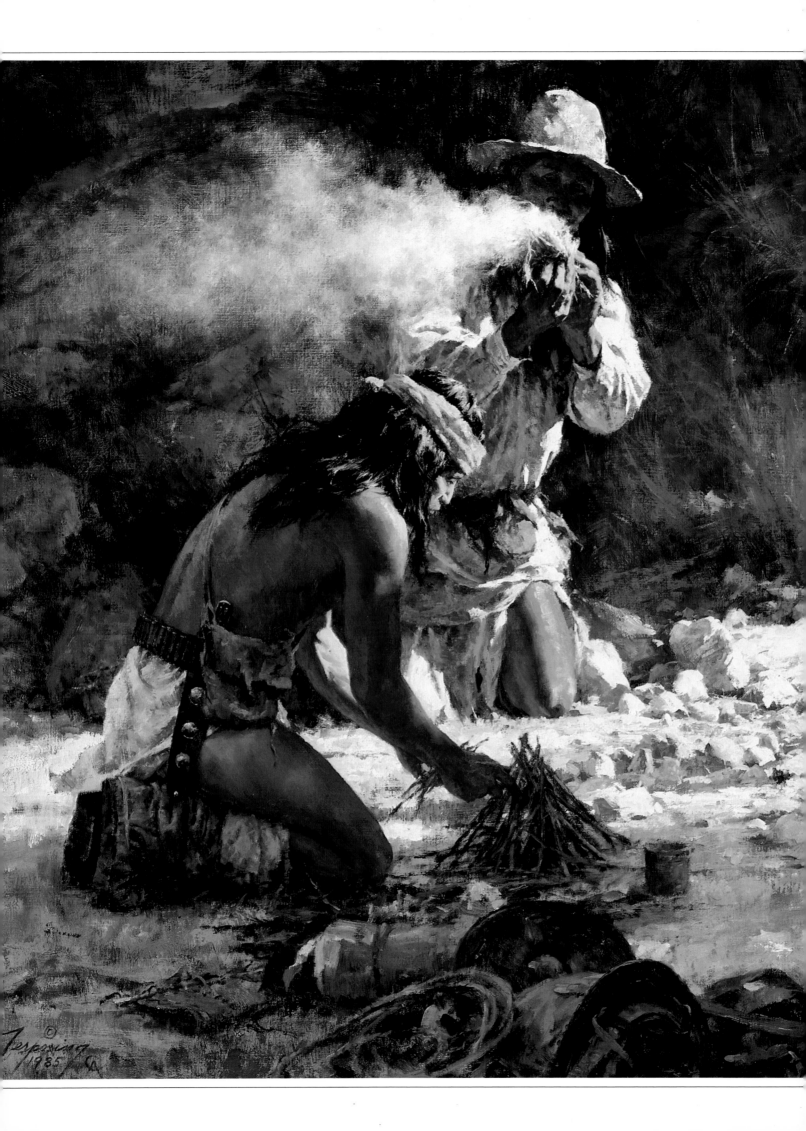

THE APACHE FIRE MAKERS

Before the white man introduced them to the wonder of matches, the Indians had several effective ways of starting a fire. These Apaches have used flint and steel to start a spark in a handful of dry grass. One blows the flame into fuller life while the other prepares dry sticks to receive the glowing tinder.

The artist explains the mental processes that went into this work: "Odd how a picture will assert itself sometimes. I had taken some photographs, just some simple record shots, of Arizona terrain one afternoon. In this particular area the sun was streaming across the desert floor, projecting fascinating patterns of light and shadow on the rocks. For some reason I thought the overall effect impressive. It was simplicity itself. . . .

"I saw in the mind's eye that little camp: corner of a cavalry saddle, ropes, bundles. And that Indian with a spark from flint, blowing gently into tinder, and I saw the light cascading across the natural stage, carrying up the kneeling figure to the smoke, then traveling across to the left. Well, by placing that old hat on the Apache's face, I kept his face in the shadow, which put more emphasis on the smoke in the sunlight. I wonder if we ever understand the process of creativity?"

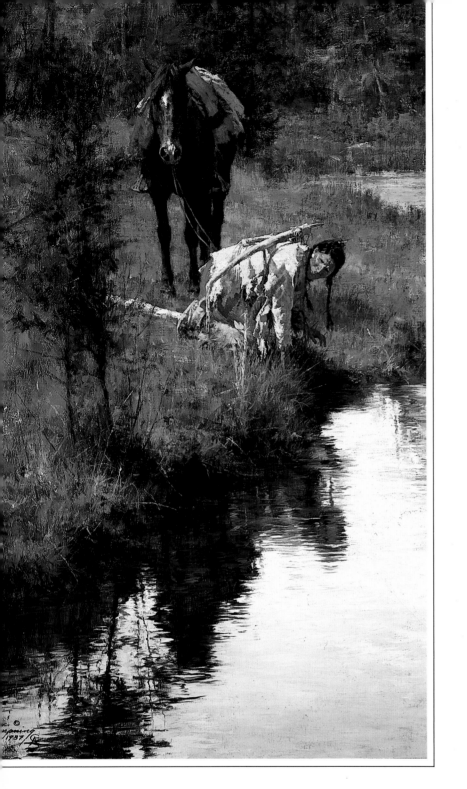

PASSING INTO WOMANHOOD

Girls as well as boys had certain rites of passage into adulthood among the Plains Indians. The subject here is a young Cheyenne girl, undergoing a ceremony that heralds her coming into puberty. It was Cheyenne custom to announce to the camp the fact that the girl had reached that stage in life and perhaps to give away a horse in celebration. The ceremonial rites of initiating the girl into womanhood were usually performed by her grandmother.

The girl unbraided her hair and bathed. Afterward, older women painted her body with red. Then she gathered a robe around her and sat near a fire. Sweetgrass, juniper needles, and white sage were sprinkled on a coal set before her. She bent forward over the coal, holding her robe about it so that the rising smoke from the incense would pass about and over her body. Afterward she and her grandmother would leave the home lodge, and she would remain in a smaller one for four days.

From this time on, she no longer talked to her older brothers for fear it might potentially lead to incest. Her mother coached her on proper conduct, emphasizing the importance of chastity.

CAUTION BORN OF NECESSITY

Plains Indian life was not the idyllic at-peace-with-the-world existence some romanticists would have us believe. The Indian lived with constant exposure to the elements, to hunger and privation, and to the less-than-tender mercies of enemy neighbors. Like the wild animals among whom he lived and from whom he took careful lessons in survival, he developed a strong sense of watchfulness, of caution.

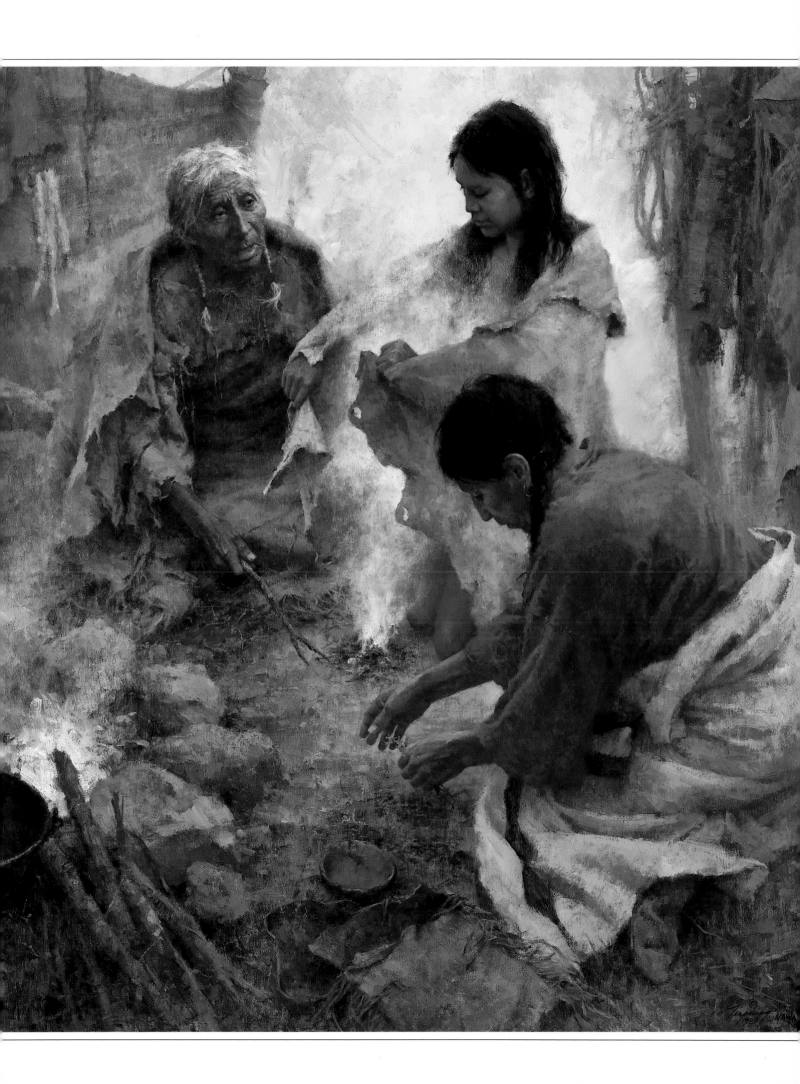

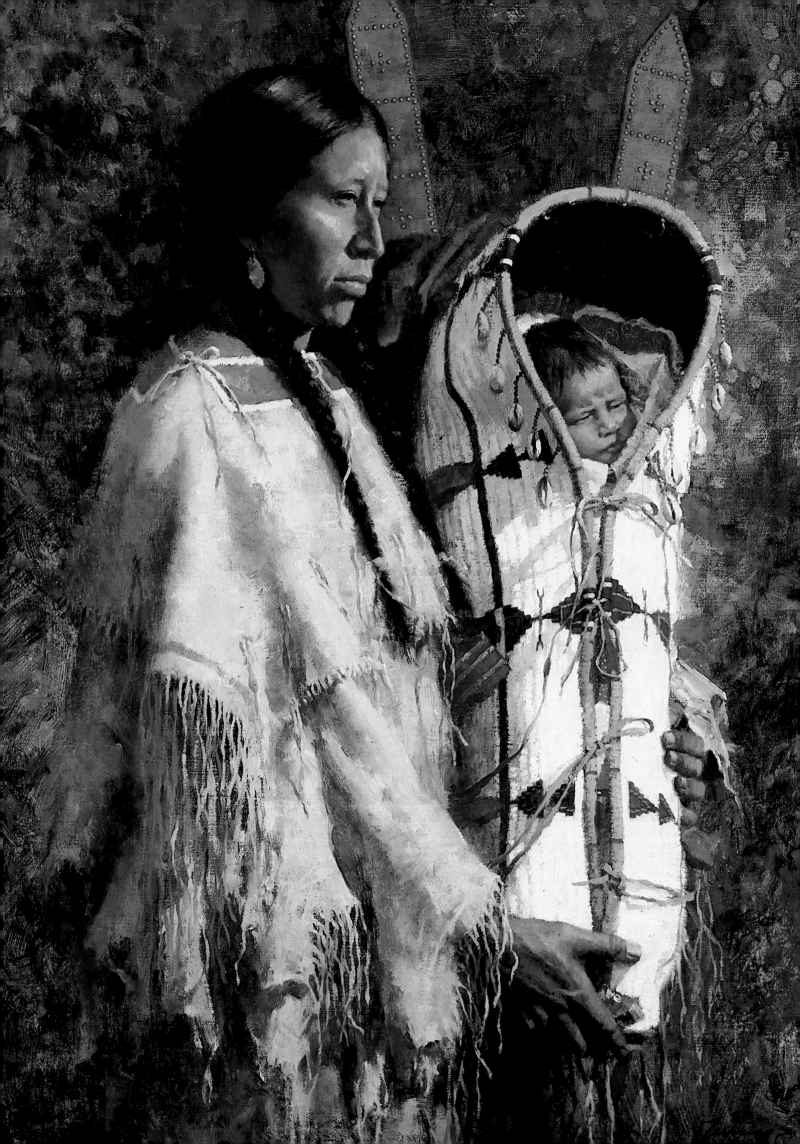

PRIDE OF THE CHEYENNE

Many today assume that the Plains Indian woman was regarded as little more than chattel, but, in reality, the social structure of many tribes was much more matriarchal than is generally supposed. Here the artist portrays a mixture of womanly confidence and tenderness in a Cheyenne, who wears an everyday buckskin dress typical of her tribe. The colorfully decorated cradleboard, formed by loving hands, is indicative of the strong affection the people gave their children.

ONE MAN'S CASTLE

Luxury is a relative matter. Given the sparsity of it in his time and place, this mountain man is enjoying the life of Riley, comfortably stretched out on his bedding beneath the shade of a blanket rigged across the most primitive type of lean-to. His Indian wife looks bored as she waits for supper to finish boiling in a bucket over the meager campfire.

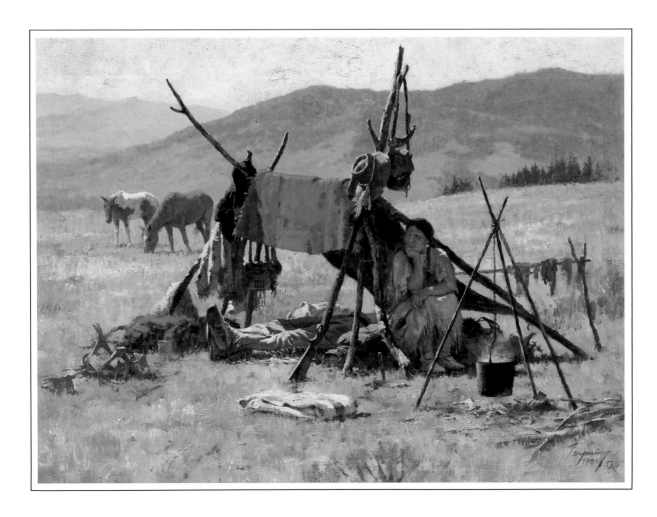

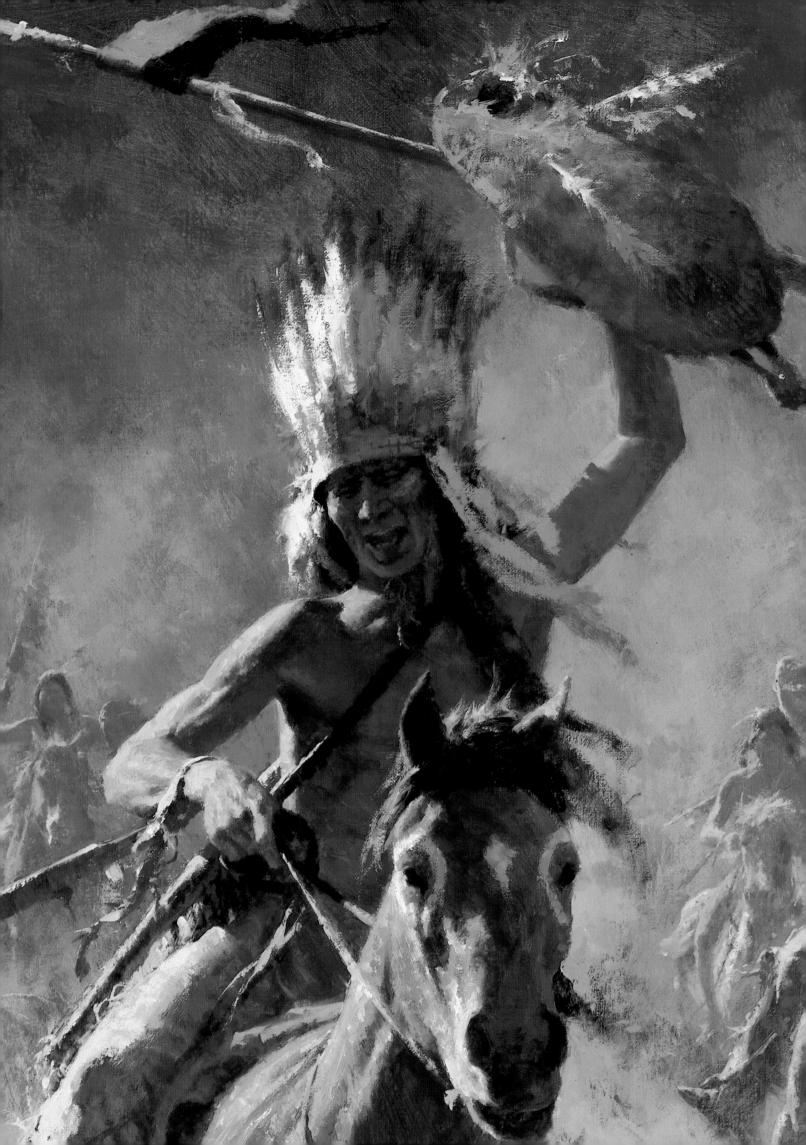

SPIRITUAL POWER

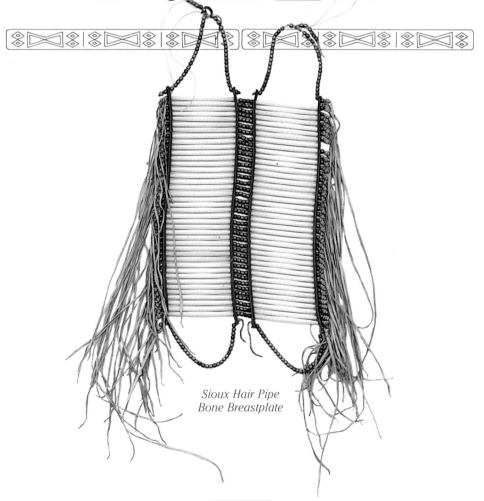

*Sioux Hair Pipe
Bone Breastplate*

*"Long before I ever heard of Christ, or saw a white man, I had learned
from an untutored woman the essence of morality. With the help of dear
Nature herself, she taught me things simple but of mighty import. I knew
God. I perceived what goodness is. I saw and loved what is really
beautiful. Civilization has not taught me anything better!"*

OHIYESA (CHARLES ALEXANDER EASTMAN), SIOUX

There has been a tendency among some writers to portray Indian life as idyllic before the white man came, the people living in innocent and happy harmony with each other and with nature. This is a romantic fable. They never lived in total harmony with one another. Almost every tribe had blood enemies, their original reasons for hatred long forgotten but each generation carrying on the old feuds with unremitting violence that took on ritualistic aspects. A death had to be avenged with death. A raid had to be answered with a retaliatory raid. Once begun, the cycle of spilled blood was difficult to break. Warfare was not only expected but welcomed as a means for a young man to prove his worth. He was not a whole man until he had faced his enemies and shown his courage.

The specter of hunger haunted most pre-horse Indians like a malevolent ghost, for nature did not always provide. Be that as it may, the Indian revered nature because his existence depended immediately and directly upon his ability to live with and from it. His religion might vary in particulars from tribe to tribe, but the honoring of nature was universal.

Most tribes believed in a supreme being, who might be called Wakan Tanka by the Sioux, the Old Man Who Did Everything by the Crows, Maheo by the Cheyenne. However, they believed in a highly varied complex of other beings and spirits. Most saw such spirits not only in the animals, birds, reptiles, and insects, but in the water, in the stones, in the sky, in thunder and lightning. In their animistic view, nothing was simply an inanimate object.

Of his people, Luther Standing Bear said: "The Lakota was a true naturist—a lover of Nature. He loved the earth and all things of the earth, the attachment growing with age. The old people came literally to love the soil and they sat or reclined on the ground with a feeling of being close to a mothering power. It was good for the skin to touch the earth and the old people liked to remove their moccasins and walk with bare feet on the sacred earth. Their tepees were built upon the earth and their altars were made of earth. The birds that flew in the air came to

CHASED BY THE DEVIL

Three Apaches race to stay ahead of a dust devil, the desert hot-weather whirlwind which picks up dust and debris and spins them around, then dies and lets them settle slowly back to the earth. The white man speaks of thermals and explains them in dry meteorological terms, but the Apache of old knew better. He knew that the devil was inside the whirlwind, and that if an Indian were caught up in it, he would soon die.

The artist saw this as an interesting problem in design. He wanted a strong feeling of motion, to convey the sense that the Apaches were galloping their horses as hard as they could.

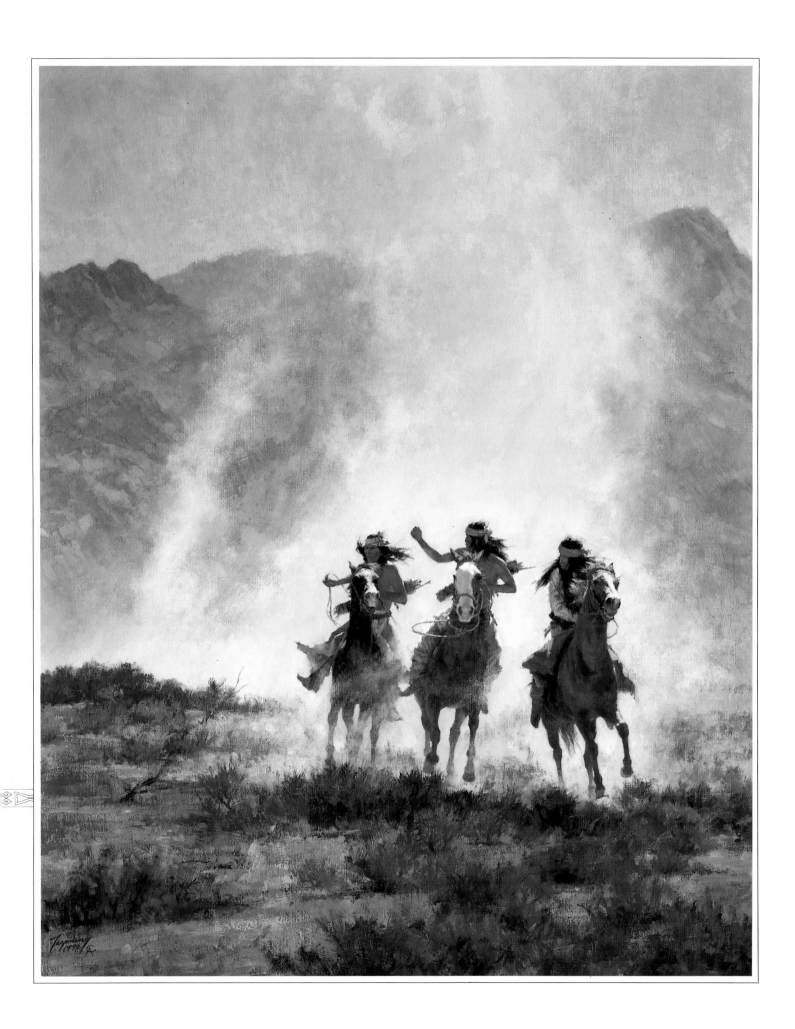

rest upon the earth and it was the final abiding place of all things that lived and grew. The soil was soothing, strengthening, cleansing, and healing.

"That is why the old Indian still sits upon the earth instead of propping himself up and away from its life-giving forces. For him, to sit or lie upon the ground is to be able to think more deeply and to feel more keenly; he can see more clearly into the mysteries of life and come closer in kinship to other lives about him."

The Indians were, then, a highly spiritual people who believed strongly in powers beyond themselves, some good, some evil. Much of their time was spent courting the benevolent spirits and strengthening defenses against the dark ones. For this they had elaborate rituals, one person's often different from another's, even within the band or the family. Far from simplistic, their religions could be incredibly complex.

The most important turning point in a boy's life was his vision quest, his doorway into manhood. It was designed to bring him the wisdom, power, and protection of some kindly spirit, often personified by a familiar bird or animal. In most plains tribes, the boy or young man first turned himself over to the ministrations of a medicine man, who saw to it that he cleansed body in a sweat bath and soul in appropriate ceremony. He taught the boy rituals which he was to observe, sometimes painting his body with designs of a religious nature. Naked except perhaps for breechclout and moccasins, the novice went alone to some designated holy place or isolated spot, often a high point or prominence, sometimes the site of a past battle or other significant event, or even the burial place of a revered holy man. There he fasted four days and nights, repeating again and again the rituals the medicine man had given him, asking for guidance of a kindly spirit.

Skeptics might say that after such prolonged deprivation, the young man was almost certain to hallucinate, but the Indians firmly believed in their visionary guides and trusted their guardian spirit or spirits with their lives.

In times of uncertainty or trouble, adults might repeat in part, or in whole, the vision quest of their youth in hope of obtaining new guidance.

Certain objects, such as medicine bundles, medicine pipes, and individuals' own small medicine bags, carried always on their persons, took on great spiritual significance. The medicine bundle or medicine pipe might belong to an individual or to an entire band. In the latter case, its care was usually entrusted to a holy person such as a medicine man known to possess certain important powers. A specific ritual went with its use to bring a spirit's blessing upon a raid, a buffalo hunt, or other worthy enterprise.

The individual medicine bag, often hanging from the warrior's neck or tied to his waist, was likely to contain items related to the particular power or medicine he had acquired through his spirit guide. The talisman might be feathers from certain birds, pieces of skin from certain animals, pebbles or stones from a holy place . . . anything of significance to the person or the being which gave him guidance. To lose this bag was an ill omen, particularly if it fell into the hands of an enemy who might turn its magic against the rightful owner.

Cheyenne Strike-a-Lite Pouch

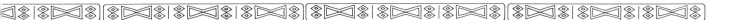

By the same token, a warrior's shield took on spiritual qualities. Most often it would be decorated with symbols related to his medicine. He might decorate it with feathers, ermine, or whatever other materials came to hand. Usually it underwent appropriate rites under the direction of a shaman to insure its protective powers.

The feeling about spiritual power was so strong that a warrior on a raid was free to withdraw if he felt that his medicine had been impaired somehow. In fact, his companions preferred it that way, because bad medicine for one could result in disaster for all.

With medicine almost always went certain taboos and sacrifices. To break a taboo might mean loss of an individual's power, leaving him at the mercy of dark and malevolent spirits. An example was the renowned Cheyenne warrior, Roman Nose, who wore the skin of a kingfisher on his warbonnet and imitated that bird's cry when he rode into battle. He carried the protection of the Great Medicine after having endured four days and nights on a log raft in stormy weather, defying the angry water spirits.

For years he seemed to lead a charmed life, emerging unhurt from the most deadly situations. In a battle on Powder River in 1865, he paraded himself at close range before the soldiers, daring them to shoot him. They tried, but their bullets missed him or, the Indians were convinced, fell away harmless.

Under a taboo that went along with his medicine, he was forbidden to eat food touched by a metal utensil. Just before the famous battle of Beecher's Island in 1868, he ate with the Sioux and unknowingly consumed bread taken from the pan with a metal fork. After discovering what he had done, he held himself back from the fight for a time. Finally he was persuaded that his warriors needed his leadership. Sadly declaring that his medicine was broken, he rode into battle and was killed. His death validated the taboo and was taken as a moral lesson by other warriors to be careful of their own medicine.

Wooden Leg's father showed him how to gather the seed of a certain grass supposed to have shielding power. He put some of the seed in a small buckskin pouch along with a patch of loose buckskin and tied it in his hair. When the time came that he needed the protection before a fight, he pulverized some of the seed between his fingers, mixed it with saliva on the patch, and passed it over his body without quite letting it touch. He protected his horse with the same medicine. This was to make the bullets turn aside. The same treatment under the hooves kept the horse from tiring, and passed in front of its eyes gave it good sight and a strong sense of smell, he believed.

Going into battle, Wooden Leg had his own distinctive face paint pattern, a black ring that included his lower forehead, chin and cheeks. Within the circle, he painted himself yellow.

He said, "With this preparation, with my best clothing, my shield, my eagle-wing bone whistle, myself, and my horse protected by the grass seed medicine, I was almost fearless. I was not entirely so, but almost. In every time of danger I tried to keep myself thinking: 'The Great Medicine sees me.' "

Disasters were usually attributed to medicine gone sour, or to good medicine being overwhelmed by a more powerful malevolent force. Thus, all kinds of events, good or bad, were the function of some spiritual force. Nothing was pure happenstance.

Having no knowledge of germs, the Indians attributed illnesses to an evil spirit entering the body. The medicine man's role had more to do with the supernatural than with medicine in the white man's meaning of the word. It was his primary function to heal the patient by drawing the dark force from the body. If he failed, it was because the evil spirit's medicine was stronger than his own.

Even so, he often supplemented his magic by treating a patient with various herbs, plants, or other materials known to have healing qualities. Modern medicine has found some of these to be effective and uses them in perhaps more sophisticated but not necessarily more effective forms.

To the Indian, life was a circle that had no end. The form of the circle dominated his ceremonies, his dances. The days and nights followed one another in an endless manner. The seasons moved in a circle, spring, summer, autumn, winter, then spring again. The early earthen houses were round. The tepees were round. Villages were laid out in circular patterns, terrain permitting, with open ends toward the east so all could see the rise of the morning sun. That sun was round, as was the moon. Even the stars at night moved in a circle.

So, too, man's life was like the seasons: birth, adolescence, maturity, old age, death, one generation following another, endlessly. Individuals came and went, but The People lived on, following the circle. ■

SUNDAY BEST

Life was often harsh for Plains Indians, so they treasured those special ceremonial occasions when they could dress up in their best finery and put aside for a little while their hardships and troubles. The artist met this teenage girl at Blackfoot Crossing in 1977, when the tribe was reenacting the centennial of their treaty which brought them peace with the Canadian government. It was an ancient, hallowed Blackfeet camping ground, where eighty-three tepees had been erected in a circle, in the old way.

With her mother's permission, he photographed the girl, whom he found shy but compelling, her long black braids wrapped in otter fur, her still growing body a little lost in a traditional dress a bit too large for her, obviously handed down from forebears whose life had been worlds removed from her own.

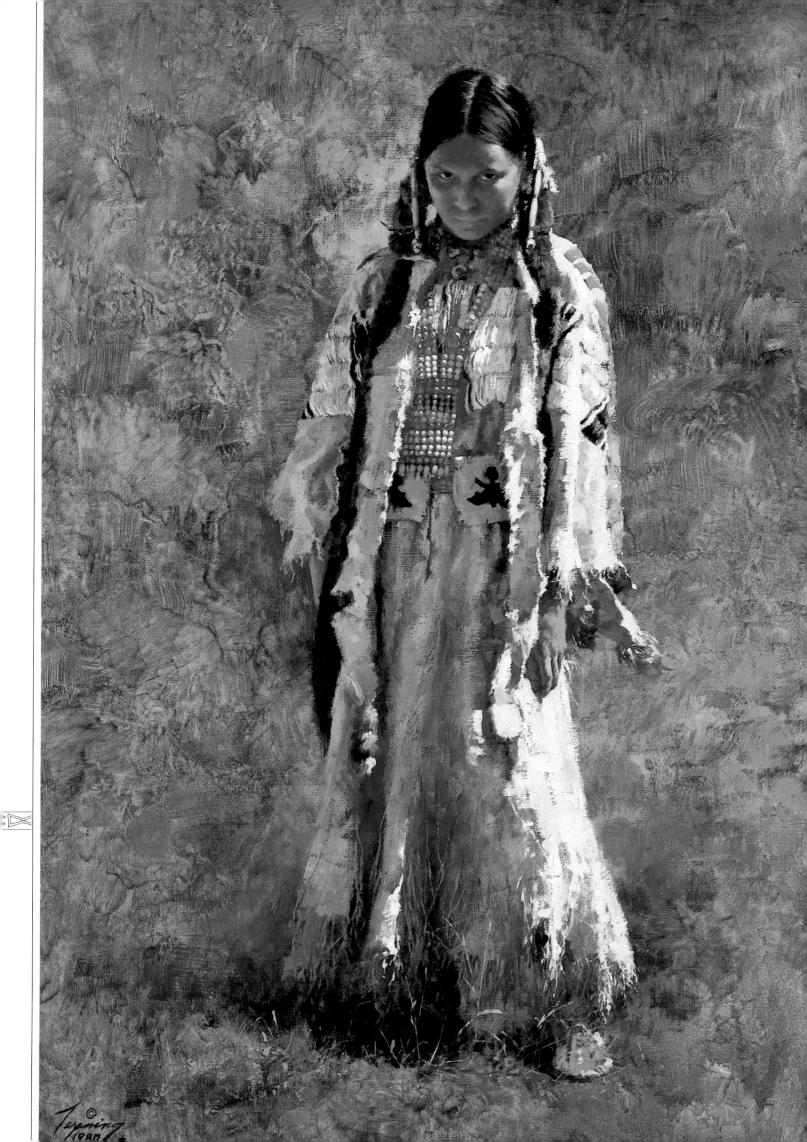

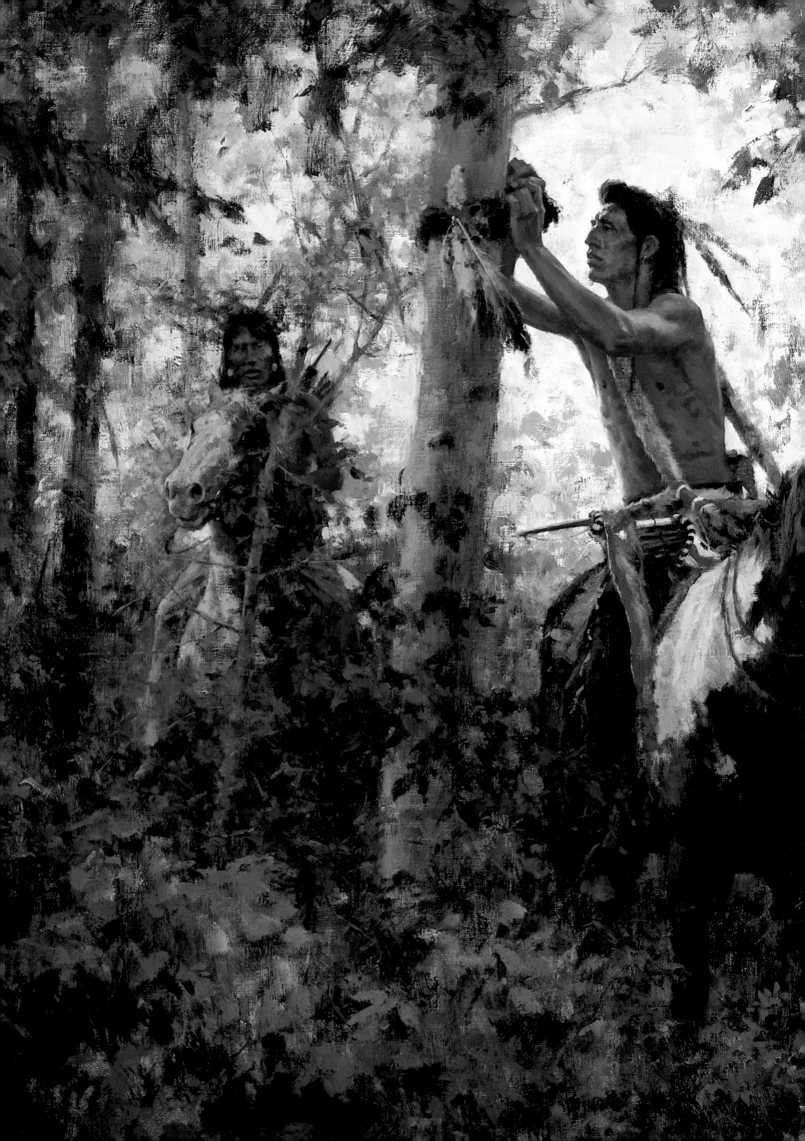

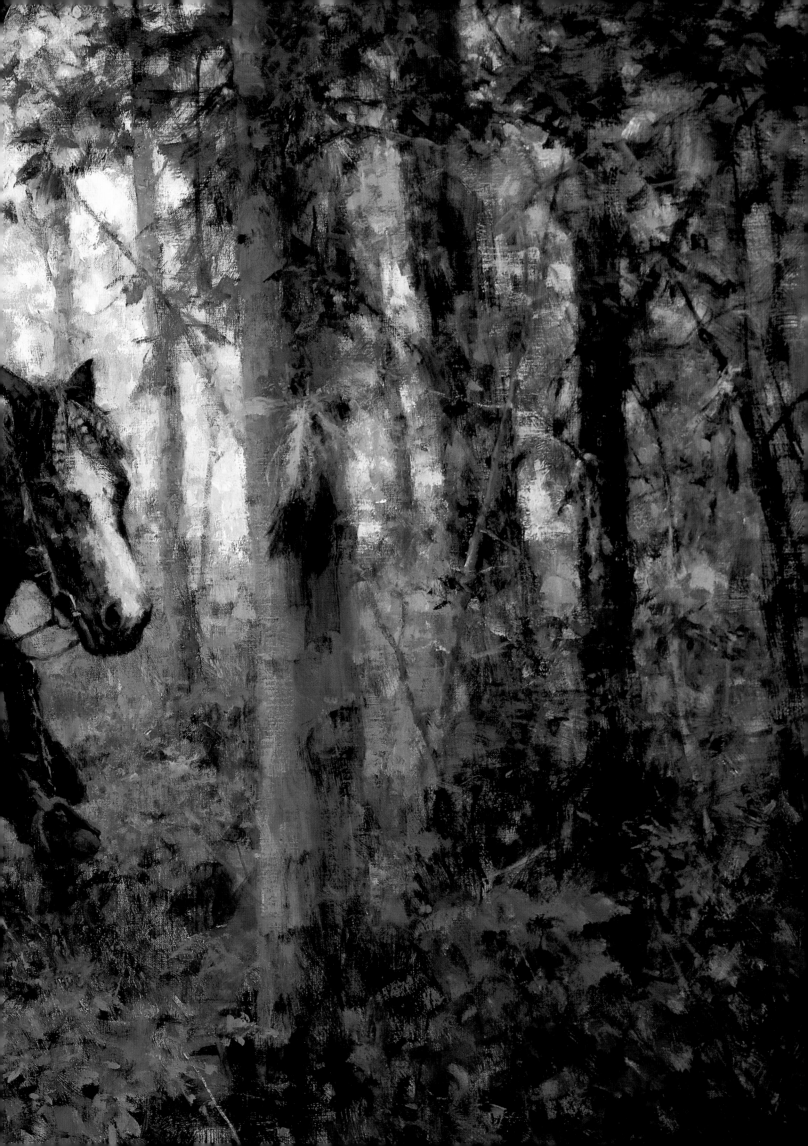

OFFERINGS TO SUN

The spiritual nature of Plains Indians led them to have holy places to which they could go to commune with those spirits that guided their lives or to feel close to what some called the Sure-Enough Father. Native American friends took the artist to such a place on the Blackfeet Reserve south of Browning, Montana. For generations and generations, the Blackfeet had been going into these woods and attaching small offerings to tree trunks and branches. In earlier times these would have been such rarities as eagle feathers or ermine tails or medicine bundles containing items of religious significance. In modern times swatches of cloth are an accepted substitute, respectfully maintaining the custom of ancestors.

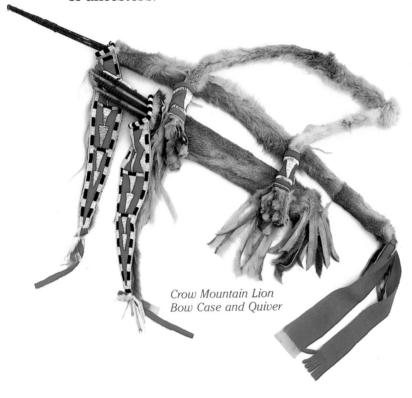

*Crow Mountain Lion
Bow Case and Quiver*

TRANSFERRING THE MEDICINE SHIELD

Among the Blackfeet people, the shield was considered a medicine object and treated with the same great care and reverence as all other medicine bundles. If the shield were to be transferred to another, it had to be exchanged in a formal ritual. The artist explains that in the tepee a smudge was made and the shield passed through it four times, four being considered a magical number by Plains Indians. The recipient of the shield was painted with yellow earth over the face and hands, the face then streaked by drawing the fingertips downward. A red transverse band was painted across the mouth. Four drums were beaten and special songs sung. The seller then took up the shield and dodged about, pretending to avoid blows or arrow strikes, as in a fight. At the end of the ceremony, the recipient paid the former owner with a horse.

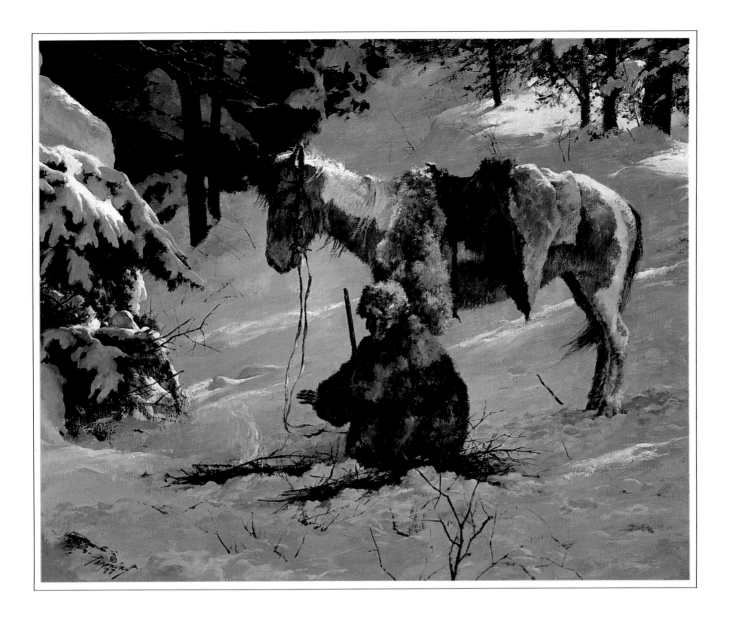

OWNER OF THE SACRED SHIRT

Sacred shirts were used by the Blackfeet for their power in battle. The holes represented the power of hailstones and sometimes bullet holes. Ownership of the shirts could be transferred in the manner of a medicine bundle. They were often worn by members of certain Blackfeet warrior societies known as Bear braves. Eventually they came to be known as the Lord's shirts.

SMALL COMFORT

The bitter cold of a Montana or Alberta winter is reflected in this painting of a Blackfeet Indian warming his hands over a very small fire while his horse turns its rump to the freezing wind. A heavy growth of winter hair gives the animal some protection against the elements, though Indian horses weakened by malnutrition often succumbed to the cold. Among some northern tribes, February was known as the moon that the ponies die.

Says the artist: "If you've ever been up in Montana or Alberta in the dead of winter, you know how below-zero cold can come right through layers of heavy wool trousers and a modern down parka."

The native people were better acclimated, but they were by no means immune.

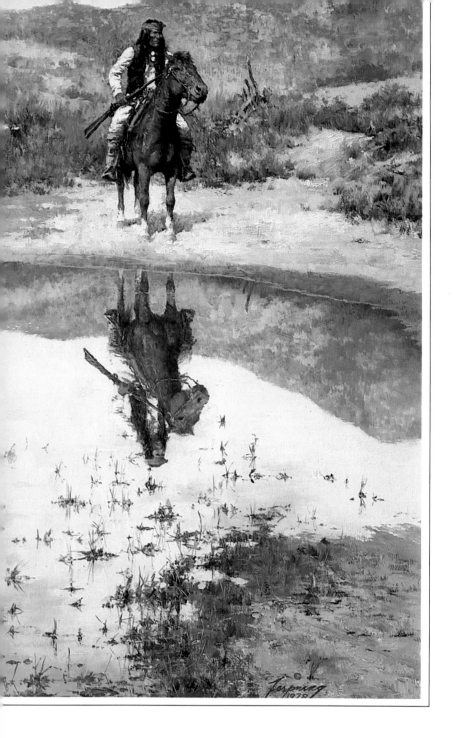

HUACHUCA POND

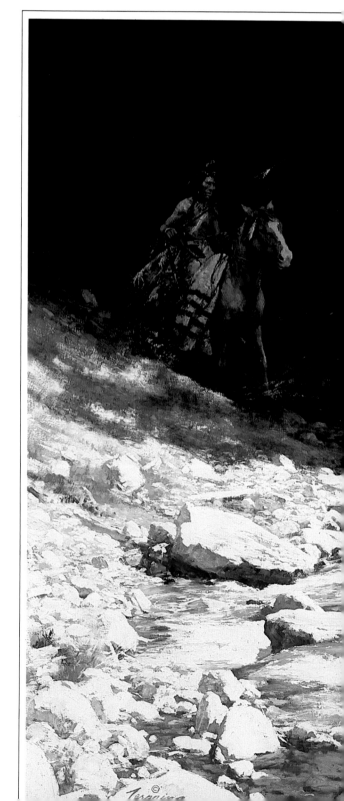

W ater was scarce in most of the desert
country where the Apache lived. The fact
that the Indians knew where to find it
and their white enemies often did not was a
factor that helped the Apaches hold out longer
than almost all other Indians.

The artist says there is no particular story
to this painting. He found the pond and was
intrigued by the patterns it created. He simply
placed a horseback Apache at the edge of it.
The rider and his reflection in the water give a
human element to the composition.

STONES THAT SPEAK

The Crows in particular were known as great trackers. Here the leader of a party finds a turned-over stone which provides mute evidence of earlier passage. Indian trackers could read much into the turned stone, the broken twig, the crushed leaves of grass.

This painting demonstrates the artist's liking for contrasting areas of darkness and light. It won for him his first Gold Medal at Oklahoma City's National Academy of Western Art Show in 1980.

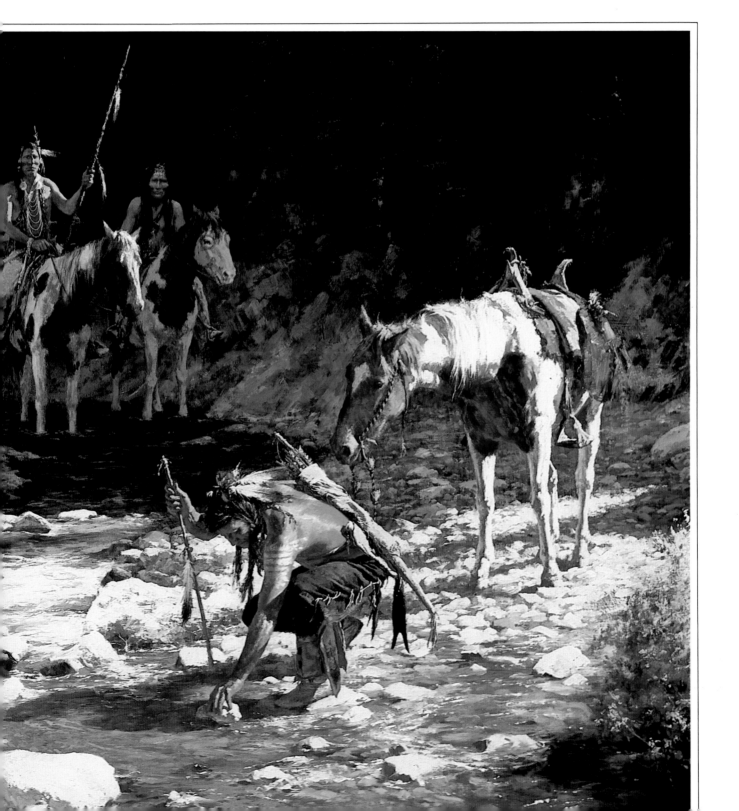

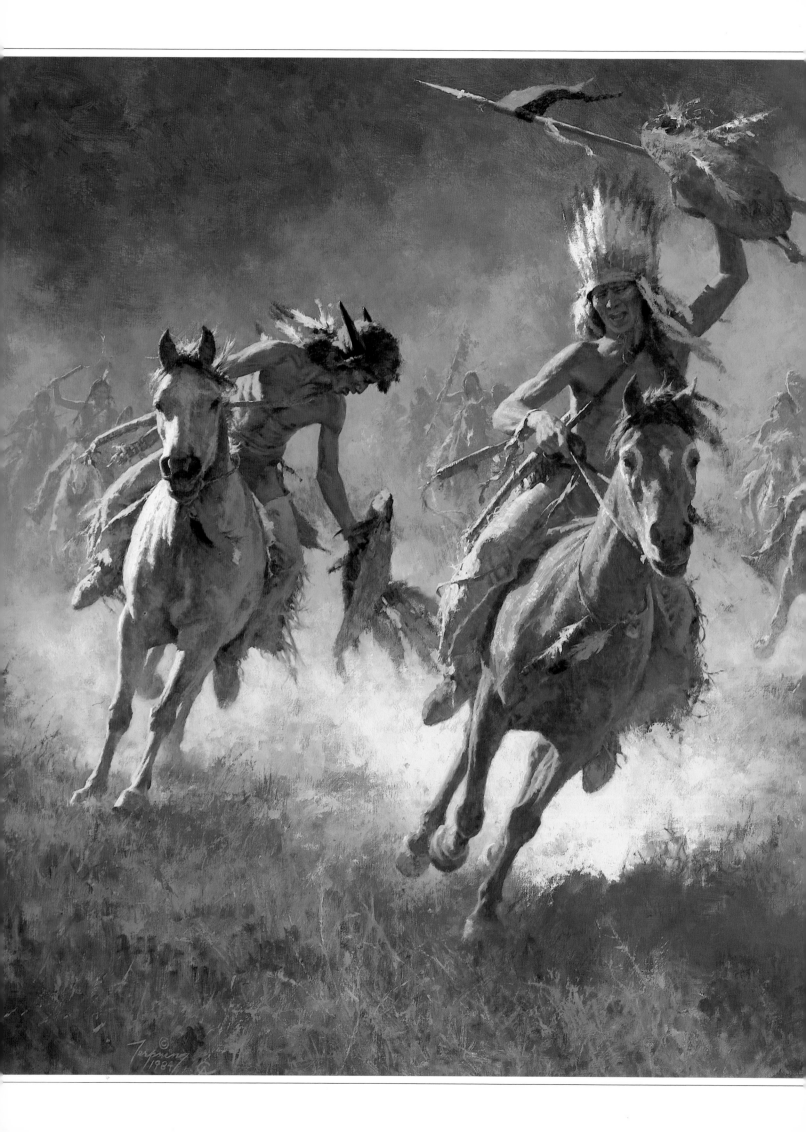

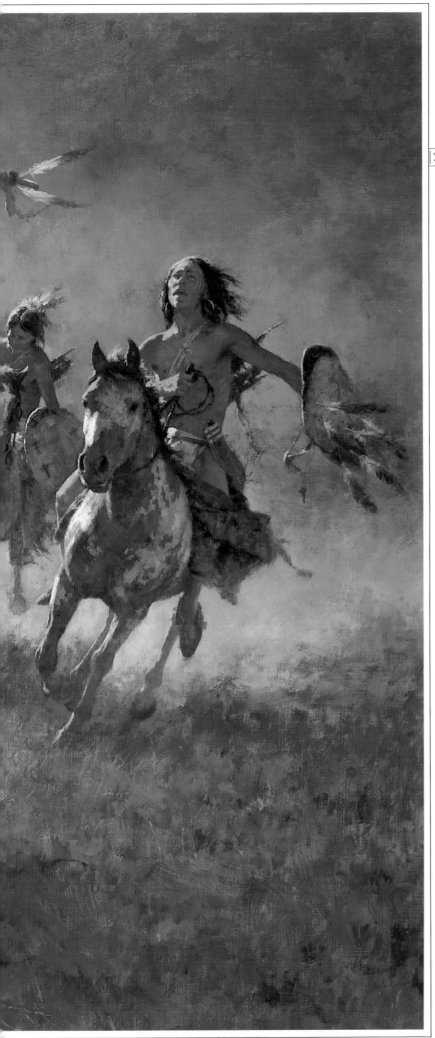

MYSTIC POWER OF THE WAR SHIELD

Because warriors depended upon the shield to protect them in battle, they went to great lengths not only to construct it as strongly as possible but also to have protective spiritual powers imparted to it. Here, Cheyennes gallop at full speed, shaking their war shields at the sun, then leaning down to brush them against the grass, invoking medicine believed to turn away enemy bullets and arrows.

A warrior might spend months making a shield, working and reworking until he was satisfied that it was just right. Often he decorated it with symbols of his own personal medicine, given him by a spirit guide. He was likely to ring it with feathers and charms. When he galloped forward in a charge, the feathers on his shield, as well as any tied in his hair or his pony's mane and tail, would stream in the wind and make him appear even fiercer than he might have been. He had a fine sense of pageantry, and of the psychological effect it might have upon the enemy who faced that charge.

The shield was jealously guarded against anything that might diminish its spiritual power. Its loss to an enemy was regarded as particularly dangerous because the enemy might use its magic against its owner and those around him.

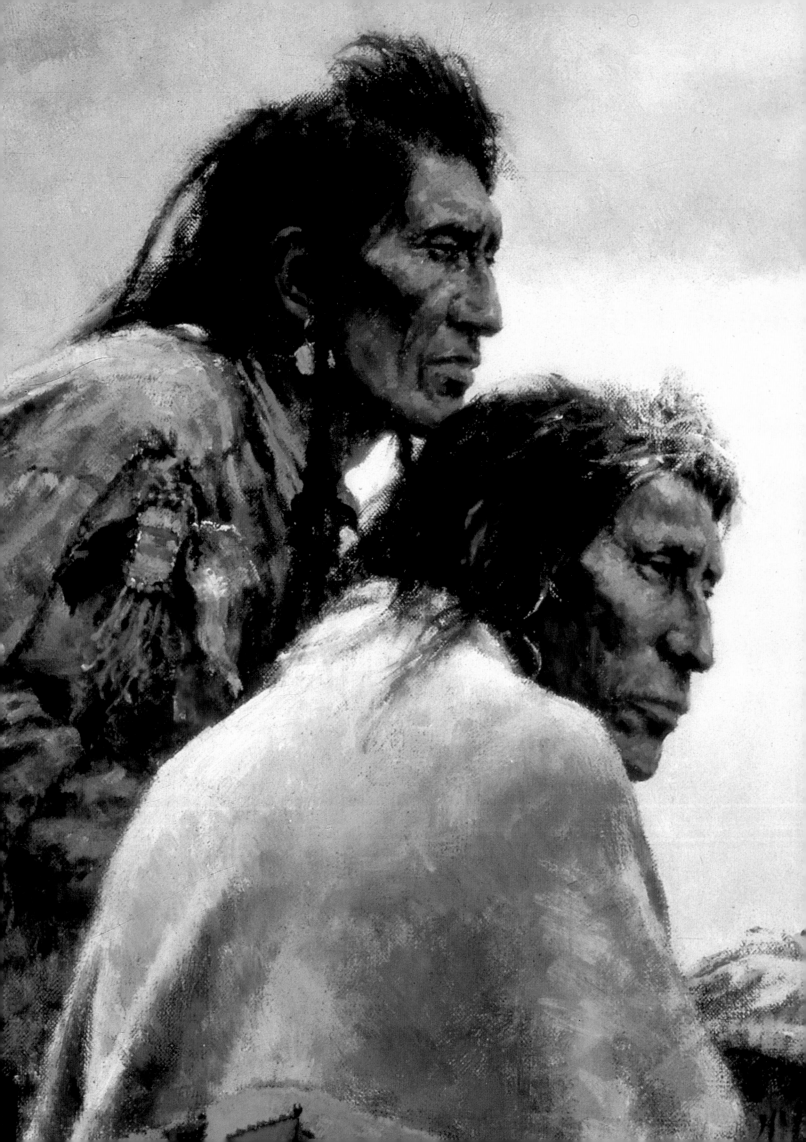

THE WHITE TIDE

*Blackfeet Elk Hide
Beaded Bag*

*"We did not ask you white men to come here. The Great Spirit gave us this
country as a home. You had yours. We did not interfere with you . . . We
do not want your civilization! We would live as our fathers did, and their
fathers before them."*

CRAZY HORSE, OGLALA SIOUX

The coming of the white man brought catastrophic change to the Indian's world. The Indian's limited technology had made negligible physical impact upon the land. He lived with nature and accepted it as it was, though he often tried to influence it with his medicine powers and those of his guardian spirits. The white man, by contrast, sought to alter nature, to "civilize" the wilderness.

Questing traders, looking for new territories and new tribes with which to do business, made the white man's first contact with Indians on the plains. By the time Lewis and Clark launched their exploratory venture to the Pacific Ocean for President Thomas Jefferson in 1804, the French had been trading among Plains Indians for a hundred years.

By and large, early traders got along well enough with the many Indian tribes because they brought goods the Indians wanted, trading them for furs and buffalo robes. Many, by their nature loners or at least resistant to the restraints of "civilized" society, fell easily into the Indian way of living. In a sense they became Indians themselves, often marrying into one tribe or another. Out of such unions came the French-Indian halfblood Metis of Montana and Canada.

Though France lost its hold on the New World after the French and Indian War, experienced Frenchmen as individual *voyageurs* and *coureurs de bois* continued to trade among the Indians, on their own or working for former rivals in the English companies. Five plains-wise Frenchmen accompanied Lewis and Clark. They included Toussaint Charbonneau, husband of the Shoshone woman Sacajawea, who proved invaluable to the expedition as a guide and interpreter.

The first American traders and trappers were bold, adventuresome individualists, usually not company men, though trading companies were not long in following up on these early contacts. Meriwether Lewis was amazed in 1806 to find two intrepid beaver trappers from Illinois near the mouth of the Yellowstone, some fifteen hundred miles west of St. Louis and "civilization."

The mountain man became a legendary figure. Though some were well educated, like Jedediah Smith and Thomas Fitzpatrick, a majority, like Jim Bridger, were unschooled in books but apt students of nature. They were by necessity courageous, for a man lacking in nerve was likely to turn back before he ever reached beaver country. Constant vigilance was the price for keeping one's hair on one's head, where it belonged. They also had to be hardy to survive the rough living and working conditions. Trapping beaver required spending hours every day wading in waters often cold enough to freeze. Rheumatism was a common ailment.

After a hard season of trapping, a high point of the year was the annual rendezvous, a time for selling or trading their catch of peltries, buying what they needed to outfit them for another year, and a few days of drinking and carousing with a ferocity that occasionally turned fatal.

Even for those Indians who met the white man in peace, the long-term result was usually tragic. The Mandans were a large and prosperous earth-lodge people who lived along the Missouri and traded extensively with the early whites who ventured upriver. Often they were middlemen in trade between whites and the tribes

farther west. Though their contact with the white man was usually friendly and profitable, it led them to almost total disaster. After the smallpox epidemic of 1837, this once substantial tribe of some sixteen hundred was reduced to fewer than a hundred survivors.

The Shoshones by and large remained friends to the whites. Much-bemedaled Chief Washakie of the eastern band of Wyoming Shoshones was honored for helping thousands of white emigrants in their covered-wagon trek across his part of the country.

The Comanches had a long history of hostility with the Spaniards and Mexicans before Americans began moving into Texas. At first they avoided conflict with these newcomers, perhaps seeing them as potential trading partners and allies against old enemies. By 1836, however, they were spilling Texan blood. Barely two months after the fall of the Alamo, a war party fell upon the civilian Fort Parker, killing five men and carrying away two young women and three children. One of the children was Cynthia Ann Parker, whose life with the Comanches was to become legendary, and whose half-blood son, Quanah Parker, would eventually help his people bridge over into the new ways.

The Comanches took a number of women and children prisoner in raids against outlying farms and small settlements. Under a fire-eating president, Mirabeau B. Lamar, the Republic of Texas took a hard line against Indians in general and Comanches in particular. The ferocity of the Texas Rangers and their skilled use of the newly developed Colt six-shooter, deadly in close combat, startled the Comanches into suing for peace and offering to deliver up their captives at a council in San Antonio. They brought in only two, however, and the peace parley turned into a deadly battle known ever afterward as the Council House Fight. Seven whites were killed and ten hurt. Thirty-three Indians died, including several chiefs of the Penateka band. Almost as many more were wounded. The Comanches slaughtered most of their remaining prisoners, and from that day forward, neither side wasted time talking of peace. The bloodletting swelled to frightful proportions.

In retaliation for the Council House incident, a Penateka chief the Americans called Buffalo Hump gathered a huge congregation on the Edwards Plateau, close to a thousand in all, roughly half of them warriors. Curiously for a war party of this ambitious magnitude, a great many families went along. In July 1840, they marched eastward, bypassing San Antonio because it had become bad medicine, then slicing through a thinly settled region toward the Gulf Coast. They surrounded the town of Victoria and killed thirteen people before pushing on down to the Gulf. They surprised and killed settlers as they moved toward a seaport village known as Linnville, driving an estimated two thousand stolen horses and mules. Among others, they kidnapped a granddaughter of Daniel Boone, killing her baby.

The forty or so inhabitants of Linnville saw the dust but thought it was raised by horses being brought for sale by Mexican traders. Almost too late, they recognized the horror closing in upon them. Those not immediately overtaken ran to the shore and tried to escape in boats. Warriors pushed their horses out into the surf,

attacking the whites as they desperately rowed away. The Indians gleefully spent the day looting the storehouses of recently received merchandise, then set the entire village afire.

They began a long retreat westward, reveling over scalps, captives, and loot. Many wore white-man and white-woman hats and shaded themselves with colorful umbrellas. They tied ribbons in their horses' manes and tails, and some dragged long bolts of calico cloth.

Their trail had been found and recognized for what it was, however, and Texan forces were gathering to head them off. The showdown came at Plum Creek, near present-day Lockhart, when Rangers, militiamen, and volunteers spread themselves across the path of this colorful and defiant cavalcade.

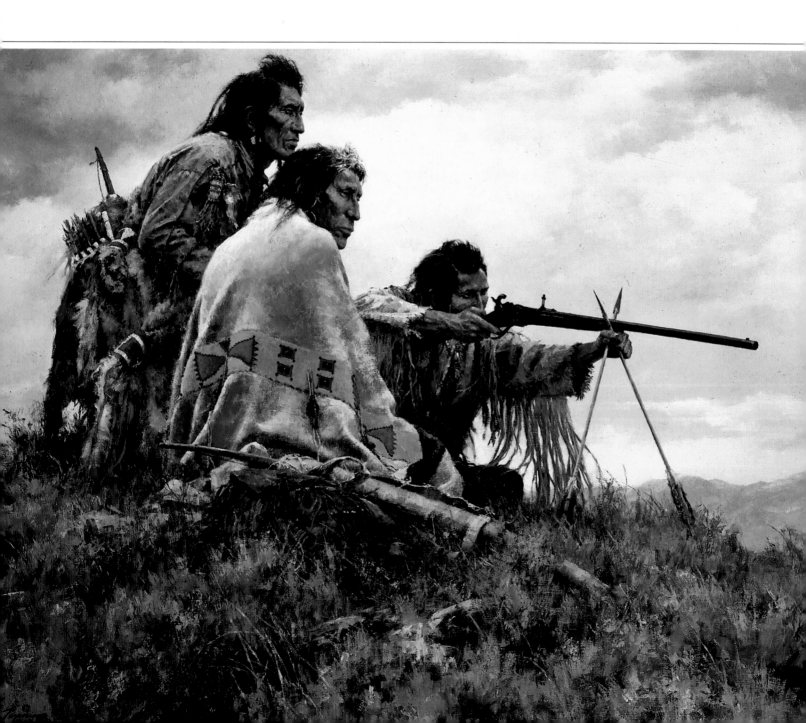

The ultimate Texas boast may have been the pep talk made to his company by Captain Matthew "Old Paint" Caldwell: "Boys, the Indians number about one thousand. They have our women and children captives. We are only eighty-seven strong, but I believe we can whip the hell out of them. What shall we do, boys, shall we fight?"

Fight they did, with the help of a few Tonkawa allies, staunch enemies of the Comanches. The stolen horses and mules were stampeded, and the Indian retreat became a headlong rout, a running slaughter. Smarting in defeat, the Indians murdered Boone's granddaughter and wounded two other women captives.

The burned town of Linnville was never rebuilt.

From that time on, Comanche incursions into the Texas settlements would be by small raiding parties except for the big 1864 Elm Creek raid, in north central Texas, staged at a time when the whites were engaged in their own civil war, and frontier defenses were weak. Recognizing this weakness, a Comanche known as Little Buffalo led a thousand Comanches, Kiowas, and Kiowa-Apaches past Fort Belknap, in roughly the same area as Elm Creek, killing eleven settlers and carrying off seven women and children. It was a hit-and-run operation but costly to both sides. Little Buffalo was among some twenty warriors killed in the fighting on Elm Creek.

The captives included the wife and two children of a black frontiersman named Britt Johnson, who single-handedly set upon four valorous missions of recovery into the midst of hostile territory. He managed eventually to ransom back his wife and children and all the surviving white captives except for one, a girl named Millie Durgan. She was found some sixty-five years later, an old woman living as a Kiowa, having no memory of her former life. Britt Johnson became a freighter and was killed in an Indian raid on his wagons in 1871.

THE LONG SHOT

White buffalo hunters most often used a portable tripod or a forked stick to support the heavy barrel of a large-caliber rifle designed for long-distance shooting. These Indians achieve the same effect by crossing two arrows for steady aim with a Sharps.

Plains Indians who violently opposed encroachment by the hide hunters quickly learned a healthy respect for the "shoot today, kill tomorrow" guns. These could bring down buffalo or Indian at a distance far beyond that of even the more advanced rifles some of the warriors had obtained through trade or capture. Any rifle was difficult to fire from horseback with real accuracy, and the big buffalo rifles were particularly cumbersome. But a man afoot, able to brace one against a tree, a post, a wagon, or even upon the seat of his saddle, was to be dreaded by anyone within the rifle's tremendous range.

One Indian leader who had some early success against the white man was Red Cloud, an Oglala Sioux. He earned a reputation as one of the tribe's most fearless warriors. In 1865–66 he vigorously opposed opening of the Bozeman Trail through the Powder River country, which he regarded as a violation of earlier treaties. A particular sore spot was Fort Laramie in Wyoming, originally a fur-trading post. The fort was meant to guard the disputed trail, but because of the hostility of Red Cloud and his warriors, it became almost all it could do to guard itself.

Another constant festering sore was stockaded Fort Phil Kearny, built in 1866 near present Sheridan, Wyoming. The Sioux and allied Cheyennes and Arapahoes constantly harassed the garrison. On December 21 of that year, Captain William J. Fetterman and eighty troopers rode out to protect a wood train that had been attacked and were lured into an ambush in which all were killed.

The following August, an attack on another wood-cutting detail was successfully beaten off in what became known as the Wagon Box Fight. But the fort remained under virtual siege. In 1868 a government appointed Peace Commission gave in to Indian pressure and ordered the post abandoned.

The Indians had gained some time, but they managed only to delay white incursions, not halt them. Discovery of gold in the Black Hills less than a decade later brought an unstoppable stampede of fortune-seekers onto Indian treaty lands. It was the army's protection of these invaders that led to the Custer battle of 1876, the last grand hurrah for the Indians of the northern plains. From that point on, they were relentlessly hounded and driven until their resistance collapsed.

The story of General George Armstrong Custer's annihilation by an allied force under such men as Crazy Horse and Gall is too well known to need repeating. Less known is an earlier fight, which in some ways prefigured the one that killed him. He made the same basic mistakes at the battle of the Washita on November 27, 1868, that would prove fatal at the Little Big Horn: an arrogant overconfidence, poor intelligence-gathering, and a fateful division of his forces.

General Philip Sheridan—who later would suggest that every buffalo hunter be given a bronze medal with the image of a dead buffalo on one side and a discouraged Indian on the other—had ordered a winter campaign against the southern plains tribes, always most vulnerable in their winter encampments because their horses were thin, game scarce, food supplies tight. Destruction of their camps in midwinter would leave them helpless.

Black Kettle, a survivor of Colonel John M. Chivington's notorious Sand Creek massacre of peaceful Indians in 1864, was encamped with his people in a timber-protected bend of the Washita River near present-day Cheyenne, Oklahoma. Black Kettle, still a man of peace, had just been advised by the Indian agent that he should move his camp nearer the agency for safety because the troops were out looking for hostiles. He planned to start the following day.

Custer's Osage scouts located the snow-blanketed village, and his troops surrounded it in the frigid, dark hours before dawn. At daybreak a bugle sounded the charge, a band played the Seventh Cavalry's *Garryowen*, and seven hundred

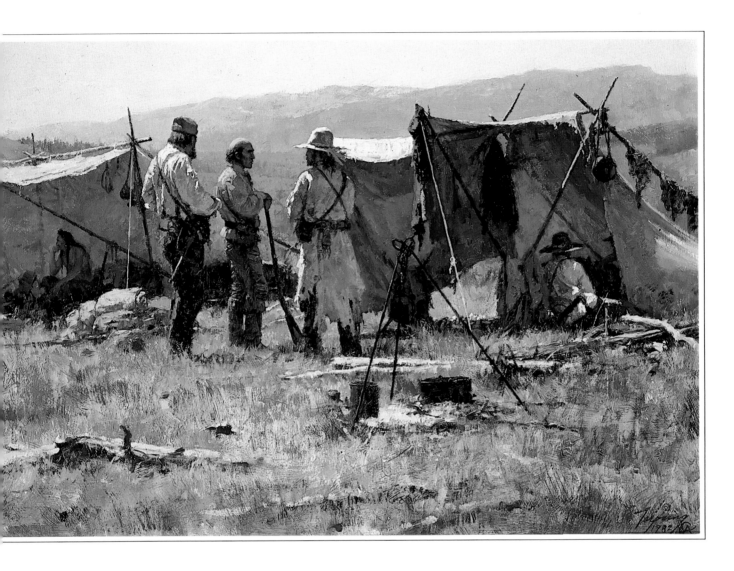

ARCHITECTURE OF THE PLAINS

Portability was a prime consideration in the time of the mountain men. If they could not conveniently pack it on their own backs or those of their horses, they did without. This Spartan little rendezvous camp of tents and crude lean-tos was probably more comfortable than it might look, and it could be moved quickly if a need arose. The men dry meat and cook up some stew while they exchange whatever news they may have. An Indian ally takes his ease in the tent at left. Friendly Indian guides could be a godsend, especially in unfamiliar country.

The first organized Rocky Mountain trading rendezvous for trappers was put together by William Ashley in 1825 at Henry's Fork on Green River. In 1830 William Sublette brought the first wagons to service a rendezvous, but the trip was so hard, he did not try again. Five years later Captain Benjamin Louis Eulalie de Bonneville proved that wagons could make the journey, carrying in more goods and hauling out more furs with fewer men and animals.

cavalrymen swept down upon a peaceful camp of fifty-one lodges. In minutes, more than a hundred Indians were killed, including many women and children. Among the dead were Black Kettle and his wife.

Custer had taken it for granted that Black Kettle's was the only village on the creek, just as he would later take it for granted that the encampment on the Little Big Horn was much smaller than his Crow and Arikara scouts tried to tell him it was. In fact, however, Little Raven's Arapahoes were encamped downstream from Black Kettle, and below him other Cheyennes, Kiowas, and Comanches. These quickly came running.

PLUNDER FROM SONORA

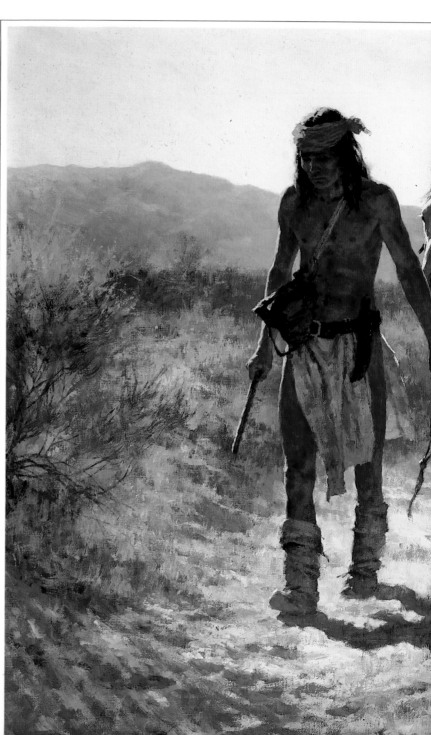

Native Americans did not allow national borders to hinder their movements, though those who lived along them learned to use them as a means of gaining sanctuary if they happened to be pursued by American, Canadian, or Mexican troops. Though the Apaches lived primarily in Arizona and New Mexico, they ranged easily into the Sierra Madre Mountains of Mexico and considered Sonora and Chihuahua their own province. To them, both Americans and Mexicans were foreign invaders deserving of no quarter, and as a general rule the Apaches offered none.

This painting depicts an Apache raiding party on its return from an excursion into Sonora, bringing home about as much loot as they could pack onto their horses.

Meanwhile, Custer had divided his forces. A detachment of seventeen men under Major Joel Elliott was cut off by the Indian reinforcements. Custer made no move to help the doomed men, being busy enough trying to defend himself. He was almost out of ammunition and facing a bleak outcome when a daring quartermaster dashed through Indian lines with his wagons and saved the day. Custer burned Black Kettle's village and killed some eight hundred Indian horses. Then he retreated to Camp Supply without even trying to determine the fate of Elliott and his men.

He seemed to learn little or nothing from his mistakes at the Little Washita. They were to kill him and some two hundred sixty-five of his troops eight years later. ■

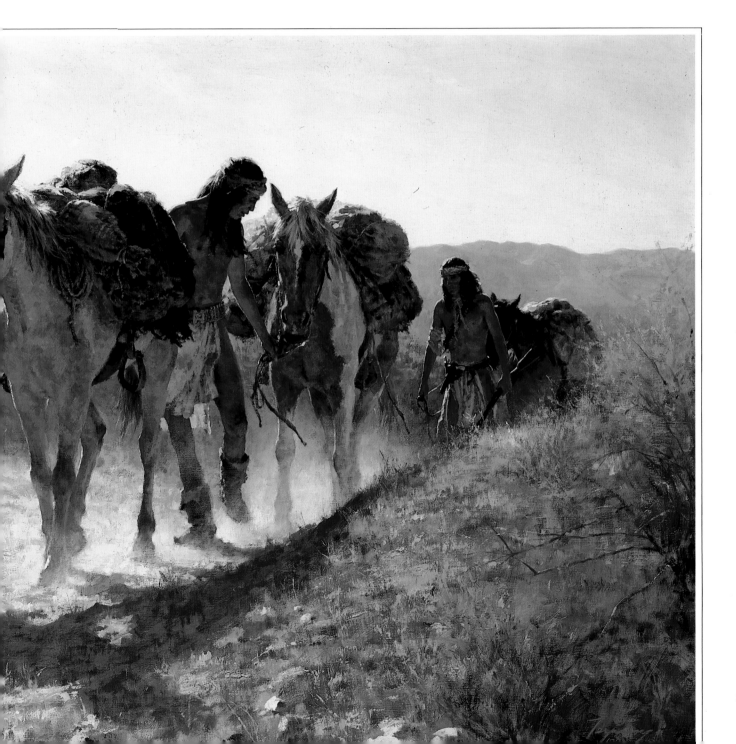

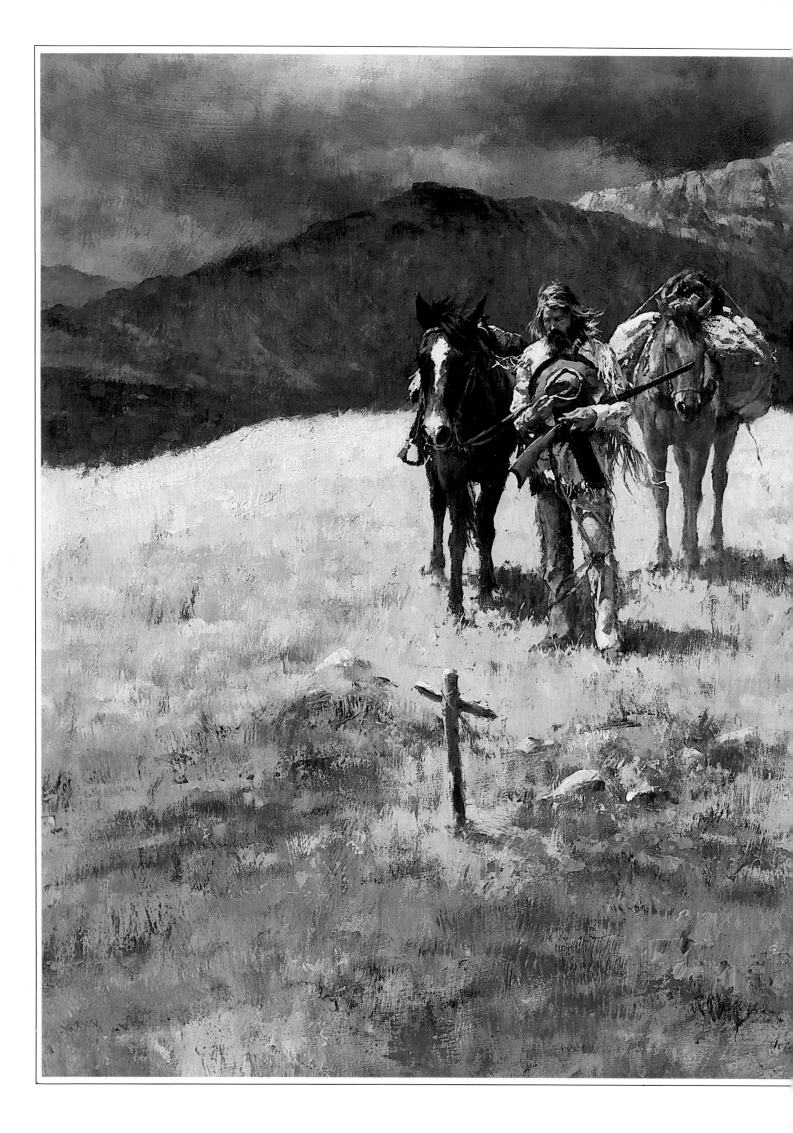

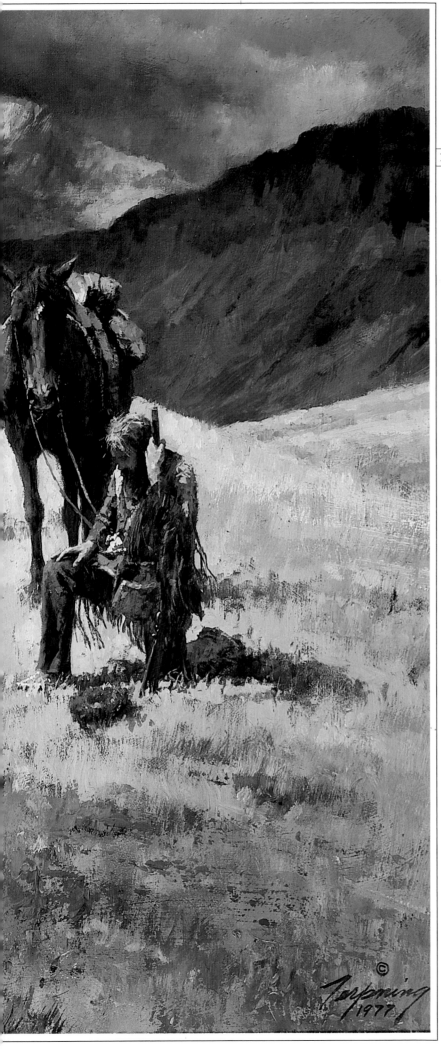

DISCOVERY OF A LOST FRIEND

Death could come swiftly and without warning to mountain men who dared ply their occupation in the midst of hostile country. At least the one who died here had friends who could bury him. Many were left where they fell, scalped and stripped of clothing and any other belongings they might have carried. To friends and family, they had simply disappeared in that vast and unknown land, their whereabouts known only to God. The mountain men as a group probably had the most dangerous occupation of anyone in their time, particularly in view of the meager amount of money their efforts usually earned. Many of them died with their moccasins on.

Howard Terpning says, "Partly because of sentiment, I suppose, this painting has gained broad acceptance. From an artistic view, this was one of those that just sort of fell into place."

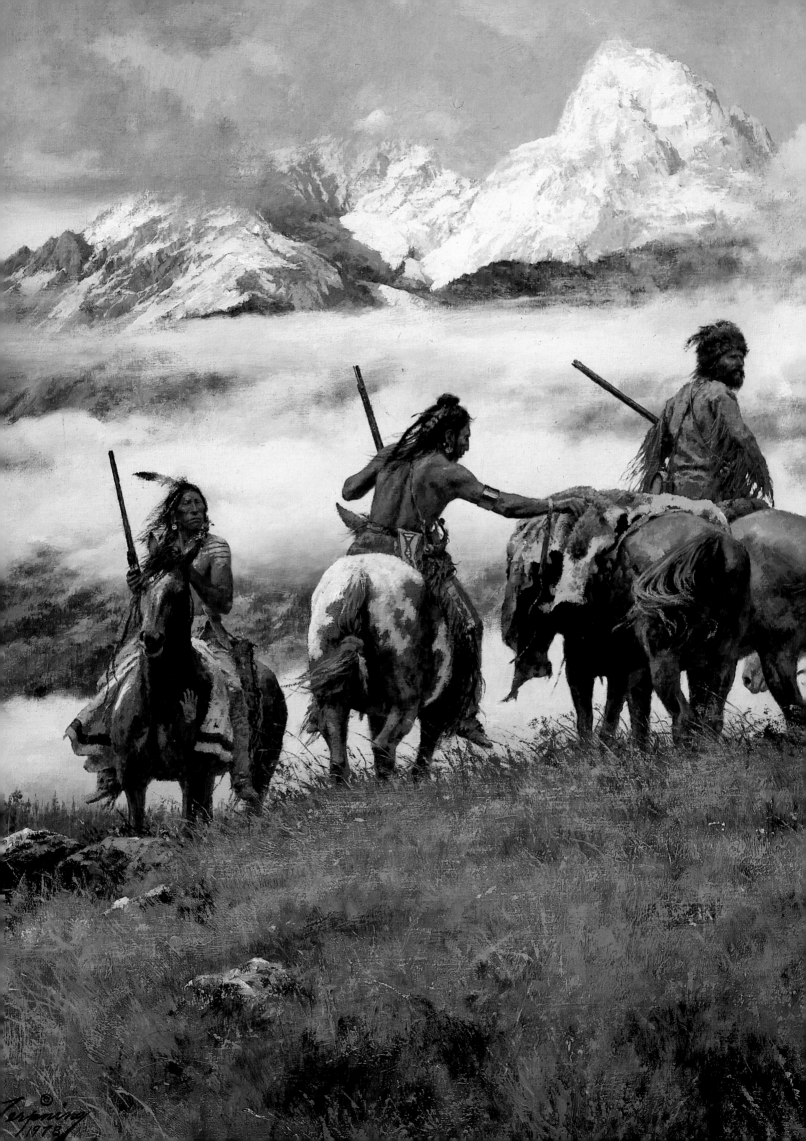

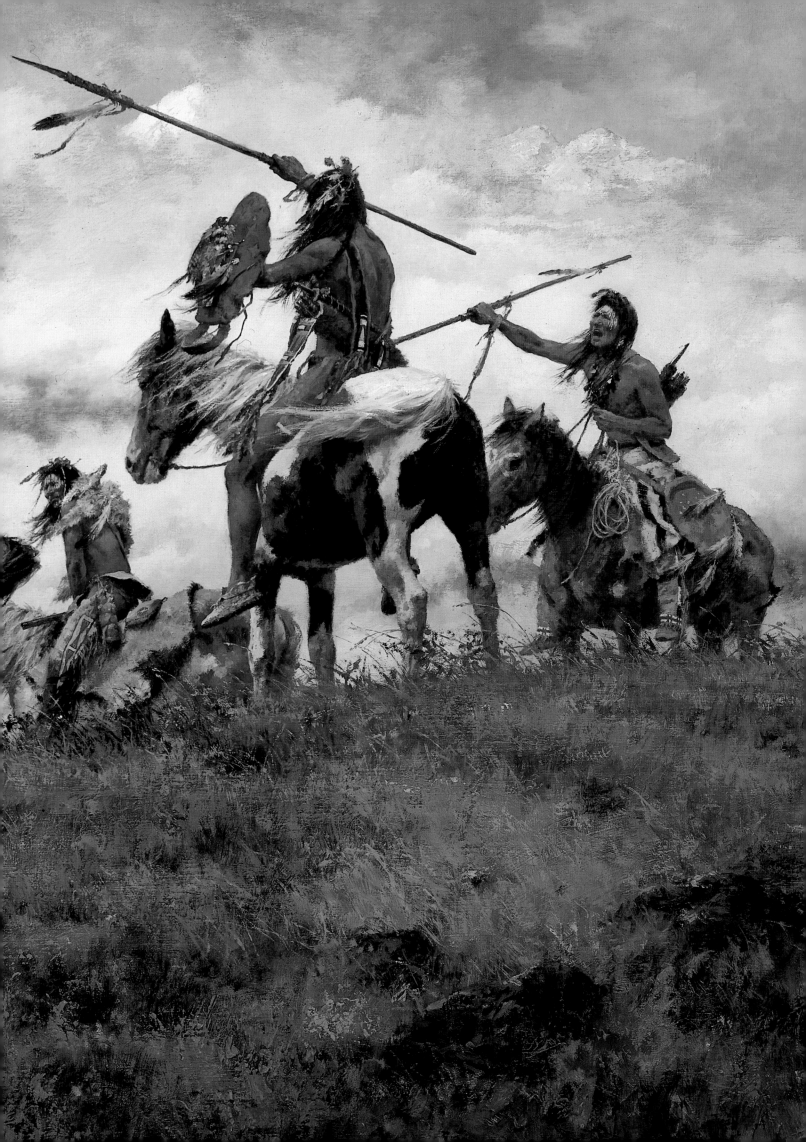

THE PLOY

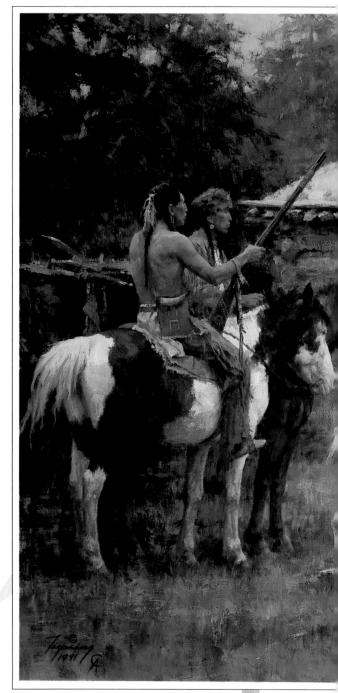

A mountain man finds himself in the midst of a group of Crow warriors, which was not necessarily dangerous because the Crows, for the most part, remained on fairly friendly terms with whites. When he gets to camp, however, he may find to his sorrow that he is missing something out of his pack. While some of the warriors divert his attention by yelling and gesturing, another is reaching in to see what he may find.

Despite their status as non-hostiles, the Crows saw nothing wrong with stealing whatever they could get their hands on, from camp goods to rifles to horses. They considered it their right to exact a toll inasmuch as the whites were invading what they regarded as their own rightful territory. Some Crows eventually became scouts for the U.S. Army against their enemy neighbors. Crow scouts warned Custer about the danger he faced at the Little Big Horn, but he chose not to heed them.

Generally speaking, Plains Indians did not look upon theft in the same light as their white adversaries, except when it was practiced against themselves. A man who could steal horses was honored. If he could steal them out of camp without the enemy's knowledge, the honor was even greater. Is-sa-keep, a Northern Comanche chief, boasted that his four sons were a glory to him in his old age because they could steal more horses than anyone else in their band.

Sioux Pipe Bag

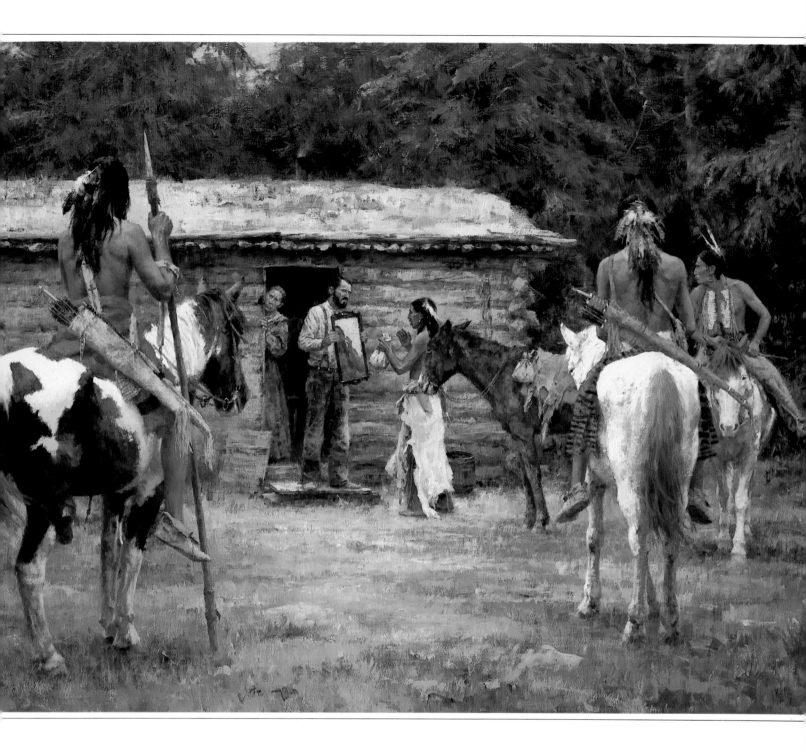

PEMICAN FOR A LOOKING GLASS

P lains Indians were intrigued by mirrors and the ability to see their own images clearly. Here Cheyennes negotiate a trade, a looking glass for a bag of pemican, the Indian's pounded mixture of meat, berries, nuts, and whatever else came to hand that was good to eat. Pemican would last indefinitely, much like jerky, and often proved handy on the trail or to help the people through a hard winter when other meat gave out and game was scarce.

It is clear that the settler and his wife feel a little intimidated, and it is a safe bet that the Indians will successfully make their trade. Sometimes the Indians were better off from the standpoint of food than the white settlers who first came among them. Many whites grew fond of pemican, just as they did of jerky.

111

SEARCH FOR THE PASS

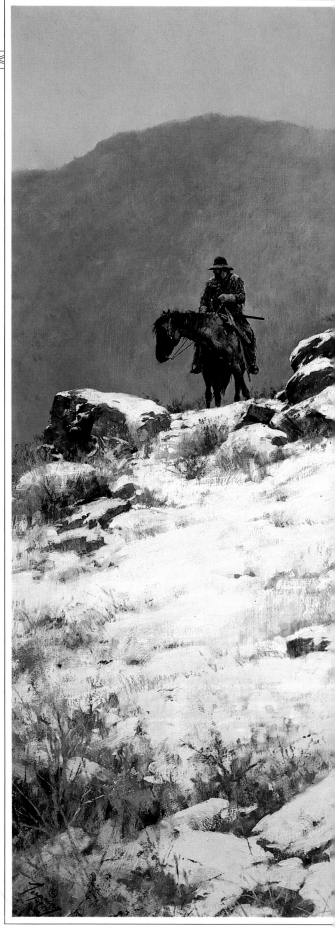

Early trappers and explorers moving across unknown mountain country dreaded the prospect of getting lost, particularly in winter snow, and finding themselves trapped by a deadly storm. Here, with the aid of Indian guides and a spyglass, such a party of mountain men seeks a pass which will take them across the mountains and down to what they hope will be a more benign environment on the other side.

Of this painting the artist explains: "I was hiking in the Rockies one afternoon when it began to snow. It wasn't very cold, and the flakes were large and wet, and they clung to everything and created the paradox of warmly colored vegetation protruding through the snow. Behind it all rose a mass of blue-gray mountains. The wind blew. The snowfall turned to sheets. Quite dramatic. It seemed to me an oddity of place and weather which mountain men might have encountered. With the help of a couple of Indians, they could look for a way out."

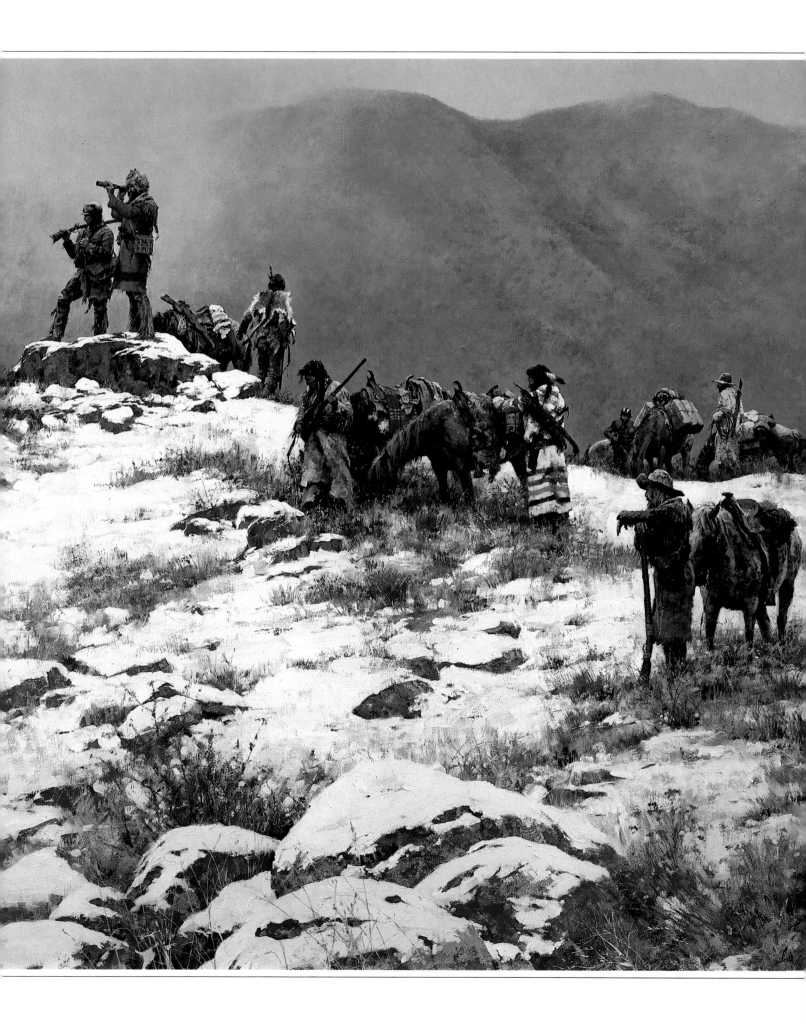

WHEN CARELESS SPELLED DISASTER

Two white trappers who have stopped to drink and wash themselves at the edge of the river have let down their guard and allowed themselves to be placed in extreme jeopardy by a large party of Blackfeet warriors. One grasps a rifle he had laid down on the rocks, but the other's rifle is in a sling attached to his saddle horn. He may not live the two strides it will take him to reach it. The lead warrior has his hand up in a sign of peace, but given the long history of hostility between American trappers and the Blackfeet, this may be only a ploy to allow him to get close enough for an accurate shot.

The figures are secondary to the huge and spectacular Rocky Mountain landscape. From an artistic viewpoint, they only help establish scale.

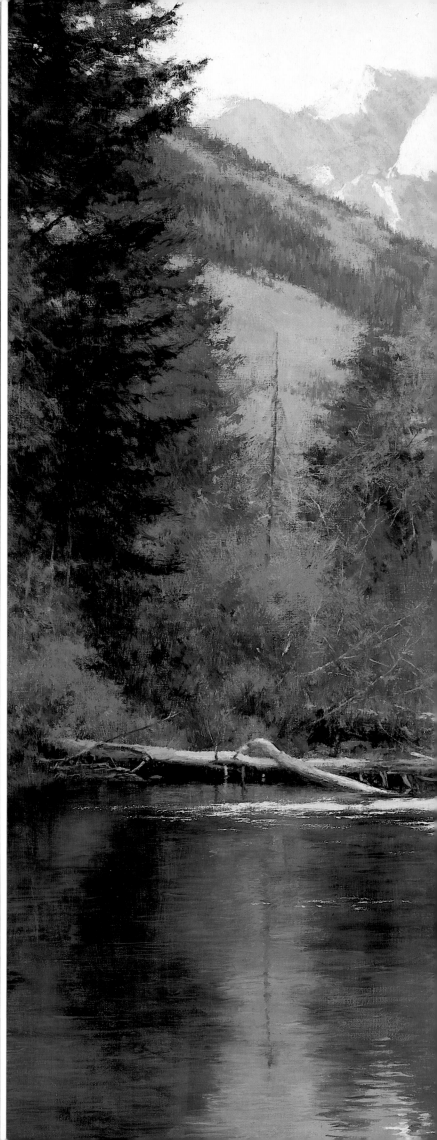

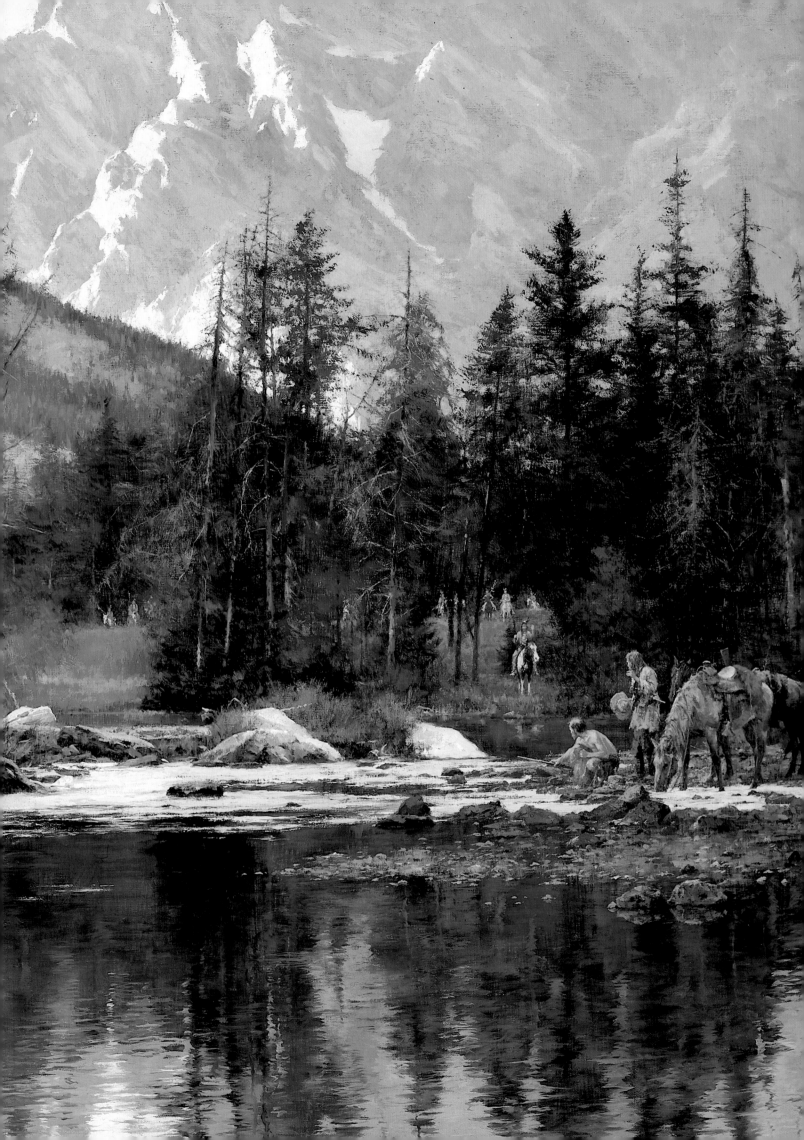

COOL, CLEAR WATER

N ot all the danger to early whites traversing Indian lands came from the Indians. In the southwest, especially, the land itself could be the most hostile enemy of all to those who came as strangers. Here a man carrying a gourd canteen has found a much-anticipated waterhole to be dry in the midst of a desert country.

Through generations of experience, the Indians knew the watering places in that broad, untracked region known on maps of the time as the Great American Desert. After a raid into white settlements, they could scatter and disappear safely in the vastness of the open plains while their pursuers were forced to turn back as water supplies ran out.

PROSPECTORS AMONG THE BLACKFEET

Blackfeet warriors find evidence of intrusion by white men: a prospector's gold pan and other debris carelessly left behind in a shallow stream. The Blackfeet were among the most implacable in their enmity toward white trespassers, first the beaver trappers and later the prospectors. For good reason they had only to look at their neighbors. Finding gold in the treaty-protected Black Hills led to the final crushing military campaigns against the Sioux and Cheyenne, and the defeat of Custer at the Little Big Horn.

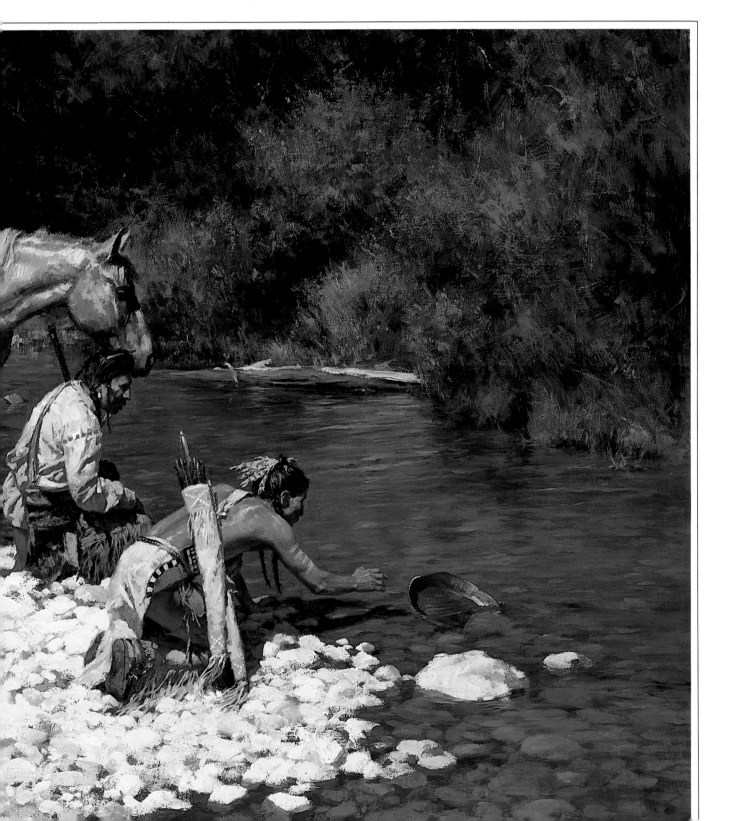

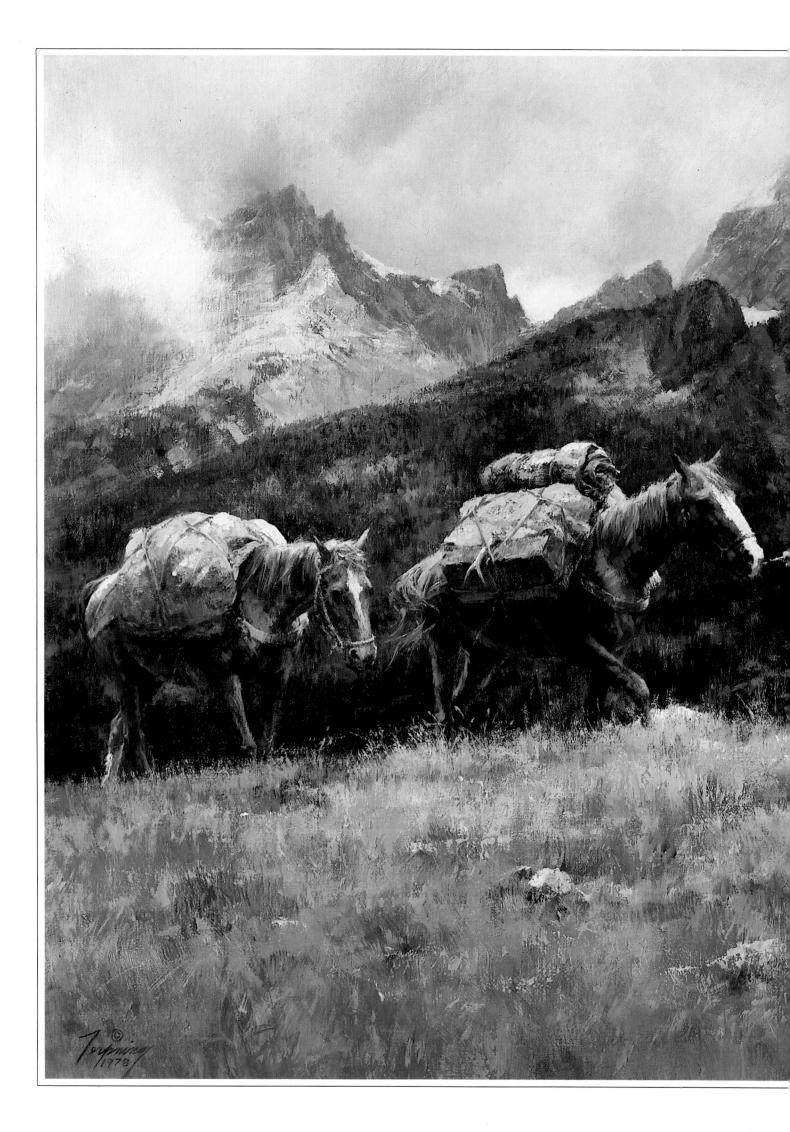

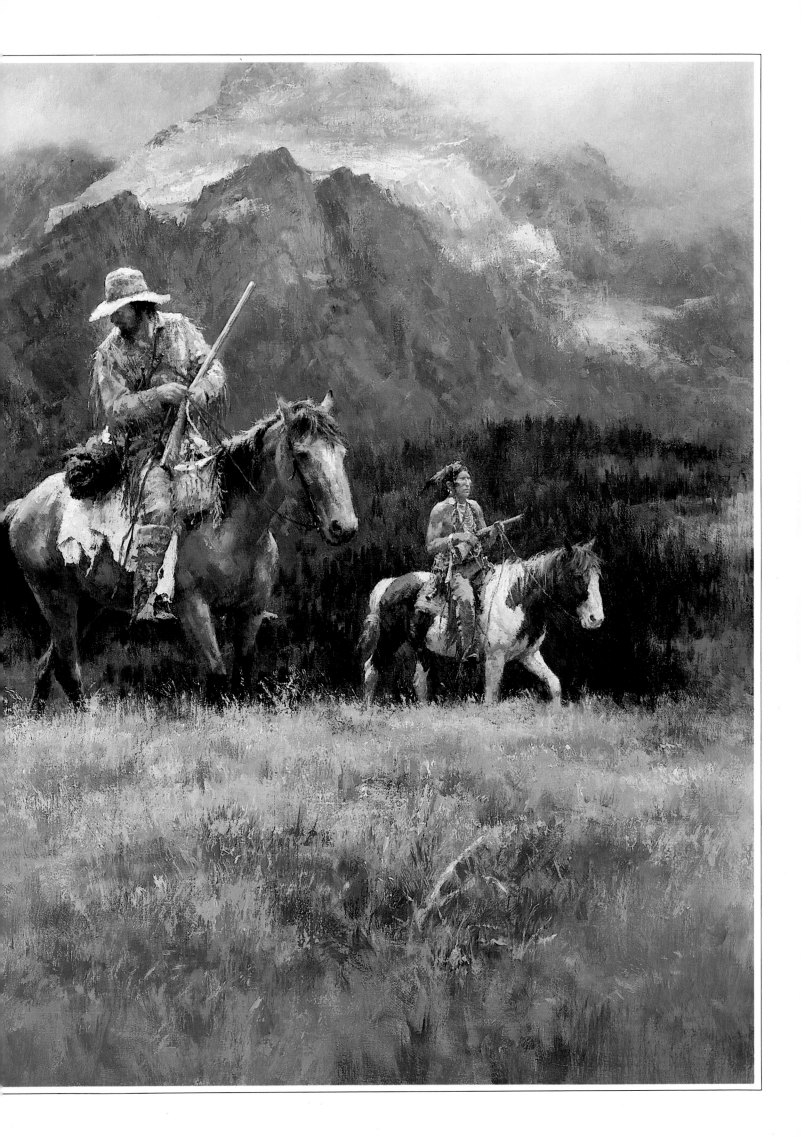

TRAVELING IN GOOD COMPANY

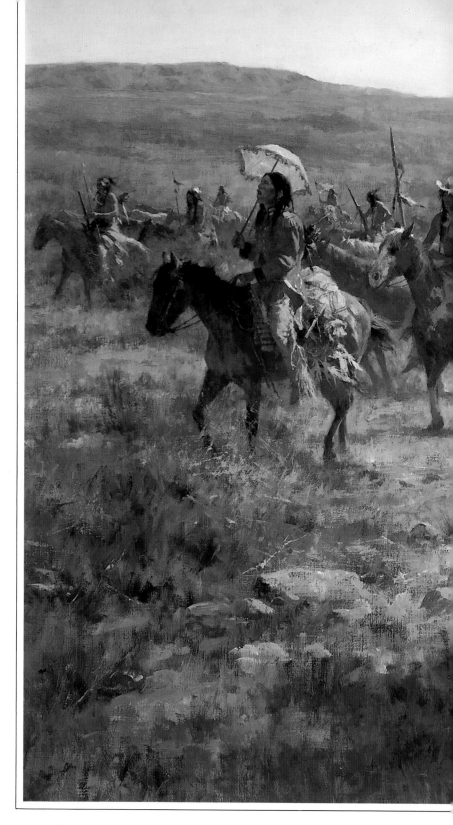

Early contacts between white men and the Plains Indians were usually friendly, or at least benign. The first newcomers were usually explorers, like Lewis and Clark, looking for trails, not trouble. They were soon followed by traders and trappers, the storied mountain men, who cut new trails of their own or mastered old trails established by the Indians. In the beginning, these bearded white men tended to establish alliances with various tribes. Some lifelong friendships were born. For furs and woman-tanned buffalo robes, they traded beads and mirrors, flint and steel, blankets, muskets, and powder. Many married Indian women, some out of genuine love, others for convenience and to solidify their position with their chosen tribes.

Strife arose as allegiances to one tribe automatically made them enemies of others, and as they began to hunt and trap on jealously guarded grounds. Some of it came out of competition between fur-trading companies, one agitating its allied Indians to war against the men who trapped for another.

This painting depicts two men of different races riding together as friends and partners in the cold light of the Rocky Mountain high country.

Kiowa Moccasins

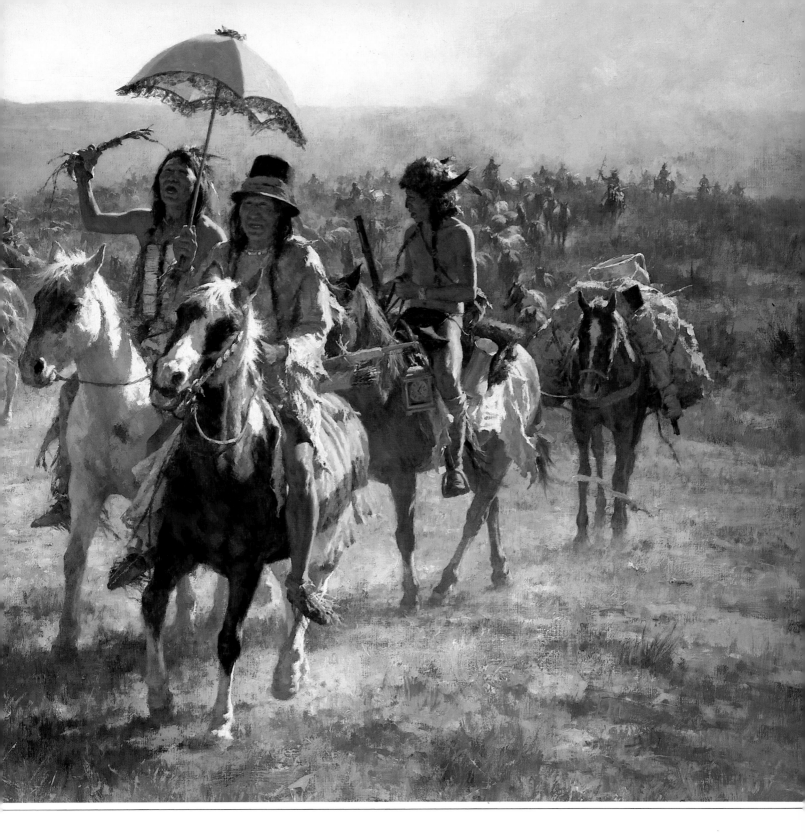

COMANCHE SPOILERS

In 1840 Comanche chief Buffalo Hump led a thousand of his people on a long raid all the way to the Texas Gulf Coast. After sacking the small port town of Linnville, the Indians began a festive retreat in a colorful display of ribbons, umbrellas, and bolts of cloth. Driving a vast herd of captured horses and mules, they also carried along several women and children prisoners. Their victory shattered into chaos at Plum Creek, near present-day Lockhart, where vengeful Texas volunteers routed them with heavy losses.

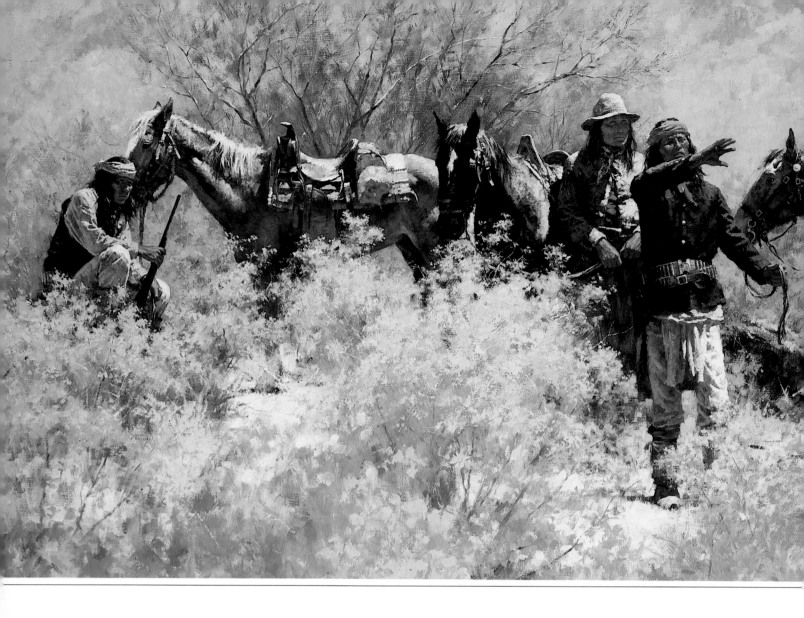

THE SCOUTS OF GENERAL CROOK

The Apaches were guerilla fighters of the highest order. Raiding parties were usually small, yet they ran the army ragged until at last General George Crook decided to set Apache against Apache by enlisting them as scouts. It proved to be an effective tactic. By and large, the scouts performed loyally and well, tracking down their renegade cousins as ordered under the leadership of such men as Al Sieber, Charles B. Gatewood, Emmet Crawford, and Tom Horn. It was these scouts' dogged service which allowed the army finally to harass Geronimo and his followers to their 1886 surrender in Mexico's Sierra Madres. In a classic bit of treachery, as Geronimo and his Chiricahua warriors were placed on a train for exile and imprisonment in Florida, General Nelson A. Miles ordered the Apache scouts then present to be shipped off with them. This was their reward for faithful service to the U.S. government.

One Apache scout made history of his own. Known as the Apache Kid, he became a sergeant under Sieber but turned outlaw after a shooting scrape. Captured and convicted, he escaped from the stagecoach that was carrying him to prison. He became a scourge not only to whites but to Apaches of what he considered enemy clans. He eventually disappeared, probably to die alone in the Sierra Madres.

THE SKEPTIC

This is one of Howard Terpning's splendid close-up character studies. He saw this face in a crowd and, from a distance, took some photographic studies as a guide to a future painting. This is a man who has been told too many lies, disappointed too many times, not an uncommon experience among native Americans.

He says, "The expression to me said so much about heartache and despair and hopelessness. I changed the pose around quite a bit for composition, but that is the genuine facial appearance of a human being who doesn't believe much in anything anymore."

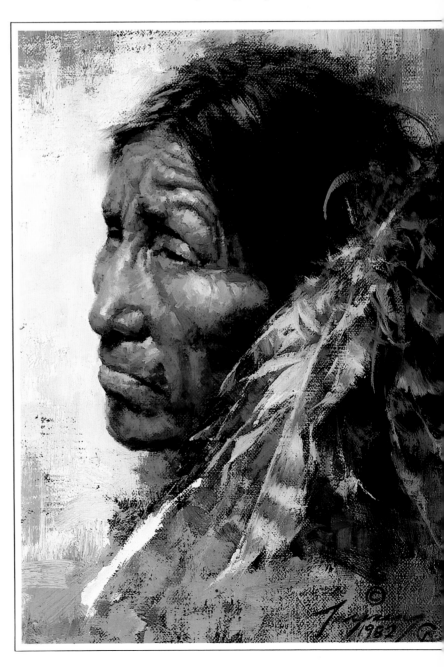

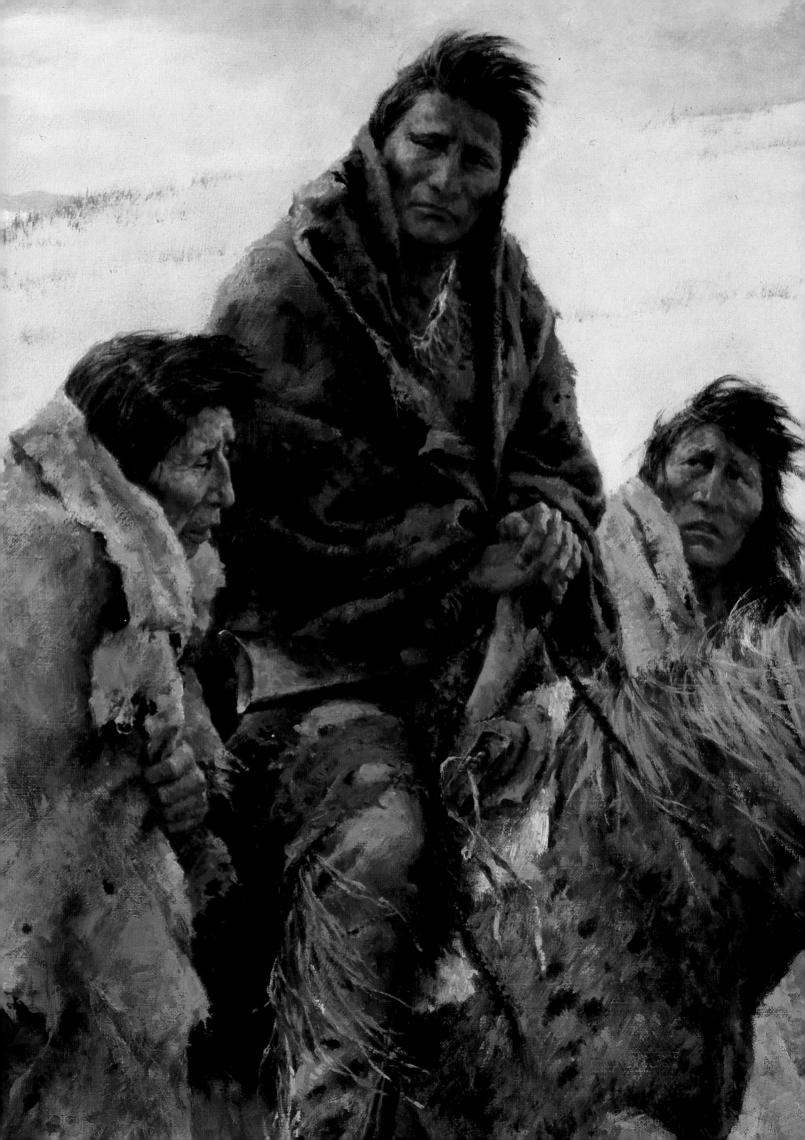

THE FADING
OF
FREEDOM

Comanche Buckskin Leggings

*"Our fathers gave us many laws, which they had learned from their fathers
. . . They told us to treat all men as they treated us; that we should never
be the first to break a bargain; that it was a sin to tell a lie; that it was a
shame for one man to take from another his wife, or his property without
paying for it."*

CHIEF JOSEPH, NEZ PERCÉ

For years, a great pile of bleaching horse bones in the Texas Panhandle marked the place where the Comanches and Kiowas, and to a lesser degree Cheyennes and other tribes, saw their free-roaming way of life draw to a sudden end on the southern plains. The year 1874 had been eventful, for the tribes had risen to arms against buffalo hunters who had spread out across the northern Texas Panhandle. The warriors' massive attempt to snuff out the trading post at Adobe Walls had been unsuccessful, but they had harassed individual hunter camps and—as the Indians expressed it—"rubbed out" a number of the interlopers.

Late that summer the army instituted a maneuver that in a much later war would be called a pincers movement, converging on the plains from several directions to trap the Indians between the many participating cavalry units. To Colonel Ranald Slidell Mackenzie fell the task of driving north from Fort Concho. He was a Civil War veteran, living with constant pain from an old wound that never healed. He was also an experienced Indian fighter who did not believe in spilling blood needlessly, even Indian blood.

In dawn's golden light on the morning of September 28, he looked down the steep wall of the Palo Duro Canyon upon an amazing sight his scouts had discovered the day before: an Indian winter encampment that stretched for some three miles along a small stream on the canyon floor. Sleeping there were Comanches, Kiowas, Cheyennes, and Arapahoes.

Mackenzie's men dismounted and quietly led their horses down a narrow zigzag game trail to the bottom. Three companies had completed the descent before they were spotted by a Kiowa camp chief named Red Warbonnet, who fired on them and set up an alarm. The cavalrymen thundered down the canyon, stampeding fourteen hundred Indian horses and mules ahead of them. Some warriors mounted a weak defense, but the surprise had been complete. Most of the camp went into a blind panic, flushing like quail down the canyon and up its steep walls. Not many warriors ever managed to get on horseback.

The fighting, what there was of it, was quickly over. Mackenzie ordered all tepees, food, and equipment burned so the Indians would have no way to sustain themselves through the coming winter.

Once before he had captured a huge horse herd, only to see the Indians win it back a few hours later. This time he took no chances. Mackenzie ordered the herd slaughtered after some of the best animals were sorted out for the soldiers and their Seminole-Negro Indian scouts. Sick at heart over the duty but seeing its necessity, the troopers shot more than a thousand horses and mules.

It was a loss from which the Indians never recovered. Without food or blankets, most had no choice but to start on foot eastward toward the reservation, soldiers giving them room but dogging their tracks all the way. Over the next several months, one band after another straggled into custody, hungry, cold, harried by soldiers until the heart went out of them. Quanah Parker and his Kwahadies, or Antelopes, were the last to go in.

A few small-party outbreaks occurred after that, but it could be said that the

warring Comanche nation died with its horses at the Palo Duro. Mackenzie accomplished this feat without one fatality among his troops, though a bugler was wounded. The number of Indian dead was never established but was astonishingly small for the sweeping nature of the defeat. The soldiers found but four.

Mackenzie lived and slid into obscurity. Custer died and became immortal.

Among the many tragic yet heroic stories to come out of the last days of the Plains Indian as a free man is that of the Nez Percé under Chief Joseph. Despite many provocations and betrayals of trust, the Nez Percé had managed to live in peace with the white man. Actually, there were two Josephs, father and son. The elder Joseph in 1855 signed a treaty that guaranteed his people their ancient home in the Wallowa Valley of Oregon. That treaty was abrogated in 1863 to open the lands for white settlement. Joseph and his people remained, defying orders to move. When he died in 1871, civil leadership went to his son, also known as Joseph, who continued his father's resistance to the loss of the Wallowa.

The pacifistic Joseph scrupulously avoided bloodshed and finally, in 1877, under extreme pressure, agreed to move his people to a new home on the Lapwai reservation in Idaho. As the Nez Percé prepared to go, whites stole several hundred of their horses. This indignity, on top of losing their traditional home, once guaranteed to them by treaty, was too much for some of the young men. Angrily they launched a retaliatory raid that killed at least fourteen white settlers, including women and children.

Knowing the army would come to administer punishment, Joseph set out to lead his people to safety. It was a long, tortuous, zigzag trip for both the Nez Percé and their military pursuers. Time and again during a four-month flight over some seventeen hundred miles, the seven hundred or so men, women, and children broke through or went around the army, fighting more than a dozen battles against heavy odds. Joseph, never considered a war chief, persuaded the men that no scalping be done, and he took pains to avoid harming innocent settlers, certainly a departure in Indian warfare.

Finally, only thirty miles from the Canadian border and potential sanctuary, the beleaguered and diminishing Nez Percé, hungry, cold, and sick, were forced to give up. Many of their best fighting men, as well as women and children, lay dead along the back trail. Among those killed at the last was Joseph's brother Ollikut, who had led the warriors in many of the battles.

An army lieutenant named Charles Erskine Scott Wood described the end, as on October 5, 1877 the weary Joseph came to surrender to Generals Nelson A. Miles and O. O. Howard:

"Joseph came up to the crest of the hill, upon which stood Gen. Howard, Gen. Miles, an interpreter and myself. Joseph was the only one mounted, but five of his principal men clung about his knees and pressed close to the horse, looking up at him, and talking earnestly in low tones. Joseph rode with bowed head, listening attentively, apparently, but with perfectly immobile face. As he approached the spot where we were standing, he said something, and the five men who were with him

halted. Joseph rode forward alone, leaped from his horse, and, leaving it standing, strode toward us. He opened the blanket which was wrapped around him, and handed his rifle to Gen. Howard, who motioned him to deliver it to Gen. Miles, which Joseph did. Standing back, he folded his blanket again across his chest, leaving one arm free, somewhat in the manner of a Roman senator with his toga."

Joseph delivered his famous surrender speech, which has been recorded in several versions. The most commonly quoted is this: "Tell General Howard I know his heart. What he told me before I have in my heart. Our chiefs are killed. Looking Glass is dead. Too-hul-hul-sote is dead. The old men are all killed. It is the young men who say yes or no. He who led the young men is dead. It is cold and we have no blankets. The little children are freezing to death. My people, some of them, have run away to the hills and have no blankets, no food; no one knows where they are—perhaps freezing to death. I want time to look for my children and see how many of them I can find. Maybe I shall find them among the dead. Hear me, my chiefs, I am tired; my heart is sick and sad. From where the Sun now stands, I will fight no more forever."

Wood concluded: "And he drew his blanket across his face, in the manner of Indians when mourning or humiliated, and instead of walking towards his own camp, walked directly into ours, as a prisoner."

Joseph and most of his people were initially sent to Kansas, then to Indian Territory, about as different from their homeland as could be imagined. Many who had survived the long, bloody march succumbed to illness. But back east the story of Joseph and his people had won a great deal of public sympathy and public

LEGEND OF GERONIMO

Geronimo, among the last of the Indian holdouts, was one of the most famous of American Indians. A medicine man rather than an actual chief, he became a leader of the southern Chiricahuas in the last years of the Indian wars. His Apache name was Goyakla, meaning "One Who Yawns." The rest of the world knew him by the Spanish equivalent of Jerome. His enmity toward Mexicans came out of the 1858 massacre of his mother, wife, and children by Mexican troops in Chihuahua. He later extended this hatred toward Americans.

He was captured only once, by Indian agent John Clum in 1877. After later breakouts he surrendered twice, once to General George Crook in 1884 and again to General Nelson A. Miles in 1886. Clapped into irons, he was shipped to exile and imprisonment in Florida along with some of his followers.

Geronimo spent his final years at Fort Sill, Oklahoma, where he posed for pictures and did a little reluctant farming. One famous photo, bridging the gap between the frontier and the twentieth century, shows him sitting in an early automobile. He died in 1909, still essentially a prisoner.

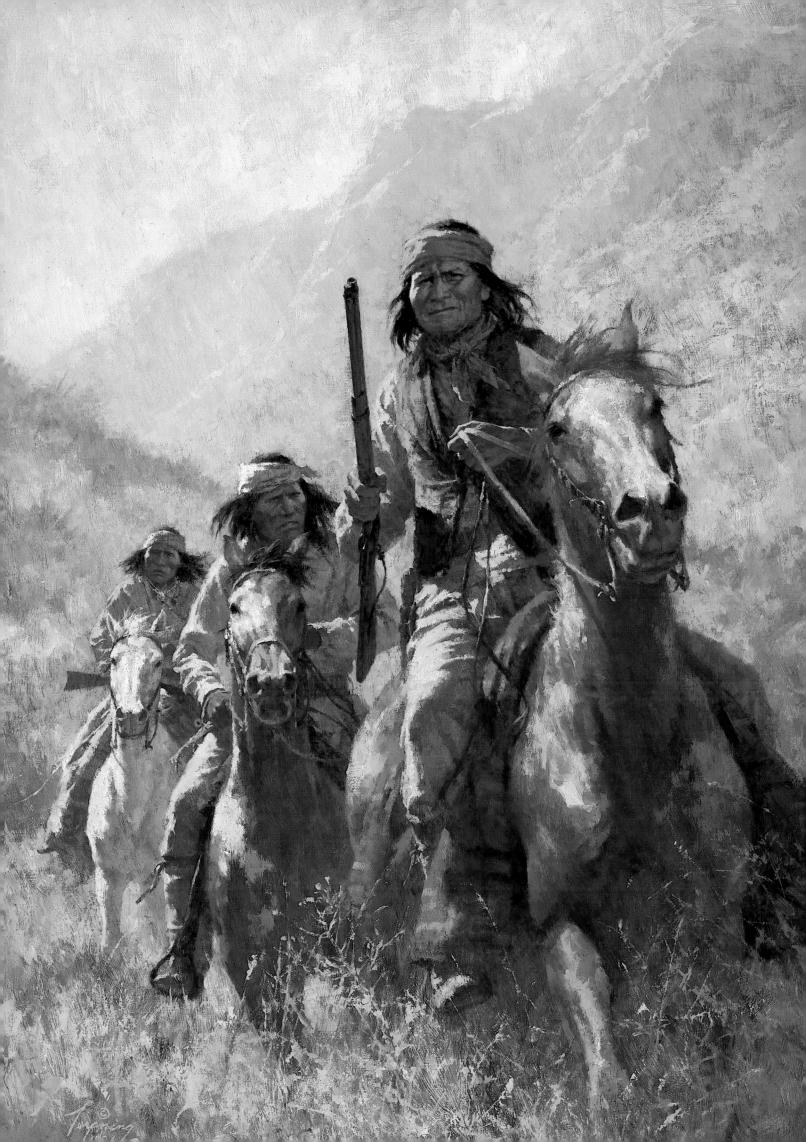

demand for justice. In 1885 the government finally relented and allowed the survivors—only two hundred sixty-eight out of the original seven hundred—to return to the northwest.

Fewer than half went to the Lapwai reservation. The rest, including Joseph, were sent to Washington Territory. He lived to 1904, still grieving over what had happened to his people and longing in vain to see once more his old home in the Wallowa Valley.

Wood, who had become intensely partisan on Joseph's side, added with bitterness: "I think that, in his long career, Joseph cannot accuse the Government of the United States of one single act of justice."

Another famous but ill-starred breakout was that of the Northern Cheyennes under Dull Knife and Little Wolf. Sent in 1877 to a reservation near Fort Reno in Indian Territory, west of present-day Oklahoma City, and far south of their original home, they found the promised rations sporadic and poor, the climate deadly to a people used to the high plains. Early in September 1878, the two chiefs led some three hundred thirty-five of their people out of the reservation, breaking northward for their homeland. Only eighty-nine were men, the rest women and children.

A great alarm went up, and as many as thirteen thousand army troops became involved at one stage or another in trying to stop the Cheyennes as they moved out of Indian Territory, across Kansas and into Nebraska. Several times, the Indians fought and won skirmishes with the soldiers. Other times, they simply managed to slip past them undetected.

North of the Platte River, they split. Little Wolf knew the sandhills and took his people there to winter on antelope and other game. Dull Knife and his band continued northward to the Little Missouri. There the army surrounded the weary Cheyennes and escorted them to Fort Robinson.

They were told they would have to return to Fort Reno, which they regarded as a death sentence. Dull Knife and his band went on a hunger strike, then in desperation broke out of their freezing wooden barracks on the night of January 9, 1879, trying to escape in the snow. The soldiers opened fire, killing sixty-four outright—men, women, and children—recapturing sixty-eight. Some who escaped died later of wounds or freezing.

Dull Knife and a remnant including some of his family succeeded in getting away to the Pine River agency. After a time the pitiably small group of survivors was allowed to go north to the Tongue River reservation, in a land they knew well.

Little Wolf's people, more fortunate than Dull Knife's, wintered in the sandhills. Found by the soldiers in March, they were eventually allowed to go home . . . the only thing they had wanted in the first place.

After the Plains Indians were subdued, many Apaches remained defiant, some never submitting to the reservation, others coming and going from the reservations almost at will. Implacable enemies of the Spanish and the Mexicans,

they tried friendship with the Americans who took over after the Mexican War. The effort did not last long. Cochise and an old war leader named Mangas Coloradas became embittered by American injustices and opened up years of bloody resistance. An army attempt at extermination in the 1860s and the 1871 Camp Grant massacre of near a hundred peaceful Arivaipa Apaches—mostly women and children—by Anglos, Mexicans, and Papago Indians made the Apaches even more intractable.

The Apaches' weakest point was that they were scattered over three states and Mexico and divided into several individualistic bands, some violently opposed to one another. General George Crook took advantage of these enmities. Correctly theorizing that it took an Apache to catch an Apache, he organized units of Indian scouts.

It was not a new idea. The Republic of Texas had used Tonkawa and Lipan Apache scouts to hunt down Comanches in the 1830s and 1840s. Major Frank North used Pawnee scouts in the 1860s against Cheyennes and other hostiles. The army used Seminole-Negro and Tonkawa scouts on the Texas plains to subdue Comanches. General Custer used Crow and Arikara scouts against the Sioux and Cheyennes.

With the help of Apache scouts, Crook managed to round up the hostiles and place them on reservations. But dissatisfaction with reservation life, particularly over the sidetracking of promised rations and supplies by grafting agents and suppliers, led to a number of desperate breakouts, particularly by the Chiricahuas. Men like Victorio, Nana, and Ulzana led bloody reprisal raids, which resulted in the murders of many innocent settlers and travelers who had nothing directly to do with the reservation problems.

Most famous of Apache leaders was Geronimo, described by one observer this way: "Crueller features were never cut. The nose was broad and heavy, the forehead low and wrinkled, the chin full and strong, the eyes like two bits of obsidian with a light behind them. The mouth was a most noticeable feature—a sharp, straight, thin-lipped gash of generous length and without one softening curve."

Resisting an order to go to the San Carlos reservation in 1876, he remained in Mexico with his followers. Slipping in to the Warm Springs reservation to visit relatives the next year, he was captured by Indian agent John Clum and sent to San Carlos. He escaped in 1878 and was never to be captured again, though he surrendered twice to army officers in Mexico. The last time was to Crook's successor, General Nelson A. Miles, who shipped Geronimo and some five hundred others to imprisonment in Florida. With them, as a hateful gesture of his contempt, he exiled Crook's Apache scouts, whom he had never liked or trusted.

It could be argued with some validity that the buffalo hunter did more to end the Indian's free-roaming way of life than even the military. Within an amazingly short time, hardly more than a dozen years, the uncountable millions of buffalo which had grazed the plains were reduced to a pitiable few, and the Indian at last was forced to dependency upon a government that promised far more than it delivered.

The trade in Indian-processed buffalo robes had already caused some decline in the number of bison on the plains, but it was nothing like the slaughter that began

after 1870, when tanners discovered they could process the raw flint hides into usable leather. By 1872, buffalo hunters were spread like ants across the middle plains, along the Union Pacific Railroad. By summer of 1873, they had decimated the great herds along the Republican and Arkansas rivers and began looking south toward the Texas herd.

Daring hunters crossed the Cimarron River that fall and winter and by the time of the spring migration were keeping their rifles hot far down into the Texas Panhandle. Hunting slowed for a time after the Indian scare raised by the Adobe Walls battle in June 1874. After September, however, Mackenzie's raid on the Palo Duro Canyon encampment had neutralized most of the hostiles, and the slaughter resumed. Within four years, Texas had hardly a buffalo left.

The final hunt moved northwestward, into the Dakotas and Montana. By 1884, it was over. The buffalo was gone, and with him any real hope that the Indians might somehow regain their old way of life.

The Crow chief Plenty-Coups expressed the Indian's grief over the annihilation of the buffalo: "When the buffalo went away we became a changed people. . . . Idleness that was never with us in buffalo days has stolen much from both our minds and bodies The buffalo was everything to us. . . . When it went away, the hearts of my people fell to the ground, and they could not lift them up again."

The final sad postscript for the free Plains Indian began with a vision by a Nevada Paiute medicine man named Wavoka during an 1889 eclipse of the sun. Indian life had always relied heavily upon visions. Wavoka said an Indian messiah was coming to resurrect all the Indians who had died and to bring back the buffalo. The white people would disappear, and Indian life would revert to its old ways. In his vision he was instructed in a ceremonial dance which would help bring about this new dawn for an old culture.

Indians in the far west gave the vision little credence, but excitement swept quickly through the disheartened Plains Indians. By this time they had been shunted off to a life of hunger and deprivation on crowded reservations and had seen promise after promise broken while white Indian agents and traders grew fat.

The ghost dance movement—so-called because of the expected resurrection of the dead—was particularly strong among the Sioux, who made and wore ghost shirts supposed to hold them immune to the white man's bullets.

The dance and the new fever among the Indians alarmed government officials, for they saw in it the seeds of potentially violent new Indian uprisings. Ironically, Wavoka's teachings called for peace with the whites, who would disappear without the Indians having to shed their blood.

Sitting Bull was among the first victims. Though in reality he had been cool to the ghost dance movement, he was blamed for fomenting it among the Sioux. At the Standing Rock reservation on December 15, 1890, Indian police attempted to arrest him. When the melee was over, the old chief and thirteen others lay dead.

The worst slaughter followed thirteen days later, at a place called Wounded Knee. There soldiers, including some from Custer's old Seventh Cavalry, set out to

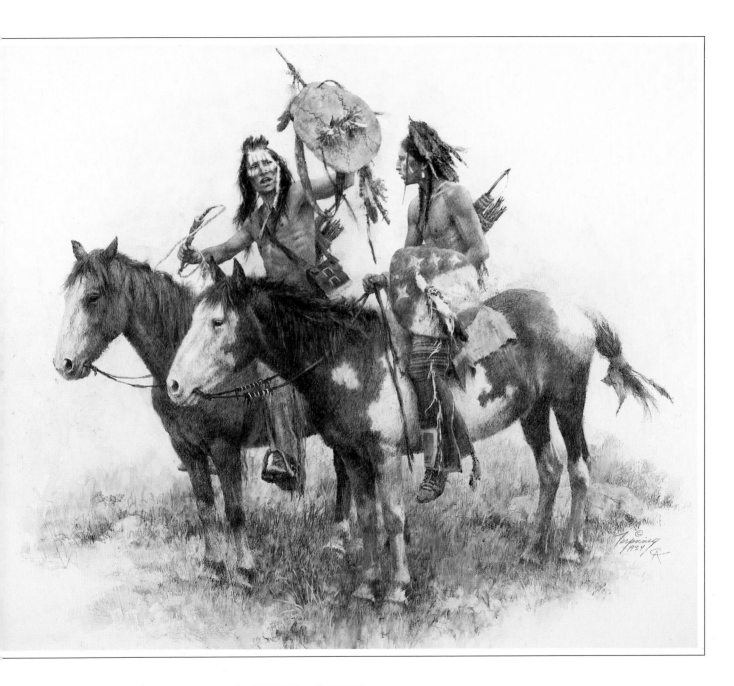

RECOUNTING THE COUP

⧉⧉⧉⧉⧉⧉⧉⧉⧉⧉⧉⧉⧉⧉⧉⧉⧉⧉⧉⧉⧉⧉⧉⧉

Frerench-Canadians began use of the word "coup" to describe the Indians' method for keeping score of a warrior's daring deeds. The more coups struck against enemies, the higher the honor. The greater the danger involved, the greater the coup. To touch a fallen enemy with one's hand, bow, rifle, or coup stick, especially if that enemy was still alive and able to fight, was the greatest feat of all. Stealing into an enemy camp at night and taking horses staked beside a warrior's tepee required special courage and earned exceptional prestige.

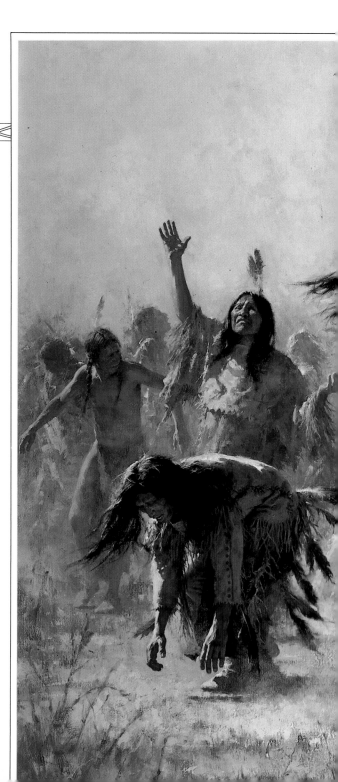

disarm Big Feet's Sioux, who had run from the reservation after Sitting Bull's death. Who fired the first shot has remained controversial, but the army—still seeking revenge for Custer—quickly opened up with rifles and Hotchkiss guns. As the shooting died away, twenty-five soldiers and more than a hundred and fifty Indians lay dead, their bodies quickly freezing in the snow.

A civilian worker, hired to help bury the Indians in a long trench, said: "It was a thing to melt the heart of a man, if it was of stone, to see those little children, with their bodies shot to pieces, thrown naked into the pit."

HOPE SPRINGS ETERNAL— THE GHOST DANCE

The Ghost Dance was the last desperate hope of the Plains Indians to regain the old way of life the white man had wrested from them. It arose from a vision by a Paiute medicine man named Wavoka, who in 1889 was in a high fever at the time of a major eclipse of the sun. He said that in his vision he was carried to the afterworld, where all those who had died were living a happy life.

The movement spread like wildfire. Tribes as widely dispersed as the Sioux, Cheyenne, Comanche, Shoshone, and Arapaho began dancing and chanting to make the white man go away and the great buffalo herds return. In the painting, Arapaho figures wear buckskin garments with long, flowing fringes, ghost shirts supposed to be impervious to bullets. They cast dust into the wind to signify the burial of the whites beneath the earth.

The movement greatly alarmed the authorities. Trouble came to a head on December 29, 1890. The Seventh Cavalry, still keen upon vengeance for Custer, massacred almost a hundred and fifty men, women, and children at Wounded Knee Creek, losing twenty-five of their own.

It was the last bitter gasp of life for the freedom-minded Plains Indian, the last hope for retaining any real vestige of the old ways. It was a forlorn hope, for the land had been wrested from him except for the reservations, usually in areas the white man did not covet. The buffalo around which his life had revolved was but a memory, a ghost from out of the past, to be seen only in visions and dreams. The wild, free-roaming horse·Indian himself had become but a ghost.

Though the general sentiment of the time favored "taming" the Indian and replacing him with what was considered a superior society, not all white men felt that way.

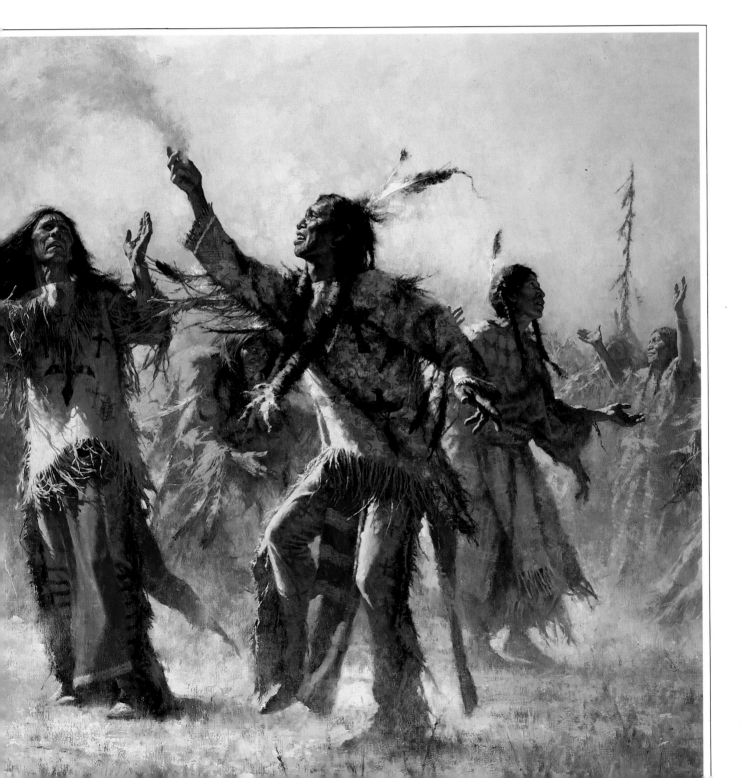

James Willard Schultz, who spent much time among the Blackfeet, wrote in the last days of the buffalo: "There are those of us, idle dreamers, who would that it might be otherwise. But it may not be. The weaker organism must give way to the stronger, the lower to the higher intellect. Before the bullets and far deadlier firewater of the whites, these simple men have been swept away like leaves before a wind. 'But they were only Indians,' say some. True: yet they were human beings, they loved their wild, free life as well as we love our life; they had pleasures and sorrows as well as we."

Big Eagle, a Santee Sioux, described a reason for the Santee uprising of 1862 in Minnesota: "The whites were always trying to make the Indians give up their life and live like white men—go farming, work hard and do as they did—and the Indians did not know how to do that, and did not want to anyway. It seemed too sudden to make a change. If the Indians had tried to make the whites live like them, the whites would have resisted, and it was the same way with many Indians."

Luther Standing Bear, a Sioux, wrote bitterly in 1931: "It is this loss of faith that has left a void in Indian life—a void that civilization cannot fill. The old life was attuned to nature's rhythm—bound in mystical ties to the sun, moon and stars; to the waving grasses, flowing streams and whispering winds. It is not a question (as so many white writers like to state it) of the white man 'bringing the Indian up to his plane of thought and action.' It is rather a case where the white man had better grasp some of the Indian's spiritual strength. I protest against calling my people savages. . . . The white race today is but half civilized and unable to order his life into ways of peace and righteousness."

In the light of history, could things have turned out differently? Perhaps, and perhaps not. The differences between the European view and those of the Indians were basic, in many ways hopelessly incompatible without drastic change being forced upon one or the other. This is not to say that either view was patently right or wrong, but that the two were diametrically opposite and could not survive side by side.

The nomadic Indian never understood the white man's concept of individual land ownership, the idea of each owning a specific piece of ground, building on it and remaining there always. Conversely, the white man saw no justice in a few thousand Indians—there may have been no more than a hundred thousand altogether on the entire plains—claiming areas larger than some eastern states, wandering at will, never putting down permanent roots, never trying to "tame" nature.

One more basic incompatibility would have remained, even if the other difficulties could have been compromised. To the Plains Indian, raiding and warfare were a natural part of life. Raiding parties often set out on the war trail as if it were a sport, much as the white man might go on a deer hunt.

The Indian's view of war as sport became one of his great weaknesses when he applied it against the white man. Many times he had a fight almost won, then decided to pull away and go celebrate his victory, leaving some sport for another day. Often all he wanted was to hit and run, grab some horses, count his coup, or draw a little blood, not to fight a full-blown battle.

He was a rugged individualist, never understanding the discipline of the organized army against which he so often fought, never understanding the white man's dogged way of pushing a fight through to its bitter end, hoping to settle matters once and for all.

Among the Indian's other weaknesses was the interminable intertribal warfare that continued even when the white man had driven him against the wall. Too many hated each other more than they hated the white man and even worked with the white man against hereditary enemies. They seemed not to realize that when their enemy was defeated, they would be next.

Had they been able early to conceive of themselves as one people and forge a chain of strong alliances all across the west, their history might have been different. They might not have stopped the white man's expansion, but they might have forced more favorable terms and avoided the miserable defeat which befell them one by one.

As it was, the Indian went into long generations of dead-end reservation life as a ward of the state, dependent upon the white man for the food he fed his children, the clothes he wore.

His existence had been heavily involved with mysticism, and now all the protective spirits in which he believed had failed him—or in his mind perhaps he had failed *them*—leaving his life in shambles. His religion was branded as false, and he was told he must embrace new deities alien to him. His children were forced to cut the long hair that had been a source of Indian pride, punished for speaking the old languages in school, admonished to renounce the legends and beliefs of their fathers and grandfathers.

Told they should become tillers of the soil and earn their daily bread by the sweat of their brows, many old warriors sternly resisted. They endured hunger and poverty rather than go against their traditions and scratch the face of their mother the Earth. Those who tried usually found that the poor reservation land was ill-suited for growing crops. Had it not been, they would not have been given it in the first place.

It was little wonder that hopelessness and despair, disease and alcoholism became so prevalent on the dismal reservations to which these once-independent people were shunted. They had been dispossessed. Their whole way of life, their sacred beliefs had been shot out from under them.

Today, though many desperate problems remain, a strong resurgence of Indian pride is being felt across the reservations, in the towns and cities to which great numbers of Indians of all tribes and faiths have gone to follow the white man's road. They are taking new stock of their Indianness, trying to preserve what they can of the old cultures that will meet the challenges of a modern world.

At a time when much of humanity seems to have lost its way and searches for guidance, for faith, some are finding new insights in old teachings once despised, forcibly suppressed. And, white as well as Indian, they are coming to take new pride in the courage of a martyred people who fought against impossible odds to preserve what they knew in their hearts was their birthright. ■

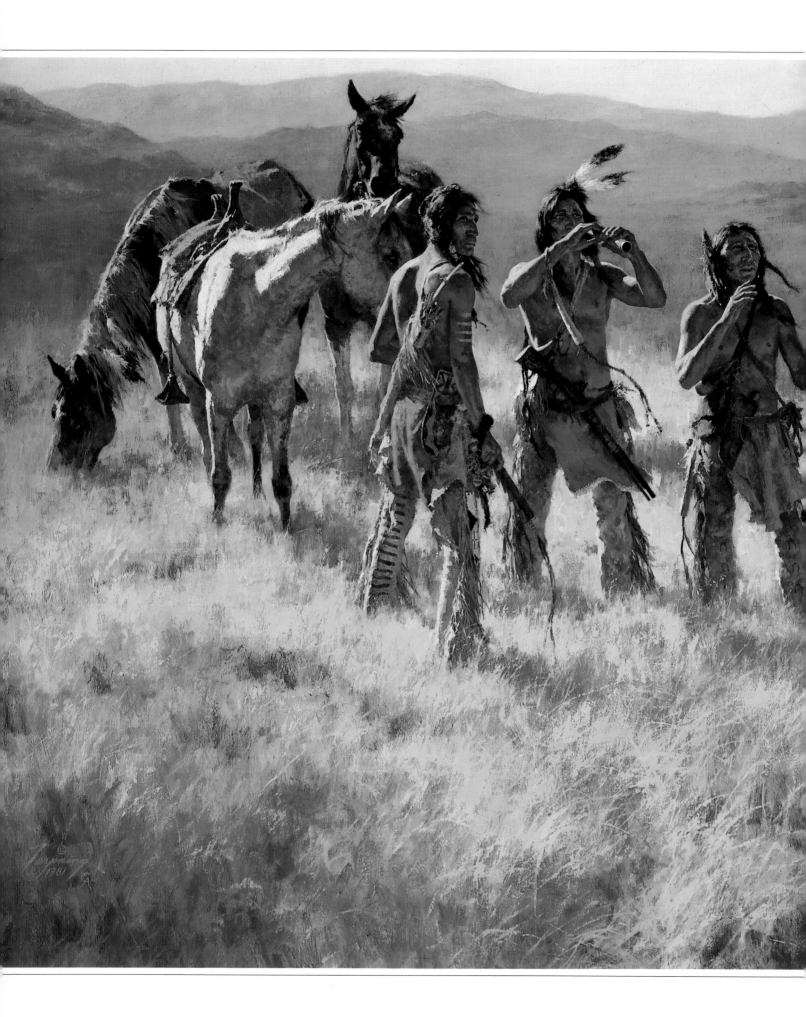

DUST OF MANY PONY SOLDIERS

Although this painting concerns a column of troops on the search for Indians, the artist has chosen to look at the situation from the point of view of three Sioux warriors watching them from afar. The grave faces of these men are a mute reflection of what they see, and what the future portends for them and their people. Their outmoded armament, old flintlock rifles, indicates that they will not be able to mount an effective defense and that the eventual outcome will be their defeat. In that sense, this work foretells the destruction of a free people's way of life.

The defeat of Custer at the Little Big Horn was like the sudden bright flickering of a candle in the moment before the wind extinguishes it. From that point forward, the Plains Indians suffered defeat after defeat, valorous to the end, but valor alone could not stand against superior technology and overwhelming numbers.

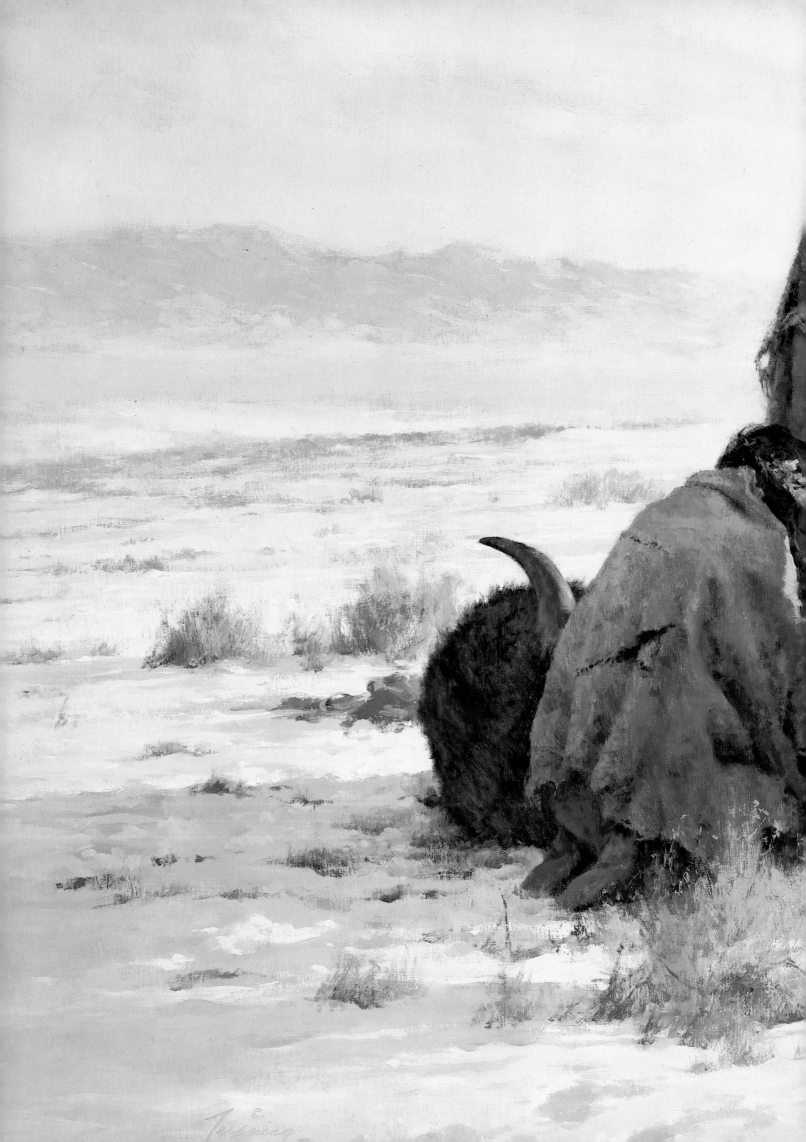

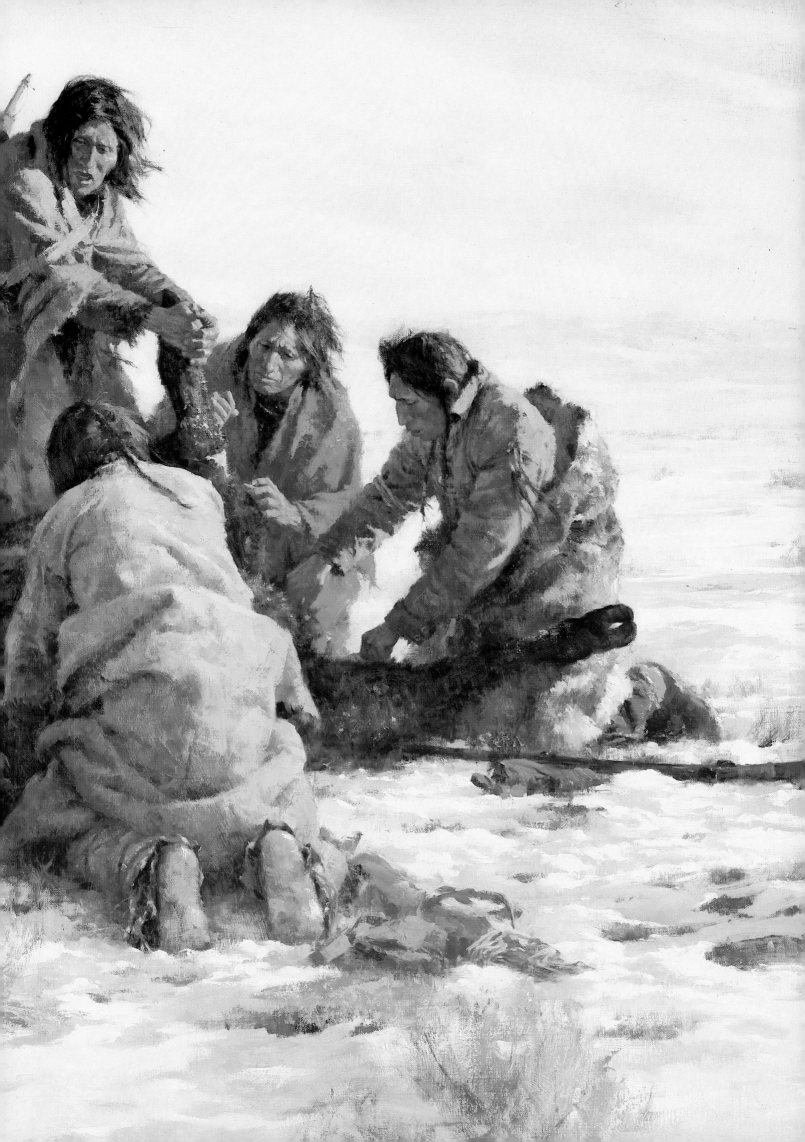

THE LAST BUFFALO

Buffalo numbers were already beginning to decline during the heyday of the robe trade as Indians slaughtered them to sell their woman-finished skins to the white man. The real slaughter began in the early 1870s, however, when commercial use was found for the untanned "flint" hides. At first neither Indian nor white man believed the great herds could be killed out; the buffalo seemed as many as the grains of sand. But by 1873 they were almost gone from the middle plains region, along the Republican and Arkansas rivers. Hunters based out of Dodge City, Kansas, next moved south into Texas, where by the late 1870s they had wiped out the southern herd. The final slaughter was on the northern plains. By 1883 the buffalo were almost entirely extinct.

Indian attempts to stop the hunters were in vain. Though official policy forbade the hide harvest, officials winked at it. Military reasoning was that if the buffalo were removed, the Indian would at last be forced to reservations. Moral judgments aside, that proved to be good prophecy.

For a time the Indians held out hope that the buffalo had retreated into a hole in the ground, the same hole from which tribal legends said they had first appeared.

The painting depicts a desperately hungry group of Indians who have just killed the last buffalo they could find. They are poor now and will become even poorer, dependent upon the mercy and benevolence of the white man, who too often has neither.

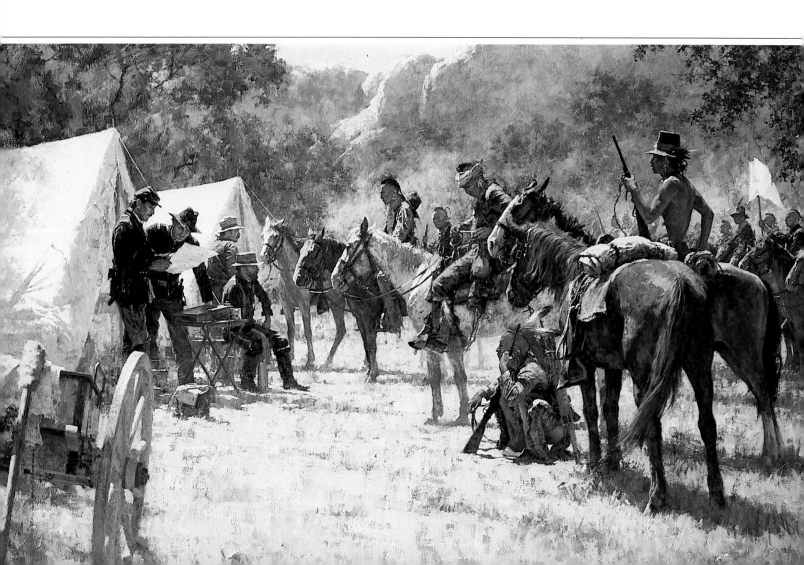

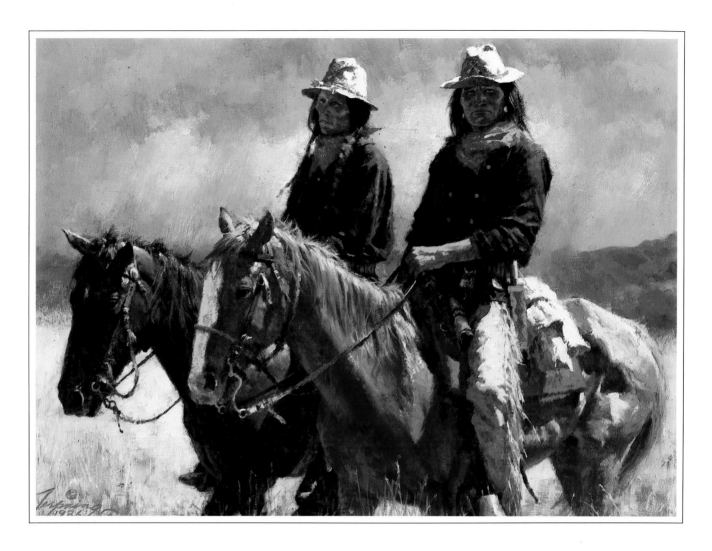

CAVALRY SCOUTS

In its campaigns against hostile Plains Indians, the army made good use of scouts recruited from among enemy tribes, taking advantage of ancient intertribal feuds. The painting depicts two Cheyenne scouts, who have adapted only that part of the military uniform and equipment which suits them. They both wear military shirts and scarves, but the one in the right foreground boasts fringed buckskin leggings and carries his knife in a beaded scabbard.

MAJOR NORTH AND THE PAWNEE BATTALION

Major Frank North was party to the army's first use of Plains Indians as scouts, organizing a company of about a hundred Pawnees in 1864 to fight against Sioux who had been raiding the Pawnees' Nebraska reservation. He used the Pawnees against hostile Cheyennes and Arapahoes also. The company was eventually disbanded, but it was followed by North's Pawnee Battalion of about two hundred men who guarded construction crews of the Union Pacific Railroad. This duty suited the Pawnees very well because it allowed them to fight old enemies with the aid and approval of the U.S. government. The battalion was an on-again, off-again unit until its final disbanding in 1877.

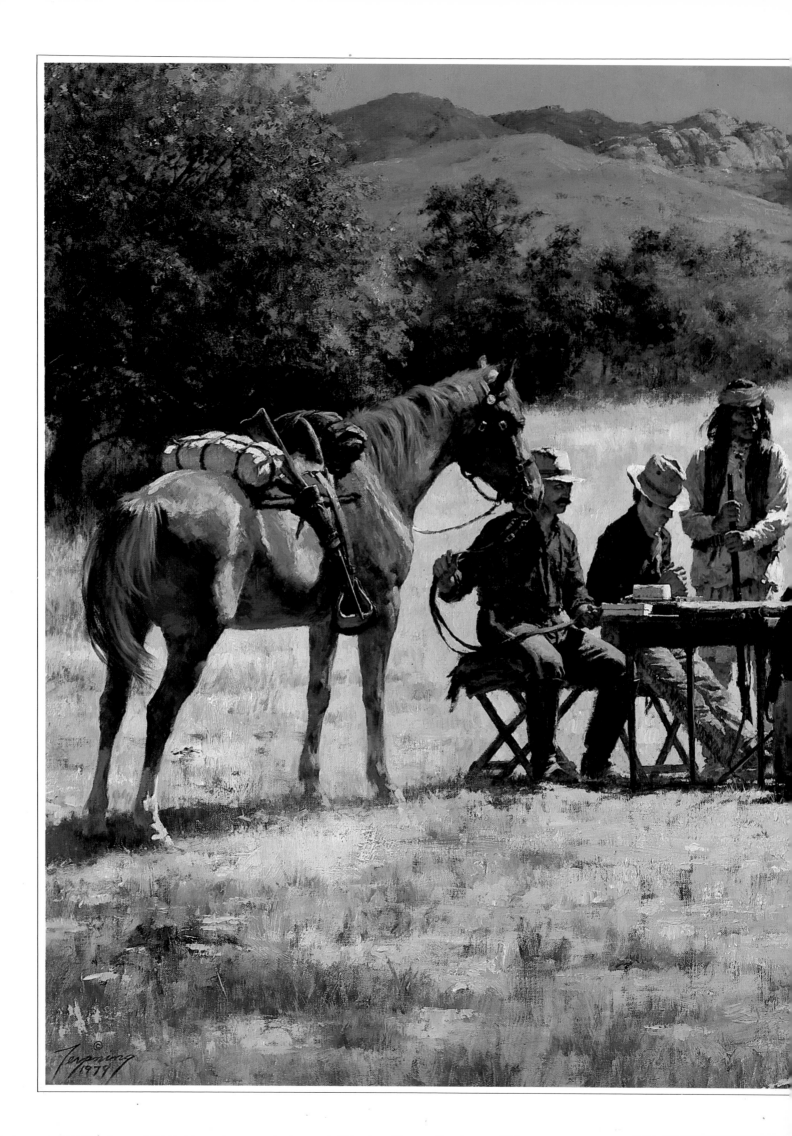

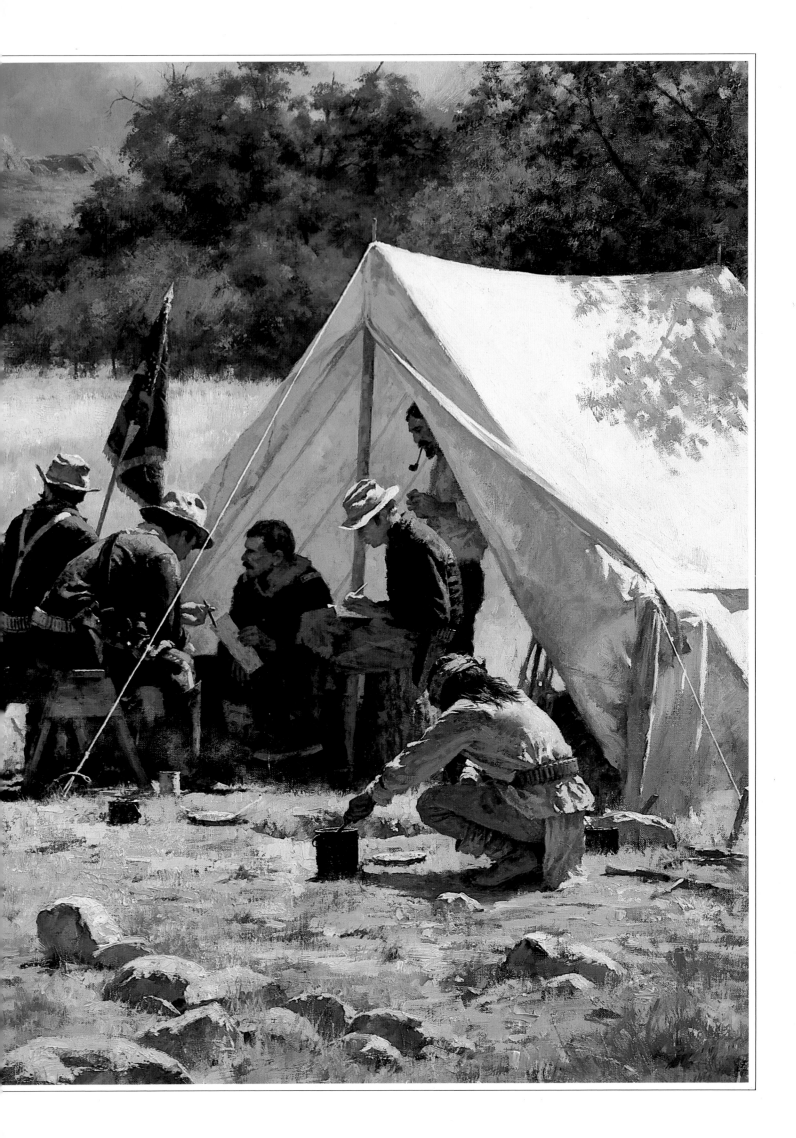

FIELD HEADQUARTERS, ARIZONA TERRITORY, 1886

The army's pursuit of Geronimo and other breakout Apaches led it back and forth over agonizing miles of rugged terrain. In May of 1886, General Nelson A. Miles took over as military commander of the Territory of Arizona from the able General George Crook, who had made much use of Apache scouts. Miles sent Captain Henry Lawton on an exhausting three thousand–mile campaign in pursuit of Geronimo and some forty or so warriors through Mexico's Sierra Madres. After Lawton's failure, Miles sent Lieutenant Charles Gatewood and two Apache scouts, who located Geronimo and arranged for his surrender.

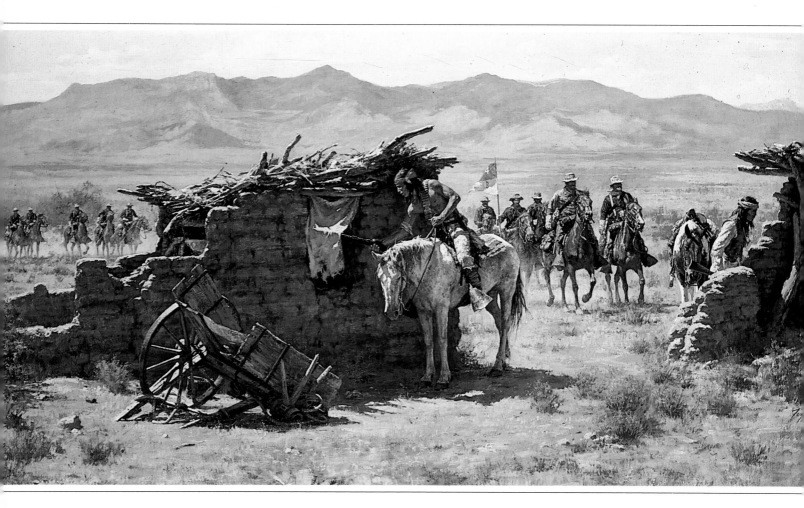

SEARCH FOR THE RENEGADES

With fewer than a hundred fighting men, Geronimo toward the end terrorized and retarded settlement in an area larger than Germany and France combined. His name sent chills down the backs of miners, settlers, and even the soldiers who attempted in vain to run him down. Only by the use of Apache scouts, persuaded to help the army hunt down their own, did the military finally gain an upper hand.

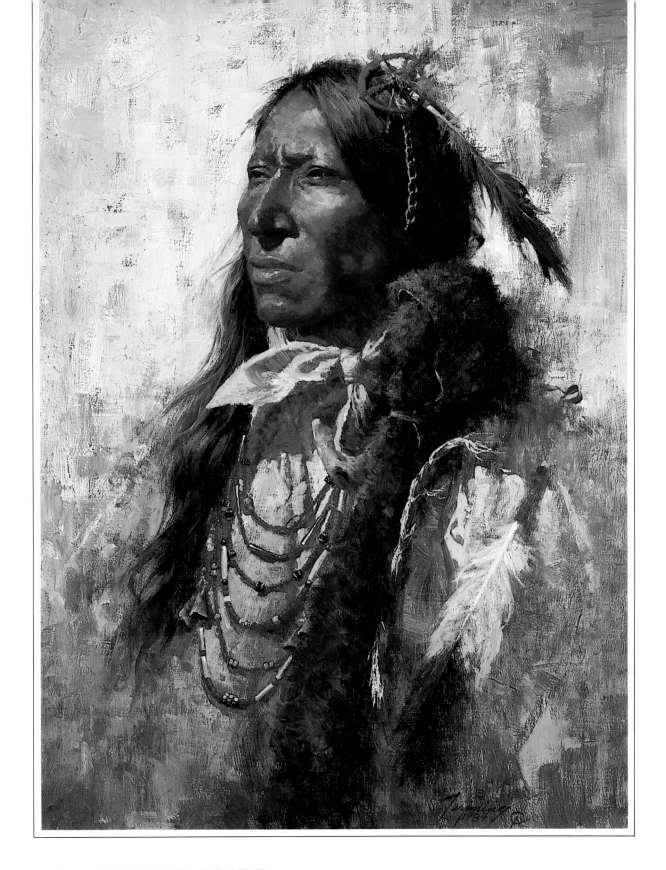

THE CAVALRY SCARF

A Sioux warrior wears a yellow cavalry-type scarf around his neck. It is up to the viewer to decide for himself whether he traded for it or took it from a soldier who would never warm himself by his home fires again. This is a splendid example of Howard Terpning's close-up character studies. He points out that every detail of the Indian's getup has a meaning.

DIGGING IN AT SAPPA CREEK

Cheyenne men and women, wanting only to go home, frantically dig rifle pits with belt axes, butcher knives, and whatever else they can find as cavalry and white buffalo hunters approach on brush-lined Sappa Creek in northwestern Kansas. This, in 1875, followed a desperate breakout from imprisonment at Fort Reno, Indian Territory. The whites shot down a leader who approached them under a flag of truce, intending to parley. When the guns finally went silent, dozens of men, women, and children lay dead.

Similar scenes were repeated three years later during the tragic 1878 breakout from an oppressive reservation. About 335 Cheyennes—mostly women and children—started a brave retreat trying to reach their homeland in the Yellowstone and Powder River country. Many on foot, they covered six hundred miles in less than a month.

"Sappa means black," the artist says. "I was out at the exact spot where this took place. It is symbolic to me of all the fights between the Cheyenne people and the cavalry. This painting is dedicated to the Cheyenne people for their courage and strength, and their belief that they had the right to live in a country where their ancestors were buried."

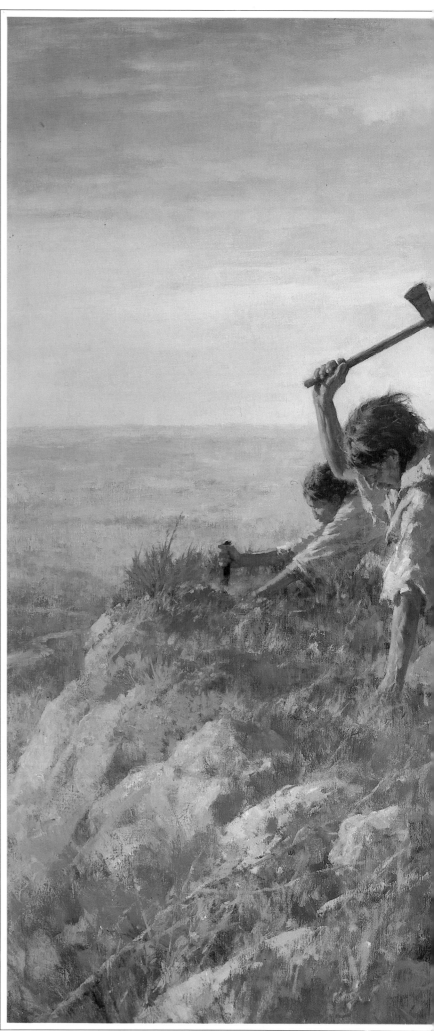

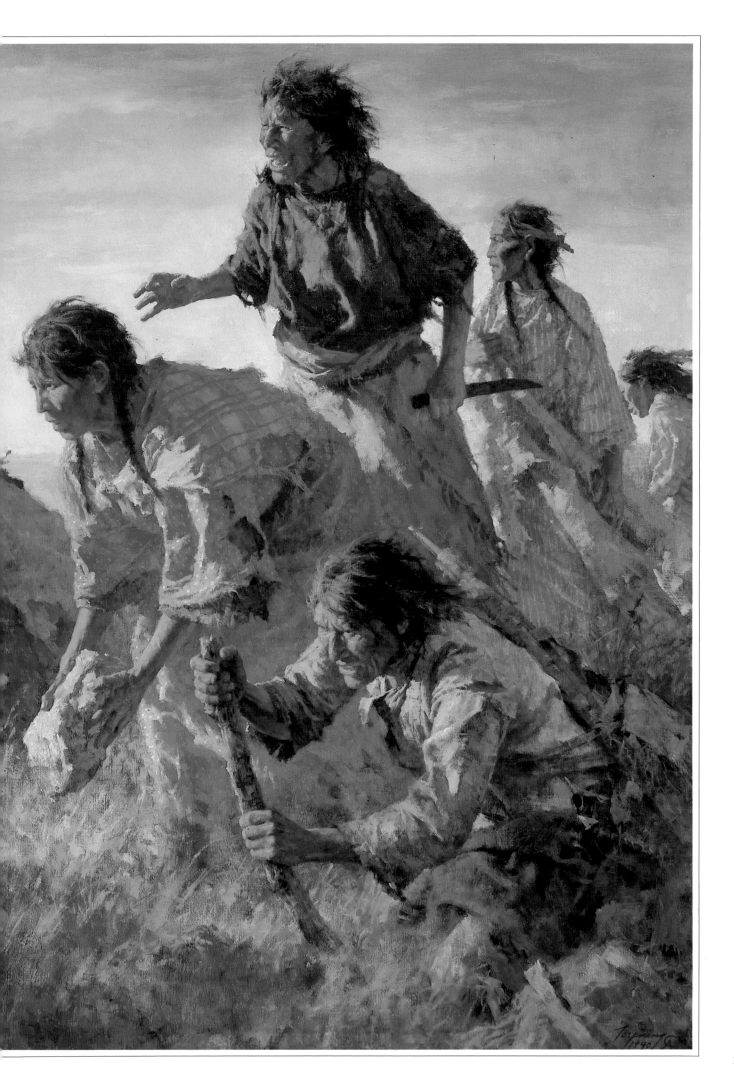

CHIEF JOSEPH RIDES TO SURRENDER

The agony of defeat is powerfully rendered in this painting of the great Nez Percé chief, Joseph, on his way to surrender to army troops in the foothills of the Bear Paw Mountains only about thirty miles short of the Canadian border. Joseph had made a gallant effort to lead his people away from what they regarded as imprisonment on an Idaho reservation.

He had counseled peace with the whites but firmly resisted their efforts to move him and his people from their traditional home on the Wallowa in northeastern Oregon. In 1877, General Oliver Otis Howard gave him an ultimatum: move or be attacked by the cavalry. Joseph's answer was to lead his band, about fifty-five warriors and some three hundred women and children, on a futile thirteen hundred—mile march toward freedom.

Army mistakes were covered up by touting Joseph's skill as a tactician, which he never really was.

Weary, beaten, he delivered his heartbreaking "From where the Sun now stands" surrender speech. His stately bearing and powers of persuasion finally won him much respect among the whites and improved their treatment of Nez Percé prisoners. Many eventually were allowed to return to their home in the northwest.

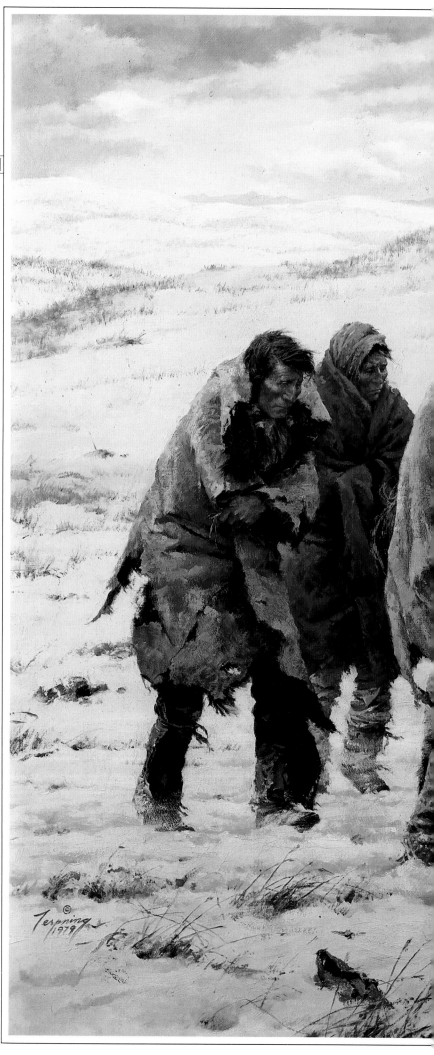

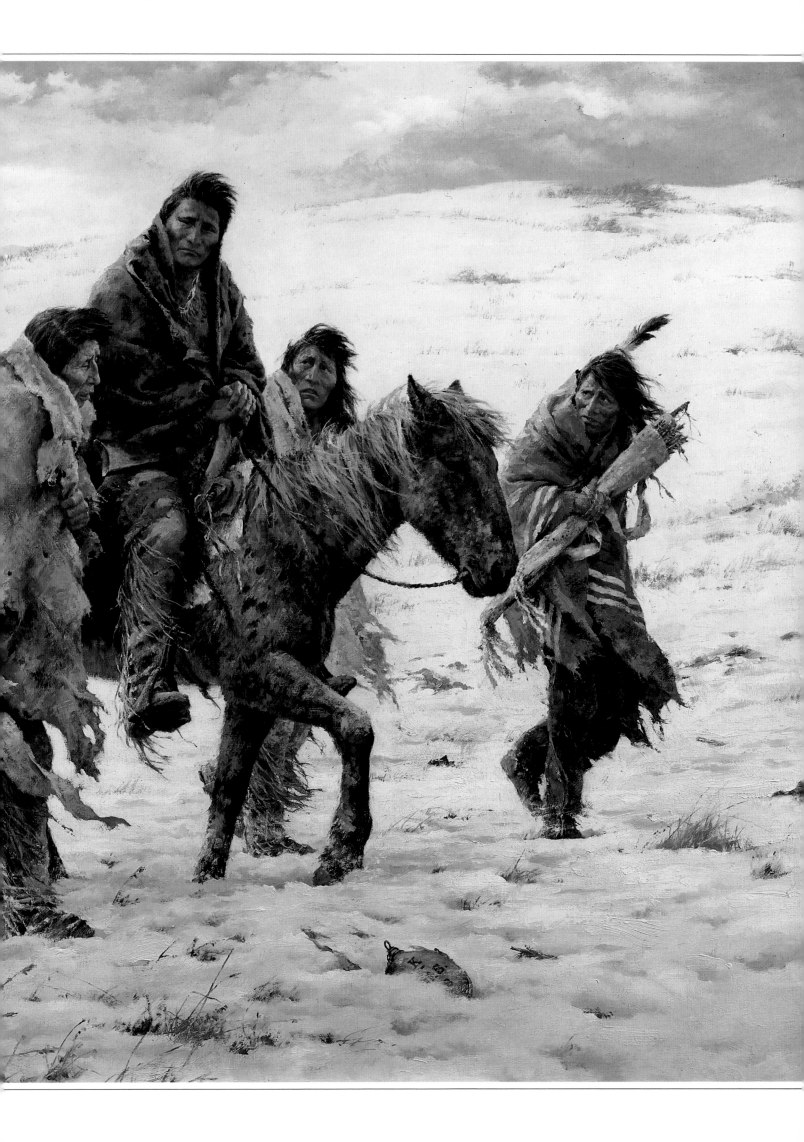

HOWARD TERPNING, STORYTELLER

A mong the free-roaming Plains Indians, the storyteller had a unique and honored place. For lack of a written language, he—and sometimes she—was the repository of tribal histories and legends, passing them from generation to generation.

Howard Terpning is a modern-day storyteller, rekindling the image of the Plains Indians by painting them with power and emotion, painting them as they were.

He is a soft-spoken man, slender, wearing a closely trimmed salt-and-pepper beard, accustomed to dressing in the casual blue-jean style common to the desert West in which he has chosen to live since 1977. Though he tends to be reticent and slow to initiate a conversation, his blue eyes become animated when the talk moves around to his favorite subject.

"We could have learned so much from the American Indians," he declares, "if we had had the interest to listen to them and pay attention to them."

The much-honored Terpning stands today at the very top rank of artists who paint Western themes. He regards himself as having a mission: "To show the American Indians, the native Americans, in an honest way, to show their ceremonies and their everyday life, to show them as people who were not always at battle but as people who raised children, made love, cooked meals, hunted buffalo. They were human beings, just like we are."

Declared the late Fred A. Myers, director of Tulsa's Gilcrease Museum: "Howard Terpning is simply the best and best-known artist doing Western subjects at this point. . . . He is among a very small group of painters of the West in the late twentieth century whose art will still be hanging in museums and appreciated a hundred years from now."

H e was born November 5, 1927, in Oak Park, Illinois, birthplace also of Ernest Hemingway. His father worked for the Northwestern Railroad. His mother was an interior decorator. As a boy he was torn between two ambitions: to be an artist or to be a pilot. His brother Jack lived out the latter ambition, becoming a B-24 bomber pilot in World War II. Unfortunately, he was lost in New Guinea.

Terpning joined the Marine Corps in 1945 at age seventeen and served as an infantryman in China. Afterward, he found educational institutions heavily enrolled with returned war veterans. He was told he would have to wait in line to enter the Chicago Academy of Fine Art. His father's friend and neighbor, illustrator Harold Mundstock, interceded with the academy. Later Terpning attended the American Academy of Fine Art.

He had made up his mind to try New York City, but after several discouraging

days of looking in vain for work in the many art studios, he returned to Chicago. Mundstock introduced him to Haddon (Sunny) Sundblom, at the time considered the dean of American illustrators. A big, tall, white-haired Swede, the gregarious Sundblom dominated any room he was in. He took Terpning on as an apprentice for thirty-five dollars a week.

"It was a marvelous learning experience," Terpning says.

After five years he moved to Milwaukee, where for three years he painted such subjects as farmers on tractors. Deciding it was finally time for New York, he signed on with Stephens Bionde de Chicco. There for five years he learned to simplify and to work quickly without sacrificing quality.

Striking out on his own then, he painted seven days a week, often thirteen hours a day. He averaged eight illustrations a month, a pace that today makes him wonder how he managed.

In 1967 he accepted an invitation from the Marine Corps to document Vietnam War scenes as a civilian combat artist. Given a temporary rank of major to allow him relative freedom of movement, he spent a month in Vietnam. Though his weapons were a camera, sketchbook, and pencils, his Marine experience led the combat troops into taking him out on patrols, where they engaged in two firefights with the Viet Cong, and flying him in a medivac helicopter behind the lines to pick up the wounded.

Out of that harrowing experience came six paintings now displayed in the Marine Corps Museum in Washington, D.C. Out of it also came something else: a much-diminished regard for material things and a heightened empathy with distressed and deprived people. That empathy would later carry over with much effect into his paintings of the Plains Indians.

In all, he worked prolifically as a commercial artist for twenty-five years, seventeen of them in New York City. Besides advertising art, he illustrated stories and articles for such publications as *McCall's*, *Ladies' Home Journal*, *Reader's Digest*, *Good Housekeeping*, *Newsweek*, and *Time*. He painted more than eighty movie posters, starting with *The Guns of Navarone*. They include *Doctor Zhivago* and a reissue of *Gone With the Wind*. One of his favorites is a poster for *The Sound of Music*.

He became restless, however. Though financially rewarding, the commercial work was no longer satisfying to him as an artist. To meet his creative urge for something more permanent, he began painting portraits for his own

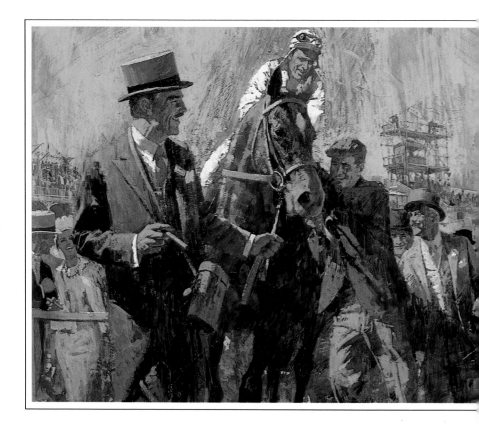

The winner's circle after a race, part of a 1967 ad campaign which Gold Label cigars placed in a number of nationally distributed magazines.

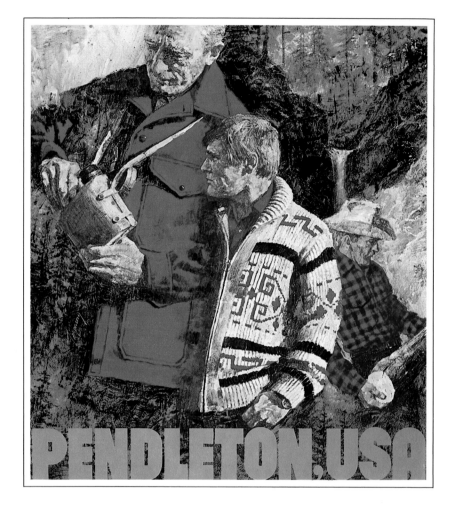

pleasure. Among the first was Sioux Chief Gall, done for his daughter Susan.

Fellow artist Don Crowley suggested that he do some fine arts paintings for galleries. Outdoors subjects were natural for him because he had already illustrated many hunting and fishing scenes. Moreover, he had long since acquired a deep interest in Western history, fostered by a summer vacation spent with a cousin in Colorado when he was fifteen. He had collected large numbers of books on the subject.

In the summer of 1974, at age forty-seven, he took a couple of months off from his commercial work and finished three easel paintings on speculation and hope. The feeling of freedom, of painting what he wanted instead of commissioned pieces, work done to order, made that summer one of the most satisfying of his life as an artist. He sent the canvases to Troy's Gallery in Scottsdale, Arizona, which sold them in January 1975.

That was a turning point. Gradually he reduced his commercial accounts, accepting fewer assignments. By the middle of 1976 he gave up commercial work altogether.

Through the Settler's West Gallery he had become acquainted with Tucson and its Sonoran desert environment. He and his German-born wife, Marlies, bought the rambling Spanish-style house where he lives and works today in the foothills of the Catalina Mountains, once Apache country.

He soon realized that his adrenaline level rose highest when he painted Indians. "The more I studied them, the more fascinated and intrigued I became."

He recognized that each tribe had its own distinctive physical features as well as its individual trappings. The Blackfeet of Montana were different from the Apaches of Arizona, for example. There was no such thing as the interchangeable all-purpose Hollywood Indian that fitted all geographical settings. He studied historic photographs by the hour, fascinated by the features that set one tribe apart from another, by the way each had adapted to its own specific environment.

He has concentrated his work on the major Great Plains tribes. He has remained fascinated more by the horseback nomads—the hunters—than by sedentary tribes. He prefers to show them in the quieter and more reflective moments of their daily lives. Violence is sometimes implied, warriors preparing for a battle or coming home from one. At times they are poised on the brink of confrontation, usually more suspenseful than actual combat.

In his paintings Indians are individual human beings with distinctive faces which vividly express their pleasures, their fears, sometimes their pain. One looks at the eyes and reads what is going on in the mind behind them. One sees the soul.

"We could learn much from the Indians of that time. We could learn to pay more attention to what goes on around us, to cherish our environment and not abuse it the way we do. They seemed to have a better understanding of what life was about. They saw life as a sacred circle. They saw its continuity.

"They had a reverence for Mother Earth."

He enjoys the field work that goes with making a painting authentic, with giving it a life and a soul. He finds no substitute for walking the ground, for absorbing the nuances of nature, the heat, the cold, the play of sunlight and shadow on the mountains and plains. He often undergoes an indefinable but very real psychic experience when he visits the scene of an important historic event.

One of his paintings, *Digging in at Sappa Creek*, portrays the prelude to an encounter between the Cheyennes and pursuing army troops. A holy man named Medicine Arrow, whose personal spirit guide was the red-tailed hawk, was killed at Sappa Creek. The Cheyennes claimed that his spirit came back every afternoon in the form of a red-tailed hawk to protect the bodies of the others who were slain.

Terpning visited the site late one afternoon. "There was a feeling that was indescribable. I heard the sound of this hawk. He kept circling around, calling, and made my hair stand on end."

Before painting *Chief Joseph Rides to Surrender*, he spent an afternoon at the site in the foothills of the Bear Paw Mountains. He found a presence, a strong emotional pull. "There is no way I could have done this painting without going there and conversing mentally with the land. It spoke of wrecked equipment, wounded bodies, broken dreams, and a vanquished people."

The emotion the painter felt at the site is carried with telling force into the anguished faces of Joseph and the five men who trudge on foot alongside his horse in the bitter snow.

This has been one of his most popular paintings. For most of the time over the last several years, it has hung in the Gilcrease Museum. When it is not there, visitors ask about it. *Chief Joseph* is among the half dozen or so paintings people come specifically to see.

Though for the most part the Indians are long since gone from the places he paints, Terpning can see them, as the Indians themselves might have said, with the eye that is in the heart.

"People ask me how and where I can conjure up images of Indians that might have been alive a century ago. My answer is that I have so concentrated my mind on these subjects, I see Indians everywhere!"

His friendship with members of the Blackfeet Reserve gave him the privilege of visiting one of their holy places south of Browning, Montana, where for generations the people had gone to a certain area in the woods and attached small offerings to tree trunks and branches. In the old times these might have been eagle feathers or ermine tails, bits of ribbon or tiny medicine bundles, items significant to them, things they felt appropriate as an offering to the spirits. Nowadays they attach swatches of cloth. A breeze pushed through the trees, and the rustle of leaves lent the place a spiritual atmosphere. He was emotionally moved, walking on holy ground where generations of Blackfeet had walked before him. The result was *Offerings to Sun*.

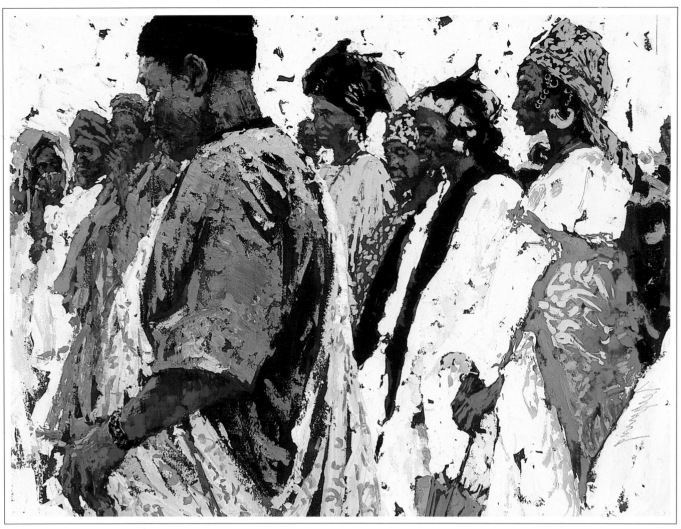

Terpning painted The Africans *in 1960 to experiment with a strong pattern of light and dark. For years afterward he used it to demonstrate his versatility to advertising and editorial art directors.*

His high-pitched studio walls are alive with color, bedecked with collected Indian artifacts which often turn up in his paintings: shields, bow cases, cradleboards, parfleches, pipes, tomahawks, war clubs, lances, powderhorns, moccasins, buckskin clothing, saddles. He is fascinated by the things the Indians made, their clothing, their decorative ornaments, their headdresses and weapons.

He regards the Indian artifacts as a true art form with a unique and exotic beauty. "The people who designed and made these things had no kind of art education, yet they had this incredible sense of design and sense of color . . .

"And they knew what they were creating, the way they must have looked on horseback or when they were running with all this fringe and all these feathers and all this color. They knew exactly what they were doing."

Occasionally when he is unable to find just the artifact he needs, he constructs a replica, using methods as nearly authentic as he can, though perhaps doctored with a little modern convenience. Once he constructed a war shield. To give the leather covering an appearance of age, he tied it to the rear bumper of his car and dragged it up and down country roads, then lay awake nights wondering how he should paint it.

Authenticity is his hallmark. A specialist once looked at a Blackfeet rattle replica Terpning had made and declared that it had to be a hundred years old.

His paintings draw six-figure prices, but he is more proud of the fact that they are well accepted by native Americans. A Kiowa woman told him at the Gilcrease Museum, "You are giving us back something of our culture that we can be proud of."

He draws or paints every day, a result of discipline developed during his long

career as a commercial artist. "When a notion strikes, I'm almost overwhelmed by excitement to paint it. I don't fuss with color sketches. Once the preliminary drawing is completed, I go directly to finish paint."

His paintings always start with an idea, followed by thumbnail sketches to determine the best design. When he is satisfied with the rough drawing, he finds people willing to pose for him. He often uses his son Steven as a model and sometimes asks artist friends to pose for him to help him achieve proper body stance, the drape of clothing, the play of light and shadow. He works a great deal from photos he has made of landscapes, details, and people. He may take hundreds of photos and extract bits and pieces from many for a single work.

Once he does the original sketch and has completed his basic research from reference materials, he decides upon the size of the painting and stretches a canvas for it. He makes a half-size drawing to scale to be sure of the composition, then repeats the drawing at full scale on tracing paper and applies a light gray chalk to the back of it. He prepares the canvas by applying a turpentine wash of thin oil pigment in medium-tone colors that will be compatible with the painting. When the wash is dry, he places the drawing against the canvas and traces it. The chalk on the back leaves a thin gray line on the canvas to guide him as he lays in the painting.

The medium tone wash allows him the advantage of using a wide range of light and dark colors as he works.

"I like painting light on dark. It is much easier to establish the painting by starting with the medium tones, then you put down your lightest and your darkest colors. You have three values that quickly establish the form."

Once started, he stays with the work. "I eat, sleep, and breathe a painting until I finish it. It is on my mind all the time."

To date he has completed more than three hundred paintings of Indians. He has no fear that he will run out of ideas.

"I could paint for two lifetimes without drying up for subject matter."

When possible he likes to use contemporary Indian models, but as a practical matter he often has to use non-Indians for composition, then paint in Indian faces. Even when he uses contemporary Indians, he realizes that because of today's diet, health, and different living conditions, they usually do not have quite the same look as their ancestors who lived forever outdoors, often in extreme hardship, at the mercy of the elements. He studies contemporary photographs of Plains Indians from a hundred years and more ago. In those proud faces and eyes, he finds a great strength and inner spirit from which he borrows to transform today's features into those of the past.

His desert home gives him immediate access to a plentitude of landscapes. Coyotes sometimes wander up into his curving driveway. Quail visit, as do owls. A family of Harris hawks lives nearby. One day he had to ease a Gila monster out of his yard, moving in its own slow and reluctant pace, for he had no desire to harm it. In front of his house stand stately saguaro cactus plants, their arms reaching up toward the desert sky. In his Spanish garden grows a variety of trees: comquats, zialasma, olive, orange, and grapefruit, as well as oleander and pyracantha.

He has a grown daughter and two grown sons: Susan, Jack, and Steven.

Marlies, whom he married in 1969, was born and raised in Germany. She came to New York to work in an art gallery and met him through mutual friends. "I cannot exaggerate her importance to my work," he says. "Obviously, I adore her, but she has a practical, organized Germanic streak that I lack. She runs the house. She keeps the books. She constantly reminds me of schedules and obligations. When I paint, I become thoroughly preoccupied, forgetful. She has a wonderful eye for art, and we think a lot alike. I encourage her to discuss a painting from inception to completion. Her suggestions nearly always are helpful."

Since 1979—just two years after moving to Tucson as a full-time easel painter—he has been a member of both the National Academy of Western Art (NAWA) and the Cowboy Artists of America (CAA). The NAWA show occupies the National Cowboy Hall of Fame in Oklahoma City each June. CAA has its own Western art museum in Kerrville, Texas. His works are offered in Tucson at the annual November show of Settler's West Gallery, the exclusive dealer in his original works. The Greenwich Workshop in Trumbull, Connecticut, publishes his limited edition prints.

In his painting career he has earned more than twenty gold and silver medals for oils and drawings, including five Colt awards and a Stetson award from the CAA, as well as the Prix de West award from NAWA. He has had a one-man show at the Gilcrease Museum and won the first $250,000 Hubbard Art Award for Excellence in 1990.

He can sometimes become emotional about what happened to the Indian, as when he tries to explain the background of his painting of a profoundly sad Joseph, riding to surrender after giving all he had for a freedom heartlessly taken from his people. "It was a sad page in western American history," he says.

"I think it is important to tell the story of the Plains Indian because it is part of our heritage, part of our history. The western history we have is the only history America has that is uniquely our own.

"It would be a shame to let that part of our history die. Why should we? Why not keep it alive?"

It *is* alive, wherever a Howard Terpning painting or print hangs. It is alive in this book. ∎

Howard Terpning in his Tucson studio, seated before his painting, Owner of the Sacred Shirt.

LIST OF AWARDS

COWBOY ARTISTS OF AMERICA

NATIONAL ACADEMY OF WESTERN ART (N.A.W.A.)

THE HUBBARD ART AWARD OF EXCELLENCE

LIST OF PANTINGS AND FREQUENTLY MENTIONED TRIBES